Woman's Eye, Woman's Hand

Preface and Acknowledgements

This volume coalesced—as many intellectual and political projects do—from a perceived set of common interests and approaches to the topic of art, architecture, and patronage by women. An international group of scholars met to present research in a workshop setting, hosted by the Doris Duke Foundation's Shangri La in Honolulu, Hawaii, an appropriate meeting place given its intermediary location between East and West, and Miss Duke's lifelong interest in South Asian art and architecture. In addition to formal presentations by the participants, we were fortunate to have present in the audience scholars of Indian art and architecture: Frederick Asher, Miki Desai, and Thomas Metcalf. We cannot tell if their comments were softened or sharpened by the fact that they are the spouses of three of the participants, but we were very grateful for their perceptive insights and lively contributions to the discussions that ensued after each presentation. From that gathering, papers were selected and new ones were added to form the present volume. My thanks to all the staff at Shangri La for their generous welcome during my first visit in 2005, when the workshop was first proposed, and in opening the doors of Shangri La for the symposium itself. In particular, the authors wish to express our collective gratitude to Shangri La's director, Deborah Pope.

Introduction

In the Presence of Women

D. Fairchild Ruggles

The year is 1947, a year of exhilarating and profoundly painful importance in India: independence from colonial British rule and transition to a parliamentary democracy but at the cost of partition into the now separate nation states of India and Pakistan. A young graduate stands facing the camera in a photographer's studio. She wears a gold-bordered but otherwise unadorned scholar's robe over her sari, one arm resting on a stack of books posed on a square column, the other lightly holding the scrolled diploma of her Bachelor of Arts degree, a simple yet powerful symbol of her educational accomplishment. This is not a family portrait in fancy

Figure 1: 1947 Bachelor of Arts graduate

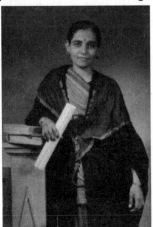

dress but a representation of a person alone, the robe, scroll, and books identifying her as a new kind of woman, supported by learning rather than father or husband, at least at this point in her life. Her expression is serious yet evinces the hint of a smile. Is she gladdened by the prospect of a new independent India? Hopeful for her prospects at marriage or career? Who is this confident young person and what will her future be? The question can be answered with specific biographical details, for she is the mother of the friend of a friend—a link in a network of women that connects us as friends, colleagues, and sisters across nations and professions. But I prefer to explore the question in a larger sociological sense, asking what were the prospects for any young female arts graduate in India at mid-century? What contribution could such a person make to the building of the new nation, and what challenges would she face?

The question, of course, requires us to reflect not only on the conditions in India in the year 1947, but the social culture of the previous decades in South Asia and the world to which it was connected. It prompts us to look beyond the fixed borders of India to a larger field of social relations that determined the possible scope of achievement for women everywhere. While national borders might be formally inscribed, the individuals contained within them could cross those borders (at least some of them) with relative freedom, so that artists and architects in India could make the journey to France, England, and the US with a similar exchange coming from the other direction. Just as men and women traveled, the material goods that they produced and consumed were also portable, carrying with them new ideas about art, aesthetics, and culture. In colonial and even postcolonial India, the production and consumption of such goods occurred within a field of economic and political relations that were exploitative—the Europeans enjoying more power and choice than the Indians—but, at least among the elite, there were always artists and patrons in both realms whose artistic vision was international and progressive (which in no way conflicted with their commitment to the nation). Women had an important role in defining those progressive values.

This volume examines the agency of women as the producers and patrons of art, crafts, and architecture in South Asia in the late nineteenth and twentieth centuries. While India is the primary focus, it does not concentrate exclusively on Indian women, instead reflecting on how women both in and outside of South Asia could affect arts production, variously as teachers, role models, consumers, patrons, writers, and architects. The theme of modern patronage in South Asia is important and timely, but it has received little attention, eclipsed by more active scholarship in the area of Mughal art and architecture and the colonial period. The twentieth century saw the rise of women's participation in the fields of art and design throughout the modern world. In India, when independence was established, it was a social rupture (and a recuperation) that promised new opportunities for women and for architecture and the arts. India became a crucible for experimentation in modern and utopian architecture with new buildings—in some cases, entirely new cities—and new museum collections giving public face to the new India. British designers Sir Edwin Lutyens and Sir Herbert Baker designed colonial New Delhi in the 1910s and 1920s, Swiss architect Le Corbusier designed Chandigarh in the 1950s, and French architect Roger Anger designed the utopian Auroville in 1968. Ahmedabad received major buildings and complexes by Le Corbusier, Louis Kahn, and Balkrishna Doshi from the 1950s to the 1980s. Although the architectural luminaries were men, women also benefited from the building boom, entering into such professions as architecture and design that had previously been closed to them. Many of these architects worked for private patrons, a logical intervention in the domestic sphere that has always been assigned to women, while a few received larger, more public commissions. If there was less change in the opportunities for female patrons, it is because, belonging to a privileged and wealthy class, those women had always enjoyed greater agency as patrons of art and architecture. Nonetheless, beginning in the late nineteenth century and continuing through the twentieth, there was a significant increase in women acting as arbiters of taste and shapers of the built environment.

These emerging groups—female artists and female patrons— had much in common. Furthermore, because the new opportunities for women were not confined to Europe and the US but occurred in all areas where modernity was embraced, a global interchange among designers and patrons in South Asia and beyond can be observed. These factors converge in the persons of Doris Duke and Amrita Sher-Gil, twentieth-century women who traveled widely and admired the arts of South Asia, albeit with different connections to that art. Amrita Sher-Gil lived an international life. The daughter of an aristocratic Sikh gentleman and a Hungarian Jewish singer, she was born in Budapest but moved to India at eight years of age. With her mother, she moved to Italy and then Paris where she studied art at the École des Beaux-Arts before returning to India in 1934. However, the words Sikh, Jewish, Parisian, and Indian do not suffice to define her, and she herself refused to step into any such easy categories. Pradeep Dhillon's essay in this volume uses location and dislocation to query art history's practice of assigning artists such as Sher-Gil to fixed identities. It is equally difficult to fix the identity of Begum Samru of early nineteenth-century Sardhana (north of Delhi), who was born a Muslim but married two Europeans and converted to Christianity, using this position to mediate among the British, Mughals, and Marathas.

Doris Duke had a restless drive to escape her extraordinary status as the richest woman in the world—a distinction thrust upon her at the age of twelve when her father prematurely passed away. As Sharon Littlefield's contribution to this volume explains, she voyaged extensively in the Middle East and South Asia, making long trips to India in 1935, 1957, 1961, 1969, 1976, and 1988. With nearly unlimited resources, she had ample means to collect objects of art historical value and to commission new works for her houses, especially her oceanside estate in Honolulu, romantically called Shangri La. In her exercise of taste and patronage, she not only drew attention to the collecting of art but also stimulated new production, such as the set of large, white marble, carved jali screens that she commissioned for her bedroom windows at Shangri La (and then

replaced with a new set when the first set arrived in fragments), or the pietra dura inlay that she had made for its luxuriously appointed bathroom. As a patron, she can be credited with considerable creativity, for these traditional arts were blended with technically innovative modernist design. The heavy marble screens, for example, were installed on gliders so that they could be rolled back from the windows whenever so desired.

Doris Duke had an impact as a patron. Indeed, women, who until the modern era were often excluded from the actual practice of art and architecture, except at the very lowest level of simple labor, often made their contributions to those fields in the form of patronage. In this respect the American has something in common with the architect Pravina Mehta, Begum Hazrat Mahal of Lucknow, the Maharanis Maji Tanwarji and Gayatri Devi of Jaipur, and the Begums of Bhopal. As designers, rulers, and heiresses they belong to quite different categories, and there is no evidence that any of them ever met. But discussing them together in this volume allows us to establish a new framework for considering the activity and even agency for women, in which production, representation, and patronage are all aspects of creativity.

The art historian Karen Barzman wrote a thoughtful article in 1994 in which she responded to Linda Nochlin's famous question: "Why have there been no great women artists?"[1] Nochlin had demanded that we interrogate the apparent innocence of that statement, investigating it not as an absence of women (with its assumption of passive naturalism), but rather as a set of structured conditions that actively and deliberately barred women from achievement in the field. In turn, Barzman proposed that we reconsider the values implicit in defining the category of "art production." She stated that the relationship of women to art has been treated in three ways: as producers, objects, and patrons of art.

Historically, women were excluded from the actual practice of art. Yet, despite this, some did contribute as *producers* by working in artisanal workshops in a supporting capacity, and some even broke social barriers to make art on terms that match those of men, and

that have even been mistaken for works *by* men. There were enough of these exceptions throughout history that, in response to the rising pressure among women for inclusion in the written histories of art, a new subcategory could be inserted in art surveys that appeared in the 1980s. These monumental texts attempted to expand the existing canon of art history by identifying a handful of artists who had hitherto been ignored, or whose work had been attributed to men. Often, the old canon was simply rewritten to include the newly discovered female artists, without changing its overall structure or values.[2] But a subsequent generation of feminist scholars did more than merely assert the presence of women such as the seventeenth-century Italian painter Gentileschi and the modern American sculptor Louise Nevelson who had previously been excluded from written history: they examined the patriarchal premises of art history as an entire field.[3] The papers of Mary Woods and Madhavi Desai in this volume perform a similar task of examining the oeuvre and careers of a generation of women architects who had an impact on the built environment of modern South Asia. Pravina Mehta, Gira Sarabhai, Urmila Elie Chowdhary, Hema Sankalia, Brinda Somaya, Neera Adarkar, Revathi Kamath, Anupama Kundoo, and Abha Narain Lambah are architects who, as women in a decidedly male-dominated field (throughout the world, even today), faced challenges that required them to negotiate their careers in creative ways. Some of them consciously self-identified as feminists, aware of their singularity and difference. Others focused on their stature as professionals, preferring to emphasize their inclusion and productivity in the field, regardless of gender.

Women as *objects* of the artist's gaze are everywhere present in the figural arts. "Woman" (as a subject of inquiry) and women (as individuals) most often appear as representations made by men and thus reflecting male perspective and desire.[4] The image question is directly taken up in Pradeep Dhillon's analysis of Amrita Sher-Gil, who was a female artist who also chose women—including her nude self—as the subjects of her paintings. Another way to frame the question of women's place in art (or displacement from art)

is by shifting from the issue of representation to one of presence, examining the gendering of space and—especially in societies with zenana and harem traditions—the relative place of women in public and private spaces. Amita Sinha takes up this question in discussing the problems of representing a Muslim woman who, although rarely seen outside her palace, became a champion of resistance against the British in the mid-nineteenth century. Only one portrait exists of the Nawabi leader Begum Hazrat Mahal, and no statues or other monuments, prompting Sinha to ask whether in the visual culture of contemporary India, memorialization can even occur without physical form. Barbara Metcalf takes a different approach to the question of presence in an essay on one of Bhopal's female rulers and most active patrons in which she asks whether the norms within which that lady operated were symptomatic of her identity as a woman, Muslim, or South Asian.

The third category asks whether artistic production must be measured exclusively in terms of material creativity and the generation of imagery, or whether it can include *patronage* (Barzman 1994: 330). Barzman notes that more people participate in visual culture as observers and consumers than as producers, and that while there is relatively little evidence of women as producers of art and architecture prior to the modern era, there is plenty of evidence for them as patrons. The importance of patronage is acknowledged in a poststructuralist perspective. Although not explicitly alluded to as patronage, a branch of literary critique that explored authorship and literary reception opened a space for thinking about arts patronage as a form of making, rather than mere commissioning. The 1967 essay by Barthes ("The Death of the Author") and Foucault's 1969 essay ("What is an Author?") propose, among other things, that the meaning of a text or work of art is not produced exclusively by the author—a group in which we can include artist or architect—but that meaning is produced by a larger shared system of knowledge and expectations (Barthes 1977; Foucault 1977). These are expectations that the *reader* brings to the text by virtue of already having the experience of reading, an act that is framed, even before the work

is penned, by structures such as chapters, pagination, paragraphs, and sentences. Moreover, Foucault removes the author from the act of authorship, substituting instead, a culturally and even legally constituted "author function." Cast thus, the author/architect is not an autonomous individual who creates text/architecture, deposits meaning into it, and then seals the interpretation at that moment in time. Instead, the author/architect is a mere position within a larger set of discursive relations pertaining to creation, authority, regulation, reception, and interpretation. Foucault's insistence on discourse, rather than individual agency, allows us to see the entire field of art and architectural production, wherein patrons and consumers are as effective and necessary as the artists and architects themselves. For women this means that despite their general exclusion from the category of artist, they can claim an important and influential role as patrons. Moreover (and more insidiously), discourse analysis reveals that art and architecture are socially regulated institutions that are as repressive and exclusive as any other elite men's club.

If we accept the reader of a text or the recipient-consumer of art as one of the producers of its meaning, we can recognize the creative roles of women as arts patrons and clients. In this sense, Doris Duke played an important role in the arts, not only in having commissioned artists and architects to produce lasting works, but also in having helped to produce its meaning. Similarly, Sarojini Naidu and Kamaladevi Chattopadhyay's advocacy for the swadeshi movement was by no means a passive reception of a set of economic and aesthetic values articulated by Gandhi. As Lisa Trivedi's essay in this collection shows, the women adopted the plain homespun khadi cloth that was promulgated as an act of resistance to British economic tactics and a sign of nationalist self-sufficiency, but in doing so they adapted it to suit the tastes and specific needs of women. For her creative embrace of artisanal homespun fabrics, Trivedi calls Chattopadhyay the single greatest patron of Indian arts since independence.

Of course, the possibilities for women in the late nineteenth and twentieth century far exceeded those of their premodern sisters. We are fortunate in the modern era to be able to see women participating,

leading, and significantly changing the arts, both in their role as patron and as artist or architect. But it was not always thus, and indeed sharp changes in norms for women can be observed even in houses where multiple generations cohabited, as Catherine Asher shows in her comparison of Maji Tanwarji, a little known wife of Maharaja Sawai Madho Singh (r. 1880–1922), and her daughter-in-law, the famous Gayatri Devi, an immensely popular and fashionable politician who in 1960 was named one of the ten most beautiful women in the world by *Vogue* (Devi and Rau 1976). Distinct from art production by women, women's patronage had always existed because, like elite men, the female members of the privileged, wealthy classes had historically enjoyed greater agency as patrons of art and architecture. One needs but think of Nur Jahan and Gayatri Devi for examples of powerful female patrons.

These are some of the themes that this collection of essays addresses. The perspective of the writers is feminist, and yet the essays examine both the embrace of feminist principles and its rejection as a framework for social action. Feminism prompts the question of gender's role in determining not only social and artistic agency, but also in determining the kinds of art and architecture that were produced. Did (and do) women produce art and architecture that reflects a feminine perspective? To answer that, we have to consider how women—supposedly invisible and denied positions of prominence in the public sphere—gained voice through family, marriage, political activism, and artistic production. While the path to such agency was different for each of the many women in the following pages, their spirited actions and voices resound. May the echo be heard by today's generation of young men and women who collaborate—variously as professionals, activists, creators, parents, spouses, and teachers—in designing India's future.

NOTES

1 See Nochlin (1971), reprinted several times since, and Barzman (1994).

2 For example, H.W. Janson's *History of Art* (first edition 1963; multiple revised editions published thereafter; some listing his wife Dora Janson as co-author with later editions listing his son Anthony as co-author), the monumental textbook from which I first studied in 1977, had not a single woman artist in it. By the time I used it as a teaching assistant ten years later, a few women had been added, without any significant rewriting of the authors' overarching interpretive framework. A similar patching occurred in major textbooks purporting to present the entire history of art: from early focus on the so-called high arts of Europe and North America, the scope eventually expanded to include Asia, Africa, and South America as well as vernacular and outsider art.

3 The antidote to the implicit masculinity of standard accounts such as Janson's was to be found in feminist approaches such as Broude and Garrard (1982), and Nochlin (1989). Enlightened and inspired by such studies, my own work (Ruggles 2004) has examined the way that genealogy was defined along exclusively male lines in the ruling house of Umayyad Spain, an exclusion of women that has been reiterated by modern historians.

4 An early key exploration of ocular desire is Mulvey (1989); first published 1975 in *Screen*.

REFERENCES

Barthes, Roland. 1977. "The Death of the Author," in *Image, Music, Text*, translated by S. Heath, pp. 142–48 (New York: Hill).

Barzman, Karen. 1994. "Beyond the Canon: Feminists, Postmodernism, and the History of Art," *Journal of Aesthetics and Art Criticism*, 52: 327–39.

Broude, Norma and Mary Garrard. 1982. *Feminism and Art History: Questioning the Litany* (New York: Harper & Row).

Devi, Gayatri and Santha Rama Rau. 1976. *A Princess Remembers: The Memoirs of the Maharani of Jaipur* (Philadelphia: Lippincott).

Foucault, Michel. 1977. "What Is an Author?" in *Language, Counter-Memory, Practice*, translated by Donald Bouchard and Sherry Simon, pp.124–27 (Ithaca: Cornell University Press).

Janson, H.W. 1967. *History of Art* (Prentice Hall). First edition 1963.

Mulvey, Laura. 1989. "Visual Pleasure and Narrative Cinema," in *Visual and*

Other Pleasures, pp. 14–26 (Bloomington and Indianapolis: Indiana University Press).

Nochlin, Linda. 1971. "Why Have There Been No Great Women Artists?" *Art News* 69: 21–46. First published in 1975.

——. 1989. *Women, Art, and Power* (New York: Harper & Row).

Ruggles, D. Fairchild. 2004. "Mothers of a Hybrid Dynasty: Race, Genealogy, and Acculturation in al-Andalus," *The Journal of Medieval and Early Modern Studies*, 34(1): 65–94.

1 Reading Place through Patronage

Begum Samru's Building Campaign in Early Nineteenth-century India

ALISA EIMEN

Begum Samru, a minor Indian official of the early nineteenth century, was an active patron of the arts.[1] She commissioned paintings and monumental works of architecture, in keeping with her political position as an important landholder and military leader in the vicinity of Delhi. Although until quite recently the Begum has been largely overlooked in modern scholarship, she was remarkable to her contemporaries, who commented on all aspects of her history, comportment, and wealth.[2] In addition to the commentaries by British observers, her arts patronage provides a corpus of material that enables some reconstruction of Begum Samru's self-styled life as a public figure. Through a close reading of this material, it is possible to discern the extent to which she was constructing an authoritative identity that was as variegated as India's ethnic and devotional landscape.

Art and architecture reflect identity, especially when they serve to intentionally promulgate cultural, historical, and communal positions. Around the world, but especially in India, the twentieth-century politics of identity increasingly targets works of art and architecture to proclaim or suppress competing identities. From the destruction by right-wing religious zealots of the Babri Masjid in 1992 to vandalism enacted in the past decade on artworks by

M.F. Husain, works of cultural patrimony are particularly strategic targets. As India's conservative Hindu right attempts to rewrite the history of the Taj Mahal as a Hindu temple,[3] a study of Begum Samru's identity provides a noteworthy case of the kind of complex, rich syncretism that has long been part of Indian cultural identity. Recent reconstructions of the past according to imaginative ideological positions—and the Taj case is an outstanding example of such politically motivated fiction—are predicated upon a perceived separation of identity—its traditions and history—that reifies distance and dissolves common ground. This case study from the first half of the nineteenth century, the period that immediately preceded British colonization of India in 1857, sheds light on an understudied era when the Other was of interest and the notion of difference was, perhaps, a virtue.

Begum Samru (c. 1750–1836) of Sardhana lived a long and colorful life that remains somewhat shrouded by time's passage and, quite likely, by her own design. It is clear, however, that she was particularly attuned to issues of representation and marshaled her resources to frame her own aspirations and legacy. From military battles to large-scale architecture projects, the Begum was an intrepid leader who carefully navigated her way in what was a particularly uncertain historical moment at the close of the eighteenth century.

Begum Samru's *jagir,* or landholding, was at a nexus of regional contests just north of Delhi.[4] For nearly sixty years, she strategically maintained her authority in this area that included the *parganas* (administrative units) of Sardhana, Baraut, Barnawa, and Kutana in the district of Meerut, as well as five parganas in the adjoining district of Muzaffarnagar, and three parganas on the western side of the Jamuna River, some of which occasionally changed hands depending on the political situation. A list of her close associations suggests the range of her reach, including European mercenaries, the Mughal imperial court, Catholic clergy, and British leaders. Considering contemporary sociopolitical upheaval, her ability to negotiate the changing political tides, shifting loyalties, and differing

cultural contexts is certainly noteworthy, and since the nineteenth century, scholars have briefly acknowledged this. Despite these passing mentions, however, it is only recently that scholars have begun to seriously consider her arts patronage, and there has been very little analysis of the lasting ways the Begum asserted her rulership through her built works.

The expense and visibility of her patronage demonstrate clearly that Begum Samru wished to articulate her own authority as a model ruler. By examining this body of built material alongside contemporary textual evidence, we can see that Begum Samru was participating in a long-standing tradition of expressing authority and identity through art and especially architecture. Moreover, the utilization of a variety of artistic tropes and architectural elements portrays a figure of regional significance, who was keenly aware of her multiple audiences, including Mughals and Marathas, Muslims and Christians, as well as British Company men and their wives. In summary, Begum Samru's narrative of authority, as articulated in art and architecture, suggests a fluidity of artistic tropes, the malleability of identity, and a sovereign space that elite women were able to claim in the decades preceding the uprising of 1857.

The Begum's Life

Begum Samru's rule was exceptional with respect to her political machinations, gender, and longevity. Even while alive, the Begum was a legendary figure, whom travelers hoped to glimpse as they made their way across northern India. Thus, there are a variety of secondary sources about her life, but they are complicated to read because discerning history from legend is difficult.[5] The absence of a personal memoir or journal penned by the Begum herself adds further difficulty to the task of ascertaining accurate details of her life, especially the years preceding her political career. A history of Begum Samru was commissioned by the British around 1820, but as it was written by her head secretary, Lalla Gokul Chand, it recounts official political and military engagements and betrays little by way

of personal information (Shreeve 1994). Whether due to time's passage or by intention, the origins of Begum Samru are obscure.

She seems to have been born in or around the year 1750. Most sources agree that she was given the name Farzana and was born in the town of Kutana (50 miles north of Delhi along the Yamuna River) to a Muslim father of uncertain descent.[6] Upon her father's death, she and her mother fled to Delhi because of the ill-treatment they received from her half-brother, and it is in Delhi where she met her future partner, Walter Reinhard, also known as Samru, a notorious mercenary.[7] It is not known whether Farzana caught his eye while dancing for him or while her mother worked for him, but sometime around 1765 she became his mistress.[8] Reinhard already had an Indian wife (apparently mentally unstable) and son, who were destined to remain under Farzana's care[9] after Reinhard's death in 1778, when she emerged as Begum Samru, assumed control of his wealthy and well-positioned jagir of Sardhana, and controlled it for an impressive fifty-eight years, until her death in 1836.

Throughout her five decades as leader, Begum Samru maintained and deployed military forces, kept up correspondences with major leaders, and oversaw the general administration of her jagir. Her prominence as a political figure, and in particular as a female ruler, has ensured the preservation of many anecdotal accounts about her. Thus we know that during Reinhard's life, she often acted in consort with him in battle and political negotiations, earning the esteem of his forces. After his death in 1778, Begum Samru continued to display keen acumen through various political contests that underscored her loyalty to the Mughal ruler, Shah Alam II (r. 1759–1806). In one instance, two of his subordinates attempted to usurp his authority, but the Begum, leading her army, intervened and the challengers retreated (Banerji 1925: 29; Francklin 1973: 118–20; Shreeve 1994: 300–30). After these confrontations, Shah Alam gave Begum Sarmu the appellation, Farzand-i Azziza, "his most beloved daughter" (Francklin 1973: 120; Shreeve 1994, line 295; Sleeman 1915: 604). These events gave the Begum political stature as well as tremendous influence at Delhi's Mughal court.

Begum Samru gained similar favor among the British. In 1791, she aided in the release of a British colonel by paying a ransom to his Sikh captors. British regard for her actions was recorded in a letter of appreciation, thus setting a precedent of relatively amiable relations between the British and Begum Samru (Banerji 1925: 74). Nonetheless, the following years brought several challenges to the Begum's authority, including a rebellion of her forces in the face of her secret marriage to a Frenchman in her service.[10] This dramatic event resulted in his death, nine months of captivity for the Begum, and much fodder for legend. However, she eventually regained her position and command of her troops, and continued to negotiate with the adjacent and opposing powers of the Marathas, Mughals, and British. She seems to have turned this intermediating role to her advantage. But as tensions turned to war between the Marathas and the British in 1803, the security of the Begum's position was threatened. Yet despite her support for the Marathas during the conflict, she managed to negotiate with the ascendant British, securing her position from Lord Cornwallis in 1805 through an exchange of letters with British officials.[11] These documents clarify the importance of Begum Samru's jagir both in terms of its agricultural prosperity and its geopolitical location, which placed her at the crux of a contest of power and made her very wealthy.[12] At a time when indigenous leaders in South Asia were being assigned a British Resident, the British officially acknowledged the Begum's authority over her own jagir. The fact that Begum Samru was a shrewd and sagacious politician certainly contributed to her continued preeminence and relative independence throughout her life. It is also quite likely that the British calculated that her gender and advancing age would keep the well-known and popular ruler malleable, though her longevity and willfulness no doubt surprised them.

The accounts sketch a portrait of a ruler whose authority was astutely crafted and tenaciously maintained. However, due to the absence of any firsthand personal accounts or reflections, Begum Samru's understanding of her own authority can only be understood at a remove. Fortunately, one other public record of her authority—

her artistic patronage—is available for scrutiny, a record that is arguably more personal and revealing than secondhand sources written by British observers or the official account commissioned from her head secretary. Like the events of her life relayed by others, art and architecture are also mediated forms of expression that result from hands other than the Begum's. Nonetheless, the expense, visibility, and the very act of patronage suggest a source from which can be gleaned significant ideas about the messages Begum Samru intended to convey, and from these it is possible to deduce something about the Begum's identity and her sense of place in early nineteenth-century India.

THE BEGUM'S PATRONAGE

The Begum's interest in visually representing her authoritative role has been convincingly demonstrated by Alka Hingorani through a series of paintings commissioned by Begum Samru. Hingorani's thesis is that the Begum functioned as an Other from many vantage points, which aided her ability to negotiate her own authority with a wide array of prominent political figures. In one image, now in the Chester Beatty Library Collection (see Figure 1.1), Begum Samru is depicted at the center of her well-appointed court, a depiction typical both in Mughal and Company painting. She appears as a diminutive figure with a shawl over her head, surrounded by her retainers, both Indian and European. The viewer's attention is drawn to the Begum through a number of devices, including her centrality in the picture's field, her singularity as the sole woman in a gathering of men, and the *huqqa,* which is placed in front of her, drawing the viewer's attention to the Begum through its coil (Hingorani 2002: 66). The huqqa is one of several motifs Hingorani traces through a series of portraits in order to examine the various ways that Begum Samru's authority was presented. With one interesting exception to be addressed later, the paintings do not function as documents of specific events. Rather they seem to summarize her considerable strengths and successes on the ground by positioning her at the fulcrum of her court, or atop

Figure 1.1: Muhammad A'zam. Begum Samru with her retainers, ca. 1820–25

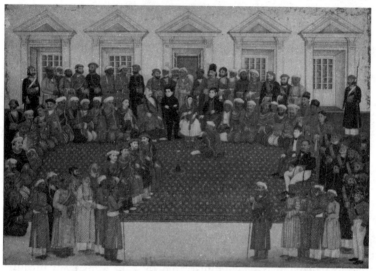

an elephant during a parade of her army. Hingorani concludes that, when read against the biography of Begum Samru, the variety of tropes and symbols included in the paintings suggest an identity of the sitter that consciously resisted conventional norms.

Contemporary sources describe events that reveal a formidable yet adaptable figure. Through comparison of multiple sources, the accounts converge to reveal some significant moments in the Begum's life and career. Of particular interest is her conversion from Islam to Catholicism on May 7, 1781. She was baptized by a Roman Catholic priest in Agra, taking the name Joanna (Keene 1907: 76; Sleeman 1915: 600). Not only does Sir William Henry Sleeman record this event, but also her signet ring includes both her Christian and Persian titles, Joanna Nobilis Somer in Roman script and Zeb un-Nissa, "Ornament of Women," in Persian.[13] This extraordinary change in her life at age thirty-one, and three years after the death of Reinhard, shows that Begum Samru was familiar with a variety of cultural traditions and identified—at least publically—with two very

different ones, Christian and Indo-Islamic. Her Christian conversion was apparently not a complete rejection of Islam, for sources reveal that she continued to celebrate Muslim and Indian holidays, while practicing Catholic Mass. Her culturally variegated interactions with individuals have also been documented in a number of diaries and travel journals, so we know that while she sat at the same table with her officers, she would not eat when Indians were present (an abstention customary among Indian women of her day). When she was in public, she kept her head covered, and holding audience, she sat behind a screen. She could be an imposing presence on the battlefield, too, as corroborated by several contemporary accounts and another painting in the Chester Beatty Collection, which depicts the Begum leading the full retinue of her troops while perched on an elephant (Figure 1.2).14 In other words, Begum Samru was aware of her multiple roles and varying audiences, which highlight her negotiation skills and her fluency in sometimes competing identities. They also underscore her interest in representing authority by diverse visual means.

Figure 1.2: Begum Samru with her army, ca. 1805–26

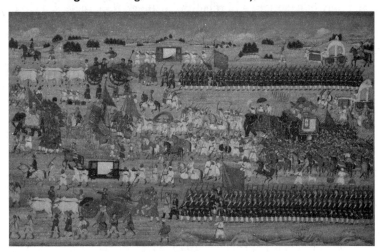

Source: © The Trustees of the Chester Beatty Library, Dublin.

However, paintings constituted only a very small part of her artistic patronage. Begum Samru invested more heavily in architecture, building forts, churches, and residences in five different cities in the region, including one near the Mughal fort in Delhi. The majority of these structures were built after 1805, once she had been officially recognized as *jagirdar* by the British. Since her jagir—though not her wealth—would cede to British control upon her death, Michael Fisher notes the variety of ways in which she and her heir organized her estate to ensure a vast inheritance (Fisher 2010: 33–47). Concurrently, however, the Begum spared no cost when it came to her architectural patronage, which was well sited and monumental and much of which was built for the public. Just as themes of leadership were represented in her paintings, these buildings likewise furthered her authority as expressions far more visible to a much wider public.

Although most of the Begum's architecture is no longer extant, it is possible to reconstruct a cursory catalogue of her patronage through secondary sources and analysis of three standing structures (two residences and a church). Most published resources focus primarily on her dramatic life and address the architecture incidentally and then only in a cursory and repetitive manner. Nonetheless, a list of impressive works can be drawn up, which is telling in its scope. The Begum had residences in five cities: Khirwa, 1828; Sardhana, 1834; Jalalabad; Meerut; and two residences in Delhi, one of which dates to 1830.[15] There are at least three references to her fortifications: a fort at Barnawa, built circa 1802 of burnt brick; a picture of her "stronghold" at Budhana; and some extant ruins 150 yards from the Sardhana palace where she maintained a well-stocked arsenal and foundry with a cannon.[16] One of Meerut's central bridges was donated by her, as was the reconstruction of the city's large Anglican church (Fisher 2010: 35). In addition to the aforementioned church at Sardhana, she also patronized a Catholic cemetery there, a presbytery and Catholic church in Meerut, 1834, and in Agra, three gardens and a market (Banerji 1925: 118, 152–53; Nair 1963: 29, 65–66, 79; Sharma 1985: 165–66). The Begum is also said to have

given generously to Hindu and Muslim institutions, building various spaces of worship for Hindus, Muslims, Catholics, and Protestants.[17]

While an exact chronology of her architectural patronage is difficult to establish, the structures can be grouped into three categories: martial, devotional, and residential. Forts, arsenals, and foundry construction would be consonant with the earlier decades, when the Begum was actively engaged in defending her jagir and her reputation as worthy heir, as the 1802 date associated with the Barnawa fort indicates. The earliest known date for religious patronage is the 1822 date of the Sardhana church's construction. Her charitable contributions continued through to the end of her life, and they may have begun as early as her official British appointment as jagirdar, considering the Begum's interest in comporting herself as a model Indian ruler. Investment in monumental residences might appear to be the last grouping of this body of works, due to the later dates of the residences at Khirwa and Sardhana. This may also have to do with her advancing age, vast resources, and the impending loss of her landholding upon her death. Her monumental residences—palaces according to the Europeans who visited them—were grand in scale, public in their visibility even if private in their functions, and attested to Begum Samru's wealth, judgment, and political significance.

Due to limited information, the only structures that can be discussed in any depth are the church and residence in Sardhana and her well-situated residence in Delhi. From style to siting, these three building share a number of elements that reflect Begum Samru's interest in asserting her authority and presence. Stylistically, all three were built in a western neoclassical idiom, as popular among Indian elites as it was in Europe. The far-reaching popularity of the style can be seen in numerous contemporary buildings across India, including the Government House in Madras built around 1800 by Charles Wyatt and the Nawab's residence, the Murshidabad palace, designed circa 1820 by Duncan McLeod. Her architectural commissions must have represented the Begum's status and wealth in significant ways, including a currency of fashion, and even cosmopolitanism. This would have been underscored by the large scale of the buildings as

well as the fine materials employed in their decoration. Moreover, Begum Samru's patronage participated in a much larger tradition of articulating authority and preserving memory through building, notable at numerous points throughout India's—and especially Delhi's—history.

The information is fragmentary regarding the two structures in Delhi, one of which no longer stands and the other of which survives in a much altered state, but there is enough to reconstruct a general understanding of them. Begum Samru had two different residences in Delhi, a haveli (an enclosed dwelling) and a *kothi* (a residence serving the needs of India's elite), which seemed to have served different functions and, perhaps, audiences. As Fisher aptly states, the two residences are "suggestive of her cultural ambidexterity and desire for standing before both high-ranking Mughals and Britons" (Fisher 2010: 27). The lesser-known haveli, destroyed in an explosion in 1857, was built in 1830 in close proximity to the Friday Mosque (ibid.: 29). Located in a dense neighborhood, it was built in a traditional style with high enclosure walls, no exterior windows, and a series of rooms around an interior courtyard, in total comprising roughly 750 square meters. This was a much more private structure than the extant residence, the kothi.[18]

The Delhi kothi has changed hands and functions since the Begum's death, and though it remains standing, it bears little resemblance to its past grandeur. A painting made before its later alterations shows a Palladian-style villa with an ample verandah (Figure 1.3, top). From its siting to its façades, it is a clear expression of her public and elite identity. It was built on a plot of land gifted in 1806 at the time of Mughal emperor Akbar Shah's accession, as a gesture of his appreciation for her loyalty and support of his father. The waning authority and wealth of the Mughals was already apparent by the late eighteenth century, yet the Begum had remained a prominent supporter of theirs in terms of capital and military aid. The land she was gifted clearly indicates her status from the Mughal perspective, for the large plot of land—a former garden—was located on a main thoroughfare, the Chandni Chowk. Hers was the residence nearest to

Figure 1.3: Attributed to Mazhar Ali Khan. North and south sides of Begum Samru's Chandni Chowk Palace from Sir Thomas Metcalfe's *Delhi Book*.

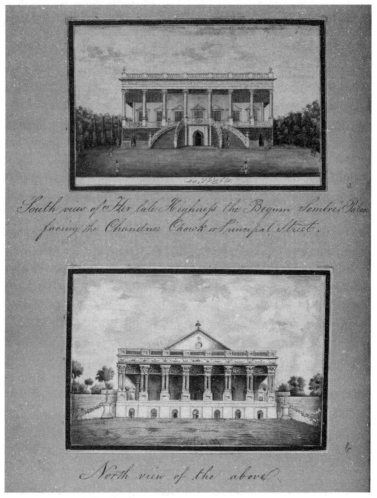

Source: © British Library Board, Add.Or. 5475, f.59v.

the Mughal imperial Red Fort, and while it could not compete in size, the fact that the palace of a mere regional ruler was one-seventh the size of the entire Fort indicates its grandeur (ibid.). Thus the kothi's siting and scale serve as further indications of the Begum's political importance, as well as the appreciation for her largesse among the

increasingly impoverished Mughals. While there is no recorded date of construction, it is likely that this was among the first, if not the first, grand residences built for Begum Samru.[19] The building may have been designed by Major Antonio Reghelini, a member of the Begum's court, who is more definitively linked with the Sardhana structures.[20] A native of northeast Italy, he brought with him to India some training in design and firsthand familiarity with Palladian architecture, which were valuable cultural commodities in the contemporary Indian aesthetic climate. In a discussion of Begum Samru's kothi, Jyoti Sharma notes the "eclectic urban grain of the colonial city," transmitted through nineteenth-century accounts of Delhi (Sharma 2010: 25) which attest to the variety of architectural sources displayed in the style of structures being built by Delhi's aristocracy, both native and British.

Begum Samru's kothi was a well-known site among her contemporaries, who enjoyed her lavish parties, according to their travel journals. Two drawings of the kothi that were included in a folio prepared for Company official Thomas Metcalfe (Kaye 1980: 110) are the only contemporary record of the estate's early nineteenth-century appearance. The south façade, facing the Chowk, is a grand verandah raised high on the second level that was reached by a sweeping double staircase. The north façade offered a commanding porch and was capped with a stately pediment. Though no graphic documentation for the interior exists, descriptive sources suggest a general idea of the building's layout, which included large rooms for reception, dining, and sleeping. While the structure certainly served as the Begum's place of residence when in Delhi, even in her absence the building would have visibly attested to her prominence in Delhi politics. The Begum's residences were both destinations and places of legend. Henry George Keene wrote in the early nineteenth century that "[t]here was always a dinner-party every evening. [...]; a band of music was in attendance, and the best wines of France and Spain circulated freely" (Keene 1907: 194). Accounts like these are numerous and indicate a notable reputation. Considering the grandeur of the architecture, the structure's prime real estate, and

the lavish entertainments staged there, the patron's wealth, status, cultural discernment, and political stature would have been clearly displayed to British and Indian audiences.

Begum Samru's residence in Sardhana, built in 1834 by Reghelini, is similar in style to the Delhi kothi (Figure 1.4). (It is now St Charles Inter College.) Built in the last two years of the Begum's life, this structure's completion was overseen by her stepson and heir apparent. An impressive staircase leads to the main façade's verandah on the second level, which is decorated with a host of neoclassical motifs, including aedicules with segmental pediments and pilasters as well as paired fluted columns. From the verandah, one enters a long, central hall, 42 by 36 feet, anchoring a series of chambers and a winding staircase that led to the Begum's private chambers, including an impressive bath decorated with mirrors and inlaid marble designs. The side wings contained other apartments and offices and enclosed a courtyard (Keegan 1932: 16; Keene 1907: 192–93). While the exterior of the building is clearly influenced by European neoclassicism, the structure was not a wholesale reproduction of western architecture. The extreme differences in climate between Europe and India demanded architectural

Figure 1.4: Begum Samru's Sardhana residence, 1834

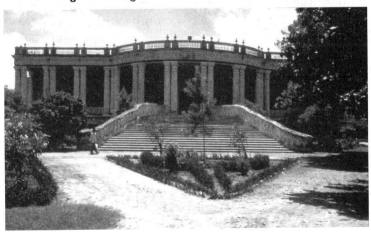

Source: Courtesy Frederick M. Asher.

variations, like the courtyard which ensured cross-ventilation, but also gave functionality to elements which, particularly in northern Europe, were primarily decorative, such as the verandah that in India provided protection from the sun and monsoon rain. What emerged was a mixture of styles, elements borrowed from one context but utilized differently in another.

While the written sources say little about the interior furnishings, they do mention oil paintings adorning the walls, including portraits of the Begum and members of, and important visitors to, her court (Keene 1907: 193). Architecture serves as the backdrop for two of these paintings, but considering the Begum's ongoing investments in building, the backdrop rather could be read as a relevant symbol in its own right. The painting of the Begum and her retainers (see Figure 1.1) is depicted in a neoclassical setting that appears to be a verandah at one of her residences, quite likely the Delhi kothi. The other image is the historical painting mentioned above, which depicts the consecration of the Sardhana church in 1822. While the original of this is missing, a copy remains in the Governor's Palace at Lucknow, and a variation on the image exists within the church today as a part of a sculpture commissioned by her stepson (Figure 1.5). The image depicts the Begum amid clerics and officers within her church and in front of the altar. The Begum took great pride in her patronage of the Sardhana church, and thus a visual record of its consecration is not surprising. The structure depicted is clearly a Christian church in form and function, and it is the building that best expresses the Begum's status and variegated identity.

Begum Samru's conversion to Christianity in 1781, three years after Reinhard's death, can be seen within the context of her independent and assertive character. At a time when the Anglican faith was increasingly prominent in India, Begum Samru adopted Roman Catholicism, broadly distinguishing herself from her peers. Practically speaking, her conversion could have been an attempt to retroactively legitimize her claim to the estate of Reinhard (a Catholic) (Lall 1997: 67), but it also popularized her court with European Catholics, who became her officers, courtiers, and in

Figure 1.5: Adamo Tadolini. Begum Samru with clerics (relief from Begum Samru, her officers, and allegorical figures sculpture, Church Basilica, Sardhana), ca. 1839–48

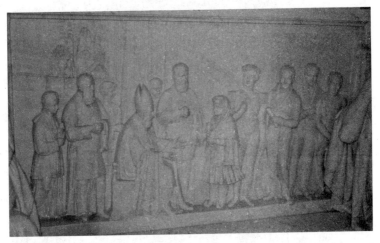

Source: Author's photograph.

one instance—albeit short-lived—her second husband. However, none of these reasons necessarily excludes pietistic ones, which also may have fueled her substantial charitable giving through the end of her life. While the Begum continued to make donations to Muslim and Hindu charities, her largest pious contribution was in the construction of the grand and extremely expensive church (Figure 1.6).

The Church of St Mary in Sardhana (today called the Church Basilica of Our Lady of Graces) opened for service in 1822, but was not officially inaugurated until 1829.[21] In keeping with the Begum's dual identity, the church has two inscriptions in Latin and Persian, which state the founding year and patron. The inscriptions are interesting, for like her signet ring, they are not mere translations of the same text. In the Latin text, the church built by "Lady Joanna" is "dedicated under the name and patronage of the Virgin Mary, according to the Roman Catholic Rite.

Figure 1.6: Church Basilica of Our Lady of Graces (formerly Church of St Mary), Sardhana, 1822

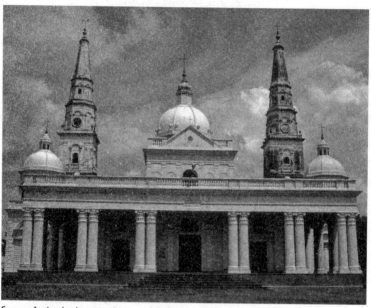

Source: Author's photograph.

> To God most good and great, the most illustrious Lady Joanna ruler of Sardhana raised (this church) from its foundations at her own expense, and dedicated under the title and patronage of the Virgin Mary, the Mother of God, in the year of Our Lord, 1822.[22]

The Persian inscription acknowledges the patron as Zeb un-Nissa but does not mention the Virgin.

> By the bounty of God and grace of Christ, in the year 1822, as desired by Zebunissa of excellent nobility, this magnificent church (*kaleesa*) was ordained to be constructed.[23]

The differences are noteworthy, as they suggest the Begum's fluency in both traditions. The Begum is identified by the name appropriate to each of her cultural contexts. Meanwhile, the church, dedicated to the Virgin Mary, is thusly identified in the Latin inscription,

whereas the Persian text honors Christ who appears in the Islamic tradition as a prophet (but not the son of God). Begum Samru was extremely proud of her church, in 1834 sending Pope Gregory XVI five lithographic prints of the structure and a letter in which she wrote, "...I am proud to say it is said to be the finest without any exception in India" (Keegan 1932: 5). The cost of the church was Rs 400,000,[24] nearly the annual income of her first husband only a few decades before. To further emphasize her church's grandeur as well as her own wealth and importance, the Begum acquired a Bishop's seat by 1829.[25] The significance and expense of the church is further reflected in many aspects of its design and decoration.

Like the residences, the church was built in the neoclassical colonial idiom, similar to other contemporary churches, including St John's Church (1784–87) and St Andrew's Church (1815), both in Calcutta (Nillson 1968: Plates 55 and 56). The church was fronted by a porch with monumental paired columns, which support a roof with a surrounding entablature, balustrade, and a steeple. Like the others, the Sardhana church originally had only one steeple until the Begum's adopted grandson and heir added the second in the 1830s (Fisher 2010: 46). The most distinguishing exterior feature of the church is the building's dome, topped by a raised oculus and flanked by a similar but lesser dome on either side. In its day the church would have dominated the Sardhana landscape, inspiring spiritual awe that was specifically linked with the Begum's name. There are very few contemporary Indian neoclassical structures, sacred or secular, that are domed, and Anglican churches virtually never included such a superstructure.[26] The dome thus enhanced the structure's already impressive silhouette, engendering comparisons with St Peter's Basilica in Rome, which most certainly would have pleased the patron (Cotton 1934: 30; Nair 1963: 44).

The interior of the Church of St Mary has a Latin-cross floor plan. The floor of the choir is made of black and white marble, and the friezes of the entablature and dome are decorated with stucco ornamentation. The most impressive element of the interior, though, is the altar (Figures 1.7 and 1.8), which is made of white Jaipur marble

Figure 1.7: Altar, Church Basilica of Our Lady of Graces, Sardhana, ca. 1822

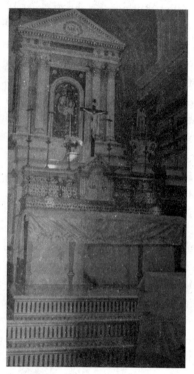

Source: Author's photograph.

inlaid with semi-precious stones, including carnelian, jasper, and malachite, which form floral designs similar to those found in earlier structures, like the Taj Mahal in Agra, the city where the Begum's conversion took place. Such work was clearly very expensive, and the only other similar altars that I know of are in contemporary Jain temples in Delhi and Jaipur.[27] For centuries Jains have traditionally been bankers and merchants in India and consequently comprise a very wealthy constituent of the population who could afford such costly materials and intarsia workmanship. Begum Samru's use of this type of altar signifies her extreme wealth and her familiarity with a variety of expressions of authority—in this case a devotional one. Thus, inside and out, the church stands as a testament both to

the Begum's piety as well as her impressive stature as caretaker of her estate.

Figure 1.8: Detail of the altar

Source: Author's photograph.

The extent to which the Begum was involved with the designs and details of her architectural patronage is unknown. However, throughout her life she had been directly involved with all that transpired in her court, whether she was corresponding with Lord Ochterlony or Lord Cornwallis, leading troops on the battlefield, or sharing meals with her European officers. Considering her level of involvement in other situations, it is difficult to imagine that she would not have been similarly involved with the design and construction of her buildings. By the time her buildings were under construction, the Begum's estate had been secured, and she seems to have been principally preoccupied with ensuring the productive administration of her wealthy jagir and the organization of her assets and plans for their care and disbursement upon her death.

These structures were her assets as well as her legacy and memorial, and so it is very likely she was quite involved with Reghelini during the design and building phases.

Begum Samru was an astute ruler who maintained authority aggressively, but not without thought to her dependents (none of whom were biologically related to her). She negotiated on their behalf, attempting to ensure pensions for over 800 of them.[28] She ruled in a time-honored fashion, providing for her subjects, endowing pious organizations of multiple religions, and patronizing monumental works of architecture in a cosmopolitan style. As a close friend and periodic benefactor to the Mughal court, Begum Samru was well versed in the important role of art and architecture vis-à-vis the representation of authority. Around the time of the construction of the church, the British commissioned a history of the Begum to be written, and her loyal head secretary was assigned the task.[29] A Mughal-style history in Persian verse, *Zeb-ul Tawarikh (Ornament of History)*, the book includes historical accounts, glowing praise for the Begum, and even descriptions of the important standing of the Sardhana church. The book's penultimate passage addresses her devotional patronage:

> For every faith she built a house of prayer,
> Mosques, temples, churches, they are everywhere. And everything she built with loving care
> And beautiful for those who worshipped there. She built with coloured stones a Christian shrine,
> All red and gold designed to make it shine, And it was painted in an azure shade,
> A work of art, and all by hand was made. [...] (Shreeve 1994, lines 747–52)

This underscores the importance of the Begum's patronage, asserting her piety as a patron of the church as well as her role as a model ruler through public works. It also points toward her independence and fluency in the leading cultural traditions of her day, which is confirmed by anecdotes from her life left by her contemporaries.

PLACE

Begum Samru was interested in representing her authority in multiple ways to reach the broadest audience. Utilizing a variety of expressions, from painting to a monumental architectural building campaign, the Begum was keen to be remembered for her rule, even if the jagir itself would be ceded to British control upon her death. Undertaking such expensive projects late in life points toward a concern with representing, and even memorializing, her authority and place in history. Rather than preserve the entirety of her wealth for her heirs to preserve or squander as they wished, she invested some of it in extraordinarily expensive structures, which, for future generations, would bear not only her name, but—interred in the church at Sardhana—her mortal remains. Moreover, the variety of structures and their locations reveals fluency in different cultural traditions. The architectural projects bring together neoclassical and Indian elements, expressing a cosmopolitanism that can be read as a reflection of the Begum herself. The monumentality of the structures in the Sardhana jagir and extending into the capital city Delhi, ensured the continuous presence of the Begum, whether literal or symbolic, while the Church of St Mary affirmed her Christian piety, public charity, and independence from the norms of other high-ranking Indians. Moreover, the architectural neoclassicism, bilingual inscriptions, and fine intarsia craftsmanship of the church's altar displayed her fluency in various cultural idioms as well as her aesthetic sensibilities and great wealth, as corroborated by the paintings which marry Mughal and East India Company influences. Begum Samru was interested in authoritative representation, and like her Indian forebears, she utilized art and architecture to underscore her stature and assert her place in history.

While Begum Samru's life events and patronage illustrate a remarkable figure, they have been obscured by the events of colonization and independence, which for more than a century have preoccupied scholars who have typically flattened the characters

in that history, representing them in large undifferentiated categories—Rajput princes, East Indian Company agents, British colonial government officials, among others. Only in the last few decades has there been critical interest in the early decades of the nineteenth century, a period that was marked less by communal identity than by region, ethnicity, language, religion, political alliance, dynastic ties, and other signifiers of social organization, some of which collided in unexpected ways. After colonization, the British formalized their understanding of India according to religious categories at the expense of the numerous intersections and ambiguities that existed in precolonial society. One of the many things that emerged, according to Francis Robinson, was a "sharpening of the distinction between Muslim and non-Muslim," which has significantly altered Indian perceptions of religious identity and its history (Robinson 1998: 272). Cynthia Talbot suggests that precolonial identities were in flux and fragmented, which impeded the kind of large-scale affiliations that characterize current politics (Talbot 1995). Rather, identity was locally construed, as illustrated by Begam Samru's varying titles, marital and political alliances, and arts patronage. The British, too, acknowledged and participated in this fluidity, as evidenced by their commission of a history of the Begum in rhyming Persian verse. Thus, the Begum's colorful life was not anomalous but rather symptomatic of an era of significant cultural interchange.

Begum Samru's obscure origins, strategic maneuvering, and perspicacity were all important assets that she marshaled in order to maintain her position during tumultuous decades. Certainly, her gender bears some consideration in this narrative of authority, but it would be wrong to conclude that, because of her gender, the British deemed her a nominal threat and thus allowed her to keep her territories. In fact, the written accounts state that Begum Samru was perceived as an effective ruler by her contemporaries.[30] By offering financial and military resources, she had earned significant respect from the Mughals as well as the British, which certainly aided her longevity. The Begum was an uncommon figure, and it may be that,

because of her gender, she escaped categorization. Difficult to place, she was able more effectively to build her own place, to remain outside normative categories of the time, perhaps indicating the possibility of a rare sovereign space that elite women like Begum Samru and the begums of Bhopal had access to in the decades leading up to the uprising in 1857, when identities became more fixed as the British crown claimed colonial authority.

ACKNOWLEDGEMENTS

I owe a debt of gratitude to Catherine B. Asher, D. Fairchild Ruggles, and Michael Fisher for their support and suggestions during the development of this project.

NOTES

1 Three sources deal principally with art and architecture: Behl (2002), Hingorani (2002), Sharma (2010). A solid history of the Begum, including a brief discussion of her architectural patronage, is included in a comprehensive and thoroughly researched history of the Begum's heir by Michael Fisher (2010).

2 Begum Samru is mentioned in numerous nineteenth-century travelogues and memoirs, including *Hindustan Under Free Lances, 1770–1820* (Keene 1907); *Life of Mrs. Sherwood, Chiefly Autobiographical* (Mrs Sherwood 1867) and *Excursions in India* (Skinner 1832).

3 For a discussion of this revisionist movement and its larger context and implications, see Asher (2004).

4 Neville (1904: 123). For a published map of the jagir from 1841, see Shreeve (1996, opposite p. 46), or Fisher (2010: 16).

5 Older sources include Keene (1907), Skinner (1832), and Sleeman (1915). Modern biographers of the Begum have attempted to write objective accounts of her life, but the force of her character and the preponderance of romantic accounts tend at some point to color their narratives. For good though dramatic accounts of the Begum's life see Lall (1997) and Shreeve (1996). A more straightforward account of her life is provided by Fisher (2010: 13–47).

6 Keene (1975: 131) and Neville (1904: 157) give her birth date as 1753,
 while Sleeman (1915: 600) details the confusion regarding the exact
 year. Her given name appears unknown in Shreeve (1994: 264, note
 8). The only mention of her mother's name, Sahib Zaldeh, is in Shreeve
 (1994, line 150). Two sources refer to her father as Asad Khan (Neville
 1904: 157; Sleeman 1915: 595), while Shreeve (1994) calls him Latif
 Ali Khan.

7 The Delhi move is attributed to ill-treatment by Keene (1975: 131);
 Nair (1963: 11) and Shreeve (1994, note for line 150) relate this story.
 Sharma (1985: 59) writes that she went to Delhi, befriended dancers,
 and entered Reinhard's harem in about 1765. Captain Thomas Skinner
 (1832: 80) wrote that she was a dancing girl in her youth in Patna.
 Regardless, she ends up living with Walter Reinhard (or Reinhardt),
 who is best known for his involvement in the 1763 massacre of "51
 English gentlemen and 100 others" at Patna, according to Buckland
 (1906: 372), although his origins remain unclear. Among other
 accounts, Skinner (1832: 80) calls him a Swiss adventurer; Sleeman
 (1915: 596) states that he was a native of Salzburg; Buckland (1906)
 states Salzburg or Strasburg; and Keene (1975: 70) calls him a Franco-
 German. He acquires the soubriquet, Samru (variously spelled Sumru,
 Sumroo, Somer, and Sombre) for unclear reasons, ranging from a
 mispronunciation to a reflection of his somber temperament.

8 Shreeve (1996: 50). Numerous sources address their union as a
 marriage, "according to all the forms considered necessary by Muslims,"
 here quoted in Nair (1963: 12).

9 The wife (d. 1837) had some sort of emotional or mental infirmity, and
 the son, Aloysius Balthazar Reinhardt (c. 1764–1801/2)—grandfather
 of the Begum's heir—was given a generous allowance by the Begum in
 order to keep him content and preoccupied (Fisher 2010: 16–17).

10 There are numerous accounts of her marriage to Le Vassoult (also
 spelled Le Vaisseau, Le Vaissoult, or Levassoult), including Banerji
 (1925: 55–57), Francklin (1973: 134–35), Keene (1975: 224–26),
 Neville (1904: 159-60), Sharma (1985: 71), and Sleeman (1915:
 604–606). For the most coherent narrative, see Fisher (2010: 20).
 The event is not recorded in the *History of Zeb-ul Nissa* (Shreeve
 1994), presumably because of the Begum's desire for secrecy and her
 retention of the name Samru.

11 Reprinted in Banerji (1925: 74–107).

12 Estimates of the Begum's annual income range from Rs 600,000 to Rs 1,600,000, depending on productivity both in terms of agriculture and war booty. In today's terms, her annual income ranged from five to sixteen million pounds a year (or Rs 370 million to Rs 1.2 billion), Fisher (2010: 17).

13 For a reproduction, see Banerji (1925: 53), or Fisher (2010: 18).

14 As successor to her husband, she received the jagir and five battalions commanded by Europeans of different countries, approximately forty cannons, and some 200 Europeans involved in artillery; see Francklin (1973: 106). Also Neville (1904: 157–58) gives similar statistics.

15 The Khirwa structure was leveled in 1848, according to Banerji (1925: 154), and Sharma, (1985: 166). Sharma also notes that the ruins of the Jalalabad building were documented in 1874. The Meerut residence was neglected for decades and razed in 1985, according to the website for the Sardhana church, accessed May 25, 2011 (http://sardhanachurch. org/BegumSumru.aspx).

16 Neville (1904: 206) reports on Barnawa, and the Budhana fort is published in the Calcutta Historical Society, *Bengal Past and Present* (1907), Appendix. The ruins at Sardhana are approximately 100 yards long and 30 feet high, though which are the Begum's palace is not specified (Banerji 1925: 144; Sharma 1985: 165).

17 Among others see Cotton (1934: 30), Fisher (2010: 34–35), Keene (1907: 194), and Shreeve (1994, line 748).

18 For more discussion and images, see Sharma (2010).

19 John Lall (1997: 104) addresses the Mughal gift of land that the Begum "lost no time in building a palace there."

20 Fisher (2010: 29) links Reghelini with the Delhi kothi. Past sources, such as Keene (1907: 192), Nair (1963: 43), and the Sardhana church website, address Reghelini as the architect in Sardhana.

21 So named according to Banerji (1925: 117); also see Cotton (1934: 30).

22 Translation published in Nair (1963: 46).

23 Translation (unpublished) by Riyaz Latif. I am grateful for this more accurate translation, updating the published version, which mistranslates the date to 1820 (see Keegan 1932: 8).

24 Keegan (1932: 6). In the mid-1990s, Nicholas Shreeve (1996: 148)

estimated this amount to be the equivalent of an impressive sixteen
million pounds, or Rs 1.2 billion (Indian).

25 Fisher (2010: 36) and Nair (1963: 49). Shreeve (1996: 148) misstates
the year of this event as 1828.

26 One noteworthy exception is St James Church in Delhi, patronized by
Colonel James Skinner. This unique Anglican church was built in the
1830s, at least one decade later than the Begum's. Their families were
connected with one another through social networks and would remain
so even after the Begum's death, as her heir lent financial support to and
sought periodic counsel from the Skinners (Fisher 2010: 39, 58). The
formal similarity in the structures thus may reflect social alliances.

27 The Bara Seth Digambara Jain Mandir in the walled city of Delhi and
the Digambara Jain Mandir Godhan in Jaipur's Johari Bazaar have
similar altars. I am grateful to Catherine B. Asher for suggesting this
relationship.

28 Fisher (2010: 23). For an insightful analysis of the Begum's familial
relationships, see Fisher (2004).

29 For a translation, see Shreeve (1994). An analysis of the document in
relation to Begum Samru's interests in representation is provided by
Behl (2002).

30 Francklin (1973: 133) writes of her as a spirited and dignified lady;
Skinner (1832: 80) states: "She is, I believe, 80 years of age, and in
possession of more acuteness of intellect, and readiness of action, than
any woman ever enjoyed"; and Sleeman (1915: 613) remarks on her
"uncommon sagacity and a masculine resolution."

REFERENCES

Asher, Catherine B. 2004. "Uneasy Bedfellows: Islamic Art and the Politics of
Indian Nationalism," *Religion and the Arts*, 8(1): 37–57.

Banerji, Brajendranath. 1925. *Begam Samru* (Calcutta: M.C. Sarkar &
Sons).

Behl, Aditya. 2002. "Articulating a Life, in Words and Pictures: Begum Samru
and *The Ornament of Histories*," in Barbara Schmitz (ed.), *After the Great
Mughals: New Light on 18th and 19th Century Painting*, pp. 100–123
(Mumbai: Marg Publications).

Buckland, C. E. 1906. *Dictionary of Indian Biography* (London: Swan, Sonnenschein, & Co).

Cotton, Evan. 1934. *Sardhana Pictures at Government House, Allahabad* (Allahabad: Superintendent, Printing, and Stationery, UP).

Fisher, Michael. 2004. "Becoming and Making 'Family' in Hindustan," in Indrani Chatterjee (ed.), *Unfamiliar Relations: Family and History in South Asia*, pp. 95–121 (Rutgers University Press).

——. 2010. *The Inordinately Strange Life of Dyce Sombre* (New York: Columbia University Press).

Francklin, W. 1973. *The History of Shah-Aulum* (Lucknow: Pustak Kendra). First edition 1798.

Hingorani, Alka. 2002. "Artful Agency: Imagining and Imaging Begam Samru," *Archives of Asian Art*, 53: 54–70.

Kaye, M.M. (ed.). 1980. *Golden Calm: An English Lady's Life in Moghul Delhi, Reminiscences by Emily, Lady Clive Bayly, and her Father, Sir Thomas Metcalfe* (New York: Viking).

Keegan, W. 1932. *Sardhana and its Begam* (Agra: St Peters College).

Keene, H.G. 1907. *Hindustan Under Free Lances, 1770–1820* (London: Brown, Langham).

——.1975. *Fall of the Moghul Empire of Hindustan* (Lahore: Al-Biruni). First edition 1887.

Lall, John. 1997. *Begam Samru: Fading Portrait in a Gilded Frame* (New Delhi: Roli Books).

Nair, Patrick. 1963. *Sardhana* (Meerut: Prabhat Press).

Neville, H.R. 1904. *Meerut District Gazetteer* (Allahabad: Government Press).

Nillson, Sten. 1968. *European Architecture in India* (London: Faber and Faber).

Robinson, Francis. 1998. "The British Empire and Muslim Identity in South Asia," *Transactions of the Royal Historical Society*, Sixth Series, 8: 271–89.

Sharma, Jyoti P. 2010. "Kothi Begam Samru: A Tale of Transformation in 19th-century Delhi," *Marg*, 61(4): 24–33.

Sharma, Mahendra Narain. 1985. *The Life and Times of Begam Samru of Sardhana* (Sahibabad: Vibhu Prakashan).

Mrs. Sherwood. 1867. *Life of Mrs. Sherwood, Chiefly Autobiographical*, ed. Sophia Kelly (London: Darton).

Shreeve, Nicholas (ed. and trans.). 1994. *The History of Zeb-ul-Nissa: The Begum Samru of Sardhana* (Crossbush: Bookwright).

———. 1996. *Dark Legacy* (Crossbush: Bookright).

Skinner, Captain Thomas. 1832. *Excursions in India*, 2nd ed, 2 vols (London: Richard Bentley).

Sleeman, W. H. 1915. *Rambles and Recollections of an Indian Official* (London: Oxford University Press). First edition 1844.

Talbot, Cynthia. 1995. "Inscribing the Other, Inscribing the Self: Hindu-Muslim Identities in Pre-Colonial India," *Comparative Studies in Society and History*, 37(4): 692–722.

2 Breaking the Rules

Purdah, Self-expression and the Patronage of Maharanis in Jaipur

CATHERINE B. ASHER

This article focuses on the patronage of two queens of Jaipur who are related to one another by marriage. One is Maji Tanwarji, a little known wife of Maharaja Sawai Madho Singh Kachhwaha, and the other the famous Maharani Gayatri Devi who had a major role in transforming the position of women in twentieth-century Rajasthan. The irony is that I have much more to say about Maji, the obscure queen, than I do about Gayatri Devi who was frequently named as one of the beautiful women in the world by the press and European photographers.[1] This is because Maji has been a focus of my research for a while, and it is only very recently that I have begun to think about Gayatri Devi, who is in many ways Maji's foil.

Maji Tanwarji was the fifth wife of the Jaipur Maharaja, Sawai Madho Singh II, who ruled from 1880 until his death in 1922. He married Maji in 1892, in his twelfth regnal year. Her sole act of architectural patronage was Jaipur's Madhav Bihariji temple which various records indicate was built between 1924 and 1943.[2] The time of the temple's construction covers a period when elite Rajput women observed strict purdah and were uneducated. Many could sign their name and read and write a simple letter, but that was the extent of it. The minds of these sequestered Rajput queens such as Maji are virtually unknown to us, translating the physical veil of

purdah into an erasure of individuality.[3] Thus we have little idea of what these women thought or even how they led their daily lives. However, by examining the Madhav Bihariji temple, Jaipur's last temple sponsored by the Kachhwaha royal house, I believe we can begin to probe the mind and motivation of Maji, the temple's royal patron. This temple's unusually rich inscriptional information and visual imagery along with archival documents provide clues to the changing concerns of Maji, over a nineteen-year period. Maji, while observing purdah, through the construction of her temple was able to subvert the normative and break the rules, revealing her concerns in 1924, the year Maji received permission to build the temple, that are quite different from those in 1943, the date of the temple's final inscription that was just a year before she died.

Maji's temple was consecrated in 1926 according to an inscription on its walls, four years after the death of her husband, Maharaja Sawai Madho Singh. The temple is dedicated to a form of Krishna known as Madhav Bihariji, although this image was not installed until April or May 1927.[4] The deity's name is a play on the late king's name, thus making clear that the temple commemorates the recently deceased ruler, Madho Singh. The temple's inscriptions and rich visual imagery as well as its location are highly unusual, for the temple is located outside the walled city of Jaipur, near the police and train stations. These three elements give this temple dynastic significance and are specific to Jaipur.

The temple is part of a large complex that covers a city block; today this real estate's value is considerable. The complex includes the temple, other shrines, shops, a garden, wells, a dharmasala (rest house for travelers), and a number of houses among other structures. While the temple's dedicatory inscription suggests it was completed in 1926, court documents indicate that work continued on the complex until at least December 1934,[5] while an inscription indicates changes were made as late as 1943. These documents reveal a number of things about the process of construction.[6] Not only was the complex built over a multi-year period but also the state monitored and controlled its construction and maintenance.

Maji did not have free rein in her temple's planning; she needed state permission for many aspects of the temple, including the acquisition of the land, the removal of its inhabitants, the buildings allowed in the complex, and the maximum amount that could be spent on any part of the project. We learn about late payments of expenditure on the part of the zenana. Since Maji was head of the zenana it must mean she herself was late in payment. For example, a complaint had been issued on behalf of laborers who had not been paid for three months. The temple complex ended up costing a good deal more than initially budgeted and these over-costs had to be covered by the zenana. Once the temple was in use, Maji started receiving reprimands for spending more than was allotted for the deities' ornaments. This didn't seem to deter her, for she continued to receive similar complaints for about nine years running.

According to a document dated December 28, 1924, Maji was granted permission by the Jaipur Darbar to build her temple and a girls' school as part of the complex. The order also indicated that equal sums were to be spent on the temple and school. However, Maji never fulfilled her obligation to build the school. She received two more mandates to provide the school, one of which was dated June 1928, that is four years after she received the initial permission to provide a temple and school.[7] The order was adamant that the school must be built because this was part of the original provision. All the same, Maji never built the school and in its place planted a garden.[8] She simply broke the rules. Later in this essay, I return to the issue of the school.

So far I have stressed the unusual about this temple, yet its exterior and plan adhere to the typical temple format found from the eighteenth through early twentieth century in Jaipur (Figure 2.1).[9] The temple's curved cornice entrance leads to an initial courtyard and then to a second courtyard, one on whose west end is a flat roofed inner sanctum, typical of temples in Jaipur since the eighteenth century. Also typical is the temple's ground plan with its large open sanctum allowing for group worship, characteristic of Krishna veneration in Jaipur (Figure 2.2).

Figure 2.1: Madhav Bihariji Temple, exterior, 1924–43, Station Road, Jaipur

Source: Author's photograph.

Figure 2.2: Interior of sanctum

Source: Author's photograph.

Other features are unique to this temple, including its inscriptions, rare even on temples sponsored by royals whose patronage is only known through court records. The exterior bears two inscriptions. One is in small script and admittedly difficult to read, but underscores its royal patronage and the family's adherence to concepts of *rajadharma* (royal obligation, often with religious overtones). Under an image of a sun, referring to the Kachhwaha's descent from the solar deity, is their motto: "Where there's *dharma* (obligation) there's Victory." The second inscription, prominently placed over the entrance, proclaims that this is the temple of respected Maji Tanwarji (Figure 2.3). It unusually focuses on the patron, not on the deity to which the temple is dedicated which is more the norm.

Figure 2.3: Exterior, Hindi Inscription proclaiming this is the temple of Respected Maji Tanwarji

मंदिर माजीसाहब श्रीश्री १०८ श्रीतंवरजी

Source: Author's photograph.

How common were temples provided by women of the Kachhwaha family? Prior to the late eighteenth century, Kachhwaha rulers built a considerably larger percentage of temples than did their wives or mothers. However, between 1800 and 1926, the founding date of Maji's temple, twelve of the fourteen royally sponsored temples were built by either reigning queens or queen mothers, while men dominated in the provision of secular buildings including museums, town halls, schools, and libraries.[10] On the surface, it appears

that the queens were assuming the role of upholding religious responsibilities, while the kings were furthering an agenda of modernity.

This reading is a little too simplistic since, for example, Madho Singh not only promoted modernity—he was responsible for extending Jaipur's railway—but also cleaned the lake at Pushkar and fed Brahmins at various *tirthas* (pilgrimage sites).[11] Madho Singh had no difficulty with supporting, for example, education in English, while at the same time remaining an orthodox Hindu. A good example of this is his voyage to England to attend the coronation of Edward VII. Torn between wishing to show his loyalty to the Crown and at the same time not forsaking his religious duty by crossing the sea, he resolved the problem by taking his deity, Gopalji, with him on a ship that had been ritually purified. Enormous containers of Ganges water and Indian soil were taken along to suffice for his four-month journey.

His commitment to modernity and tradition are also seen, albeit indirectly, in the two lengthy inscriptions, one in English and one in Hindi, that detail the temple's foundation and dedication (Figure 2.4). These inscriptions, among other features on Maji's temple, suggest that she too found a way to interweave religious responsibility, in this case temple construction, with personal and familial agendas which ultimately served political purposes. Not mere translations of one another, they contain much parallel information. The English inscription is shorter and its presence is somewhat more surprising than the Hindi one. It is unlikely that Maji knew any English herself, but her husband had promoted English language education in Jaipur. He also had been the single largest sponsor of Mayo College, a school founded by the British for the education of elite Indian boys. His adopted son, the then current Maharaja, Man Singh II, was being educated in English at Mayo College when the temple was consecrated. The presence of an English language inscription acknowledged policies promoted by the Jaipur raj.

The English inscription begins by stating the temple was dedicated to the memory of Madho Singh; following this is the

Figure 2.4: Entrance to the second courtyard, English language
inscription dated 1926

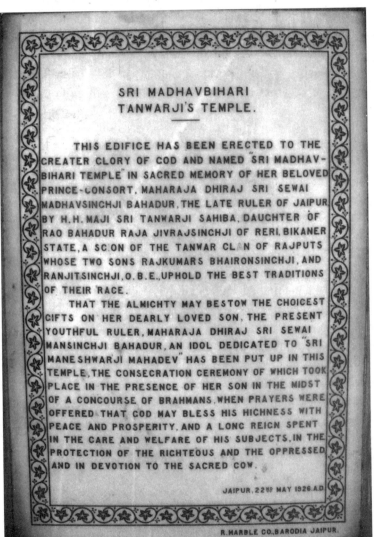

SRI MADHAVBIHARI
TANWARJI'S TEMPLE.

THIS EDIFICE HAS BEEN ERECTED TO THE
CREATER CLORY OF COD AND NAMED "SRI MADHAV-
BIHARI TEMPLE" IN SACRED MEMORY OF HER BELOVED
PRINCE-CONSORT, MAHARAJA DHIRAJ SRI SEWAI
MADHAVSINCHJI BAHADUR, THE LATE RULER OF JAIPUR,
BY H.H. MAJI SRI TANWARJI SAHIBA, DAUCHTER OF
RAO BAHADUR RAJA JIVRAJSINCHJI OF RERI, BIKANER
STATE, A SCION OF THE TANWAR CLAN OF RAJPUTS
WHOSE TWO SONS RAJKUMARS BHAIRONSINCHJI, AND
RANJITSINCHJI, O.B.E., UPHOLD THE BEST TRADITIONS
OF THEIR RACE.
 THAT THE ALMICHTY MAY BESTOW THE CHOICEST
CIFTS ON HER DEARLY LOVED SON, THE PRESENT
YOUTHFUL RULER, MAHARAJA DHIRAJ SRI SEWAI
MANSINCHJI BAHADUR, AN IDOL DEDICATED TO "SRI
MANESHWARJI MAHADEV" HAS BEEN PUT UP IN THIS
TEMPLE, THE CONSECRATION CEREMONY OF WHICH TOOK
PLACE IN THE PRESENCE OF HER SON IN THE MIDST
OF A CONCOURSE OF BRAHMANS, WHEN PRAYERS WERE
OFFERED THAT COD MAY BLESS HIS HICHNESS WITH
PEACE AND PROSPERITY, AND A LONC REICN SPENT
IN THE CARE AND WELFARE OF HIS SUBJECTS, IN THE
PROTECTION OF THE RICHTEOUS AND THE OPPRESSED
AND IN DEVOTION TO THE SACRED COW.

JAIPUR, 22ⁿᵈ MAY 1926.A.D.

R.MARBLE CO., BARODIA JAIPUR.

Source: Author's photograph.

queen's natal lineage, including the names of her father and brothers and a reference to her nephews. The Hindi version is more detailed, commencing with her natal family's descent from the lunar race. There's considerable information about her father including his date of birth, his landholding, and his familial relationships with the major Maharajas of Rajputana, then the name for Rajasthan. His sons' names, Maji's two brothers, are also included. Only considerably into the Hindi inscription are cited Maji's marriage and the subsequent construction of the temple in her husband's honor.

While women's donative inscriptions often mention their husbands and occasionally their fathers, I don't know of any instance where brothers, uncles, and nephews are featured, and in this case in terms more glowing than her husband who is simply a beloved consort. Both inscriptions then heap praise on the current Maharaja, her sixteen-year-old son, Man Singh II, wishing him a long and prosperous reign in which he will protect his subjects and cows; that is, he will fulfill the obligations of a traditional Hindu monarch. At this time, Maji installed an image of Shiva as Maneshvarji, a play on the name of her son, the king, in a side shrine. Of these two inscriptions only the English language one bears a date, May 22, 1926. It was on this date that the image of Shiva as Maneshvarji was installed, not the temple's main deity Madhav Bihariji. That image was installed in the following year. Both epigraphs underscore Man Singh's role as a dharmic ruler, for we learn that Brahmins were fed as part of the temple consecration. The Hindi inscription also indicates the presence of her son, father, brothers, and nephews at the temple's consecration.

The interior of Maji's temple plays out visually the literary content of the temple's inscriptions. The temple's walls, brilliantly painted with a variety of images, are a striking contrast to the plain ones typical of Jaipur's Hindu temples.[12] There are three types of images embellishing these walls: epic heroes and gods, in particular scenes from the life of Krishna; immediately recognizable buildings in Jaipur, such as the Hawa Mahal and City Palace (Figure 2.5); and

portraits of living and deceased people (Figures 2.6, 2.7, 2.8, 2.9, 2.10). Each image is labeled in a lucid Nagari script, suggesting that Maji intended them to be recognized and remembered by posterity.

Figure 2.5: Interior of sanctum, painting of Jaipur's Hawa Mahal, 1924–43

Source: Author's photograph.

The side walls are painted with portraits of the previous Kachhwaha rulers including the god Rama through whom this house claims descent from the solar race (Figure 2.6). They are placed in settings immediately recognizable as unique to Jaipur state. Between each ruler is a figure holding the Jaipur flag. This cycle is completed on the temple's west wall where flanking either side of the sanctum are portraits of the recently deceased Maharaja, Madho Singh, on the left (Figure 2.7), and the new Maharaja, Man Singh II, on the right (Figure 2.8). His regnal titles are provided even though Man Singh was not fully invested as the ruling monarch by the British until 1931; Madho Singh's portrait includes his name, but more significantly the date of his marriage to Maji, the temple's patron.

Figure 2.6: Interior of sanctum, painting on side walls of previous rulers of Jaipur, 1924–43

Source: Author's photograph.

Figure 2.7: Portrait on west wall of Maharaja Madho Singh, 1924–43

Source: Author's photograph.

Figure 2.8: Portrait on west wall of Maharaja Man Singh II, 1924–43

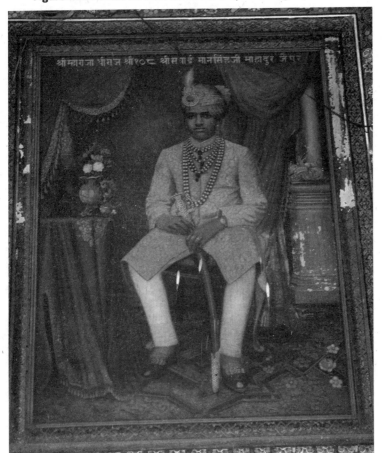

श्रीमहाराजा धीराज श्री १०८ श्री सवाई मानसिंह जी बहादुर जैपर

Source: Author's photograph.

Facing these images on the opposite wall are a portrait of Maji's father, a renowned *jagirdar* (landholder) in Bikaner (Figure 2.9), and another of his two sons mentioned in the exterior inscriptions (Figure 2.10). Beneath these portraits are ones of Maji's nephews also cited in the Hindi inscription. While the presence of these portraits is highly unusual, they play out visually the lineage traced on the exterior inscriptions. Reference to Maji's natal family underscores her distinguished Rajput heritage. Her father belonged to the inner

Figure 2.9: Portrait on east wall of Maji's father, Raja Jivraj Singh, 1924–43

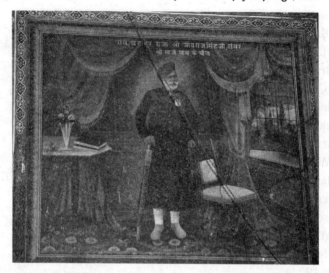

Source: Author's photograph.

Figure 2.10: Portrait on east wall of Maji's brothers, Bhairon Singh and Ranjit Singh, 1924–43

Source: Author's photograph.

circle of Maharaja Ganga Singh of Bikaner. In fact, the Maharaja named Maji's father as one who could administer Bikaner state if the British were to allow him to fight in World War I (Panikkar 1937: 235). I was unable to learn anything about the brothers, but their portrait reveals an enormous trophy marked in English "Kotah Polo Club," indicating their athletic ability. By extension, it symbolizes their bravery, a must for Rajput men; surely the trophy substitutes for stock hunting imagery found in all princely courts, but inappropriate for a Krishna temple.

While honoring her natal family, these portraits may also be understood as a composite donor portrait, that is, they substitute for Maji's portrait which could not be shown as she observed purdah. As the senior-most woman in the Jaipur court, Maji not only was veiled in front of men, but even her son's three wives could not show their faces while in Maji's presence and had to sit at a distance from her (Gayatri Devi 1976: 170). Maji is represented by a depiction of the moon on the temple's silver altar, a reference to the exterior inscription that proclaims her descent from the lunar race. The moon, coupled with the sun, the emblem of the Kachhwahas, symbolizes their marriage. This imagery on the altar that ensconces Krishna and his consort, Radha, likens Maji and her husband to those very deities.

The painted and labeled portraits are intended to bolster the text of the dedicatory inscriptions, making clear Maji's role as the senior court female. As the former ruler's wife, she is the head of the zenana, a powerful position, but in the 1920s a potentially corrupt one. By the end of Madho Singh's life, the zenana and court in general had been dominated by two unscrupulous characters whose notoriety had scandalized all of Jaipur.[13] Maji's stress on her natal lineage and her own role as an upholder of dharma seems to be an attempt to distance herself from the zenana's recent torrid past.

The presence of the portraits of Madho and Man Singh might seem straightforward: simply images of the past and present ruler. But such portraiture in a north Indian temple setting is unknown. We might recall that the inscriptions barely mention Madho Singh; the real focus is the natal and marital lineage of Maji and the future

of her son, Man Singh. To explain this focus on the future, we must examine the recent past.

Most historians evaluating the reign of Madho Singh have little positive to say, although he was liked by the British and did increase the revenues of Jaipur, making it the richest state in Rajputana (Crewe 1985: 15; Rudolph and Rudolph 1984: 111). He is best remembered for his adherence to orthodox Hindu ritual and his prodigious sexual appetite. In spite of his five legal wives, he had no heir but many children from concubines; it had been predicted that if he produced an heir, he would die shortly thereafter. The concern for an heir weighed heavily on his mind in his old age. Adoption was common, but was often fraught, for there was intense rivalry among various lineage groups. There were several families from which the Kachhwahas could adopt, but theoretically primacy was given to a specific branch.[14] However, for a variety of reasons, Madho Singh preferred a boy from another branch, which was that family from which he himself had been adopted. The adoption did not go smoothly, and death threats against the boy, the future Man Singh, continued even after he succeeded to the Jaipur throne.

In the context of these events the temple's portraits along with those of the earlier Kachhwaha rulers appear to be legitimatizing ones. They suggest a smooth transition from one ruler to another since the inception of the Kachhwaha line, however fictitious this may have been. With the death of all four of Madho Singh's other wives by 1926, the year of the temple's consecration, Maji becomes the sole "mother" of Man Singh. She also becomes an ideal Hindu wife as she has "produced" a son, thus fulfilling her dharmic duties.

Man Singh's portrait, bearing an inscription that auspiciously blesses him, resides in two realms. One is that of the gods painted on the walls, and the other is specifically Jaipur, as is also very clearly indicated on these walls. While nominally the temple commemorates the former Maharaja, it in fact celebrates the current Maharaja, the status he has given to Maji, and the promise he shows in fulfilling the responsibilities of a traditional Hindu king, caring for his subjects, feeding Brahmins and protecting cows.

This temple, the realm of the gods, is a mini Jaipur in the larger city; it breaks a trend in royal temple construction. Of the fourteen temples built by the Jaipur royal family over the 125 years prior to Maji's temple, only four were in Jaipur city (Roy 1978: 230–32). The rest were built at tirthas, largely at Vrindavan, a long-standing site of Kachhwaha patronage, suggesting that more merit was believed to accrue from construction at established pilgrimage sites where a large number of devotees would be served than in Jaipur. However, the imagery on this temple makes clear that it is site specific and intimately linked with dynastic image.

All the same, the temple's location needs consideration, for it was built outside Jaipur's walls, the only royal temple in such a location. Documents make clear that Maji wanted this location even when it meant moving twenty-two houses.[15] Why choose a location far from the palace when every other royally sponsored temple in Jaipur was close to the king's residence? Since the founding of the walled city in 1727, little construction had taken place outside the city's walls until the mid-nineteenth century. Important institutions such as the newly modernized police department as well as the mansions of the elite were built along Station Road, as the name indicates, the street leading to Jaipur's Railway Station (ibid.: 111–12; Rudolph and Rudolph 1984: 144–45). It was under Madho Singh that the rail lines had been extended, connecting Jaipur with all the major cities in north India, thus dramatically increasing revenues for the state (Stern 1988: 190 ff). Even though there still was empty land in the walled city, Maji decided to build the first major temple in Jaipur outside the city walls on Station Road across from the new police station, a location associated with power and progress—and now rajadharma. Kingly duty embraced not only feeding Brahmins and protecting cows but also the new order. The location of Maji's temple, like the temple itself, was intended as a celebration of the future of Jaipur's raj.

Today Maji's temple has lost its relevance and is visited by few devotees. While I don't know when this occurred, it is tempting to suggest that the temple's imagery no longer resonates with Jaipur's

citizens. During my numerous visits I noted that other than the extended family of the temple's owners, the devotees appear old enough to remember, perhaps with nostalgia, the days of Jaipur's raj.

Possibly Maji even anticipated a potential lack of interest in her temple near the end of her life, when pro-independence forces were increasingly active in Jaipur. For she added to the temple another Hindi inscription, this one dated March 22, 1943, just a year before her death, when she is clearly showing concern for her own mortality and for the future of her temple.[16] Unlike the others, this epigraph is written in the first person. Maji again breaks the rules, letting her wishes be publicly known. It spells out the financial arrangements for the temple's maintenance, noting that anyone who tampers with them will have to answer to the god, Madhav Bihariji, who she claims will continue to represent her after her death.

While similar inscriptions appear on some premodern monuments, they are rare on modern ones. Maji's concern with her temple may have been rooted not so much in the fear of an individual doing harm, but rather in the pro-independence movement supporting India as a secular nation state. It resulted in India's independence in 1947. Then in 1950, Jaipur's royal temples lost their income with the abolition of the princely states. Maji's worst fears, expressed in her temple's final prophetic inscription of 1943, were realized only seven years later.

Besides the temple and its documents, the only written record I know that reveals aspects of Maji's personality is a passage about this Dowager Maharani in Gayatri Devi's *A Princess Remembers* (1976). In addition to mentioning the very formal relationship that Gayatri Devi had to maintain with Maji, her mother-in-law, including never showing her face, she relates that Maji was very kind. Maji was worried that Gayatri Devi, western educated and liberated, might be bored living in the zenana during World War II when Man Singh was on the frontlines. So she ordered her ladies-in-waiting to devise plays for the princess in which they played roles of the heroic Man Singh much to the delight of the young Gayatri Devi (Gayatri Devi 1976: 170).

We have already seen that the purdah-bound Maji was capable of getting her way even if it meant breaking the rules, such as when she planted a garden rather than building a girls' school in spite of official reprimands. While her husband, Madho Singh, had given generously to multiple educational institutions (Sarkar 1984: 375–76), and another of Madho Singh's wives had also provided financial support for medical education for women (Ramusack 2004: 143–44), I suspect Maji didn't build the school because of its projected cost. Her temple was clearly more expensive than initially imagined, depleting her resources; she probably was not against education but obviously was more interested in promoting her family in the name of devotion.

Maji lived in a world where all Rajput women from elite families observed purdah. By contrast, Gayatri Devi, who married Maji's son, Maharaja Man Singh, grew up in the westernized court of Cooch Behar and spent considerable time in London and Switzerland.[17] Her father, Maharaja of Cooch Behar, died when she was young; her mother did not take to the retiring life of many Hindu widows but traveled widely in Europe. Both abroad and at home she was renowned for her beauty, gracious hospitality, and lavish parties. When sixteen-year-old Gayatri Devi announced she was marrying Man Singh, her mother hoped she would eventually change her mind. She was fond of the young Man Singh but concerned about her daughter becoming a third wife, especially in the conservative Jaipur state where the young princess would be expected to observe purdah. In spite of her mother's concerns, Gayatri Devi married Man Singh in 1940 just a week before her twenty-first birthday. In Jaipur she was able to live in two worlds—one with relative freedom at the Rambagh Palace, and in purdah when residing at the City Palace.

In her memoirs, Gayatri Devi cites the positive aspects of the purdah system. She notes:

> It is difficult ... to understand why... these conservative women were perfectly content with what seems, from the outside, a hopeless dull and claustrophobic existence. In fact their lives in purdah were

much fuller and more active than you would imagine a woman with a wide circle of children, grandchildren and relatives was the focal point of the entire family Perhaps most important of all, she would never be without companionship and she would always be needed Many of the women would have been lost ... if they had been suddenly exposed to the outside world without the protection they had come to rely on. (Gayatri Devi 1976: 209)

According to Gayatri Devi, even before their marriage, Man Singh had told her that he hoped under his rule the tradition of purdah would lessen (ibid.: 208). Gayatri Devi believed that education was the way to break the system of purdah, so, at the age of twenty-four, she decided to open a girls' school with the hope that young girls from the elite strata of society, currently living under the purdah system, would change their lifestyles. Her paternal grandmother and aunt had been generous contributors to a girls' school in Bengal (Ramusack 2004: 144), and her maternal grandmother was an outspoken advocate for educating women (Kanwar 2004: 70), which may well have played a role in Gayatri Devi's decision to open this school. She was supported in her decision by a number of prominent figures, including Jaipur's prime minister, Sir Mirza Ismail, and the Minister for Education, whom we can only assume placed pressure on elite families to educate their daughters. The initial resistance among the elite was less because of the requirement for a formal education than the mandatory extracurricular activities including sports, dancing, and drama.[18] Miss Lillian Lutter was hired as principal, a position which she held for thirty-seven years.[19] She must have been an extraordinary woman, for in 1970 she was honored with a Padma Shree among many other awards.[20] Underscoring this is an email I recently received from a former student, now a practicing architect, who spoke of the transformative affect Miss Lutter had on her. She noted that Miss Lutter told her students they could do anything because they were girls.[21]

The school's prospectus for the first class in 1943 had a remarkable vision for the uneducated purdah-bound girls of Jaipur. It states:

The aims of the institution will be ... to secure to the pupils the advantages of training in home craft and domestic hygiene, for the betterment and happiness of their homes, to create in them a taste for the fine arts, colour decoration and culture ... to create ... an esprit de corp in girls. In general, the aim and effort would be to impart an all-round education ... which will prepare them to play the role required of them as efficient members of ... society. (Kanwar 2004: 73)

This was an extraordinary goal for a society that sequestered its women and barely taught them to read or write. It is also remarkable that the education occurred in English, a language which the first twenty-four girls who entered in 1943 would not have known or only known imperfectly at best.

The Maharani Gayatri Devi Girls' School, known as MGD, was opened on July 4, 1943. Gayatri Devi, who frequently visited her school (and did until her death in July 2009), worried that it wouldn't last more than the first year. But MGD succeeded and is now considered one of the best educational institutions in Rajasthan. Moreover, the purdah system is barely practiced today by either the elite or the middle classes. Pro-Gayatri Devi literature credits the MGD school for this, but clearly its leadership under Miss Lutter also played a major role. At the same time, the Maharani is still given considerable credit. One woman who entered the school in 1943 said, "My purdah-clad mother, influenced ... by the beautiful Maharani, was happy to let me pursue a career" (ibid.). A former foreign secretary claims that Gayatri Devi's school and her example of driving her own car, wearing trousers, hunting and playing tennis set examples for women in Rajasthan. He claims, "She was an educationalist who started this school for girls and made it possible for women all over Rajasthan to come out of purdah" (ibid.: 73–74).

The school's initial curriculum included English literature, Hindi, math, geography, Indian and world history, art and music among other subjects.[22] Sports were also part of the curriculum, including tennis and swimming favored by Gayatri Devi herself. To

this end she donated a swimming pool to the school. A partial list of alumnae indicate that women who graduated from the early years of the school are now business executives, textile designers, artists, doctors, principles of prestigious schools, and more.[23]

What does this discussion of Gayatri Devi, her school, and western lifestyle have to do with the theme of this volume? I see Gayatri Devi as a foil to Maji. One Maharani, Maji, practices purdah and sees a provision of a school as much less significant than building a temple, while the other, her daughter-in-law, Gayatri Devi, just one year before Maji's death, attempts to decrease the practice of purdah by the construction of a school with a radically innovative curriculum for Jaipur's elite young girls. To what extent did Gayatri Devi have anything to do with the design and appearance of the campus of MGD? This is a question that can only be answered through an dedicated examination of school archives—a project that awaits a future scholar—but for now, we can speculate that Gayatri Devi, who appreciated beauty, had a deep love for Jaipur, and respected the power of education, would have taken a keen interest in every aspect of her school, including its design.

The school first opened in an old building outside the city walls and shifted to a permanent building a year later (Figure 2.11). Today the campus covers 26 acres and has eight dormitories, many classrooms, a kitchen, a gym, a modern swimming pool, and so on. In keeping with the official color of Jaipur, most of the buildings are painted pink even though in this part of the town it is not mandatory. The architecture, too, while not uniform is an attempt to evoke the *chattris* (domed kiosks), arches and *jalis* (screens) of buildings found in the old walled city. This recalls Maji's temple, which too is a conscious recreation of Jaipur. Gayatri Devi's love of Jaipur's architecture becomes evident considering that in February 2008 the eighty-nine-year-old Rajmata, as she was called in her later years, joined a protest against developers who are illegally building high rises thus ruining the once beautiful skyline of the city.[24] In this way she can be seen as a preserver of Jaipur's former royal culture.

Figure 2.11: Maharani Gayatri Devi Girls' School, first building of newly constructed school, 1944, Jaipur

Source: Author's photograph.

The period I have been discussing was a transformative one in Jaipur's history for the women of Jaipur. The 1920s to 1940s, the time during which Maji built and used her temple, was one when purdah was observed by elite women. Maji, even though observing purdah, was able to break the normative rule of society by the use of painted imagery and inscriptions on the temple's walls as well as her defiance of the state by refusing to build a school and continuing to overspend on her temple. Gayatri Devi, however, broke more rules by publicly not observing purdah. By constructing a school intended for elite purdah-bound girls this Maharani helped transform Jaipur's understanding of normative roles for women. She founded three other schools, of which one is a co-educational school—a signal of the success in transforming education in Jaipur.[25] The school's alumnae association recently sent me a list of over twenty-five graduates who are today practicing artists or architects; one graduate, Dharmendar Kanwar, has gone on to be a successful travel writer, designer, and architectural conservator. Another graduate wrote to me that MGD is an institution that

encourages creative expression and that it inspired her to become an artist and graphic designer.[26] It is women such as these who are potentially empowered to transform the cultural landscape of India and its Diaspora.

NOTES

1. For example, see "Gayatri Devi," in People Obituary, Economist.com, August 20, 2000 at http://www.economist.com/obituary/displaystory. cfm?story_id=14257294 (accessed September 2, 2009) and "Gayatri Devi, 90, a Maharani and a Lawmaker, Dies," New York Times at http://www.nytimes.com/2009/07/31/world/asia/31devi.html (accessed September 2, 2009).

2. These include inscriptions on the temple and legal documents originating from the official offices of Jaipur State Darbar and now residing in the Rajasthan State Archives. Copies of these documents, most of them originally written in Urdu, were transcribed into Nagari for Devesh Swami, an advocate, so he could prove the temple is his family's property. According to a document dated April 15, 1947 bearing Man Singh's personal seal, the temple and its property were gifted to Swami Tota Ramji. Devesh Swami says that this was his grandfather and the temple was conferred on the family in thanks for services rendered during the adoption of Man Singh by Madho Singh who had no heir. I am grateful to Devesh Swami for giving me copies of all these documents and to Dr and Mrs Prasannanshu for assisting in their translation. Hereafter these documents will be cited as "Document" with a date.

3. Some insight, although not from women who lived permanently in purdah, is provided by Gayatri Devi herself in A Princess Remembers (1976: 209). For a contemporary male view see Singh (2000: 218–30, 387–89, 395, 397–99, 409, 420–21, 433–35, 449).

4. Document dated February 3, 1927 indicates the temple must be completed by the month of Visakh, which commenced on April 21. While the temple itself was finished, work on surrounding structures continued for many years.

5. Documents dated February 2, 1934 and December 22, 1934.

6. For examples see Documents dated December 28, 1924, July 7, 1926,

March 3, 1927, April 25, 1927, October 21, 1927, November 16, 1927, August 16, 1928, January 1, 1938, and March 28, 1938.

7. Documents of June 25, 1926 and June 6, 1928.

8. Document of June 6, 1928.

9. Sachdev and Tillotson (2002: 83–85) include a plan of typical temples of Jaipur of this approximate period.

10. This data is in Roy (1978: 227–32).

11. For Madho Singh see Sarkar (1984: 363–77) and Stern (1988: 172–229).

12. Asher (2001: 68–77). The plainness of the facades is carried through to the interior.

13. Crewe (1985: 15–23). Although this is a popular book, Crewe has clearly done careful work reading materials in the India Office Records and unpublished portions of the Amar Singh diaries, and thus is considered reliable.

14. For this adoption see Crewe (1985: 2–13), Singh (2000: 344, 551, note 17), and Stern (1988: 225–28).

15. See Documents dated June 6, 1928, August 16, 1928, September 9, 1928, and November 11, 1928. It was largely houses of gardeners that needed to be relocated.

16. She died November 11, 1944.

17. In addition to Gayatri Devi's own memoirs, *A Princess Remembers*, Dharmendar Kanwar (2004) tells the story of the princess's life. Most literature on Gayatri Devi is uncritically laudatory in nature and obituaries on her death (July 2009) continue this trend. See http://timesofindia.indiatimes.com/opinions/4834040.cms for a variety of comments by ordinary people on Gayatri Devi's legacy (accessed September 2, 2009). Often noted for her beauty, photographs of her can be found in multiple places including one of the most famous taken by Cecil Beaton (http://www.hindu.com/mp/2004/04/29/images/2004042901200101.jpg, accessed September 2, 2009).

18. I am very grateful to Chandralakha Mathur, one of the twenty-four girls who first joined Maharani Gayatri Devi School in 1943 for this information and extensive discussion about the school during August 2008.

19. http://www.mgdgirlsschool.com/stalwart.asp#lutter (accessed April 12, 2008).

20. http://www.mgdgirlsschool.com/stalwart.asp (accessed September 2, 2009).

21. Email from Priyamwada Chadha dated April 26, 2008.

22. http://mgdgirlsguild.org/first_prospectus.php (accessed April 23, 2008).

23. http://www.mgdgirlsschool.com/information_longway.htm (accessed April 21, 2008).

24. http://www.dawn.com/2008/02/25/int13.htm (accessed April 23, 2008).

25. Discussion with Chandralakha Mathur, August 2008. See Kanwar (2004: 119) and Gayatri Devi (1976: 394).

26. Message from Roopali Kanbo Puri on April 30, 2008.

REFERENCES

Asher, Catherine B. 2001. "Amber and Jaipur: Temples in a Changing State," in Giles Tillotson (ed.), *Stones in the Sand*, pp. 68–77 (Mumbai: Marg Publications).

Crewe, Quentin. 1985. *The Last Maharaja: A Biography of Sawai Man Singh II Maharaja of Jaipur* (London: Michael Joseph).

Gayatri Devi. 1976. *A Princess Remembers: The Memoirs of the Maharani of Jaipur* (Philadelphia: Lippincott).

Kanwar, Dharmendar. 2004. *Rajmata Gayatri Devi: Enduring Grace* (New Delhi: Lustre Press, Roli Books).

Panikkar, K.M. 1937. *His Highness The Maharaja of Bikaner: A Biography* (London: Oxford University Press).

Roy, Ashim Kumar. 1978. *The History of the Jaipur City* (New Delhi: Manohar).

Rudolph, Susanne Hoeber and Lloyd I. Rudolph. 1984. *Essays on Rajputana: Reflections on History, Culture and Administration* (New Delhi: Concept Publishing Co.).

Ramusack, Barbara N. 2004. *Indian Princes and their States* (Cambridge: Cambridge University Press).

Sachdev, Vibhuti and G.H.R. Tillotson. 2002. *Building Jaipur: The Making of an Indian City* (New Delhi: Oxford University Press).

Sarkar, Jadhunath. 1984. *A History of Jaipur* (Hyderbad: Orient Longman).

Singh, Amar. 2000. *Reversing the Gaze: Amar Singh's Diary: A Colonial*

Subject's Narrative of Imperial India, edited by Susanne H. Rudolph, Lloyd Rudolph, and Mohan Singh Kanota (New Delhi: Oxford University Press).

Stern, Robert W. 1988. *The Cat and the Lion: Jaipur State in the British Raj* (Leiden: E.J. Brill).

3 | The Buildings of the Begums of Bhopal

"Islamic" Architecture in a Nineteenth-century Indian Princely State[*]

BARBARA D. METCALF

The lineage of rulers of the central Indian state of Bhopal from 1819 to 1927 included four remarkable women, the female succession interrupted only briefly by one male ruler (from 1837 to 1844). Of Orakzai[1] heritage, these rulers were scions of one of the warrior polities that had emerged during the decline of central Mughal power and the ascendancy of regional kingdoms in the eighteenth century. The polity was saved by the prescience of key figures at the turn of the nineteenth century who threw in their lot with the East India Company. These British officials saw the Muslim Bhopal chiefs as a counter to the powerful Hindu Maratha states, however little the religious difference had mattered in strategies or alliances to that point. In a series of treaties and negotiations around 1818, British hegemony in Central India took hold, and the Bhopal diwan, Wazir Muhammad Khan (d. 1816), shortly before his death, laid the foundation for colonial support to him and his heirs within demarcated territorial boundaries.

[*] Warm thanks to D. Fairchild Ruggles who organized the conference at the Doris Duke Foundation for Islamic Art's Shangri La, Honolulu, in May 2008, which was the genesis of this paper, and to Sharon Littlefield and others of the Institute's staff for all they did to make the event so successful. I am especially indebted to Catherine Asher for her encouragement to me to take up this topic and for her expert advice on art and architecture.

In 1819, Gauhar Ara ("Qudsiyya Begum"), the wife of Wazir Muhammad's son, Nazir Muhammad, was widowed when her eight-year-old brother accidentally shot dead her husband. The strong-willed teenaged widow, against considerable odds, negotiated power for herself and, ultimately, her daughter. That daughter in turn secured succession for her daughter. There was a story behind this determined effort at subverting characteristic male succession, namely, that Wazir Muhammad had wrested power from the lineage that had produced five successive chiefs. The last of them was none other than Qudsiyya's father, still holding nominal power at the time of the settlement with the British, and subsequent developments reflected in part the struggle between rival lineages. With recognition from the British, Wazir Muhammad's lineage had appeared secure but British power also made possible the subsequent departure from patriarchal customs.[2]

And only British stability, and the particular mix of delegated power—internal administrative and ceremonial rights without military or external political autonomy—created a context in which cultural patronage, coupled with some degree of orderly administration and philanthropic noblesse oblige, defined the limited range of princely rule. Central to these new cultural activities of the Bhopal rulers was creating a settled capital city for themselves. The successive ruling Begums built mosques, palaces, administrative centers, serais, markets, guesthouses, and gardens to provide the setting for the political, ceremonial, administrative, and economic activities of their regime in its new colonial context.

The art critic Gayatri Sinha judges the Begums of Bhopal as the foremost women patrons of architecture in the whole sweep of Indian history (Sinha 2006). She makes this judgment in comparison to women who patronized temple buildings, particularly those of the powerful Chola dynasty; Mughal women who were well known as builders of tombs, madrasas, gardens, palaces, and mosques; the nineteenth-century consort of a European noble, Begum Samru, the celebrated patron of church buildings; and the women of the eighteenth- and early nineteenth-century Awadh court, the builders

of Shi`a *imambaras*. Sinha's judgment certainly justifies attention
to the building programs of the Begums, and especially of Shah
Jahan Begum (r. 1868–1901), the third of the Begums and the most
important in relation to architecture.

Sinha further suggests that there is typically a gender division
in forms of patronage, with rulers devoting themselves to secular
buildings and female consorts patronizing religious ones. At times,
in the case of women, she adds, there was a "shift to architecture on
a smaller and more intimate scale." The Begums, she argues, crossed
both divisions, patronizing alike the sacred and the secular, the
public and the intimate, and so challenged "the image of woman's
patronage of architectural structures as delicate, personal or familial"
(Sinha 2006: 73). These categories are somewhat problematic since
such structures as a Chola temple or a Mughal dynastic tomb would
assuredly be at once devotional and political in their meaning. Thus
the categories "religious" and "secular" do not in fact serve well
to understand the meaning of buildings, even among those Sinha
names. Nonetheless, her suggestion encourages attention not only
to architectural style but also to the goals pursued by the Begums in
the functions, locations, and styles of the buildings they sponsored.

The few scholarly works that take up the buildings and urban
planning of the Begums typically label their architecture and
urban projects as "Islamic" and suggest a progressive program of
"Islamicization" as characteristic of this regime. I want to argue,
however, that the term "Islamic" in relation to objects or even
policies needs to be carefully scrutinized, especially in the case of
South Asia where categories of colonial sociology persist (Ruggles
2008: 131–46; Wagoner 1996).

In South Asia, as elsewhere, the term "Islamic" is often used simply
to describe cultural production whenever the political elite is Muslim
or of Muslim background. That, for example, seems to be the guiding
principle of the collection of the Doris Duke Foundation for Islamic
Art at Shangri La as well as in the collection of the Honolulu Institute
of Art, where objects from the Mughal or other South Asian Muslim
regimes are assigned to the collection of "Islamic Art" rather than to

the India gallery. Such classification may distort periodization when objects or styles attributed to a specific religious or ethnic group are locked into the period characterized by that group's rule (Varma and Menon 2008). The broad sweep of such categorization also limits an understanding of shared regional practices. It reinforces the dangerous fallacy of attributing whatever Muslims do to "Islam." And, finally, given the strength of majoritarian nationalism in India today that marks Muslims as "foreign," the suggestion that "Islamic" is distinct from "Indian" is to take sides in a political discourse that marginalizes a category of Indian citizens. It is notable that New York's Metropolitan Museum of Art in 2012 opened a new gallery whose title, "The Arts of the Arab Lands, Iran, Central Asia and Later South Asia" was explicitly devised to avoid these pitfalls (Denny 2011).

As many scholars have argued, describing objects and buildings as "Hindu" or "Islamic" is an artifact of colonial practices and the colonial strategy of ordering "communities" in terms of "religion," a strategy that marked the colonized as backward, even medieval, compared to the presumed advanced and scientific Europeans. In relation to architecture and urban layout, this process of labeling also privileged particular forms deriving from the Middle East. For all the prestige associated with some dimensions of Arabic and Persian traditions, most of the world's Muslims, of course, live in cultures, like Bhopal, outside those areas so that other regional forms and styles may well be ignored by such labeling.

BUILDINGS IN BHOPAL TO 1868

Before the stability permitted by colonial domination, the buildings of the nawwabs had focused largely on forts and fortified palaces. During the first long century of the family's presence in central India, they operated within the political culture of the times as warrior clans, often on campaign and living a fundamentally unsettled life. The lineage's founder, Dost Muhammad, in his final years was able to build a major fortified center, Islamnagar, some 11 kilometers

from the city of Bhopal. By the early eighteenth century, it became
the site of residences and gardens built in the recognizable "late
Mughal" style of flattened "Bengali" domes, cusped arches, and
ornamented pillar brackets (Figure 3.1). A palace, fountains and
gardens, and a hammam were laid out within the heavy walls and
towers of the fort. This regional style certainly cannot be identified
as Islamic or Hindu.

Figure 3.1: Gardens and pavilion at Islamnagar

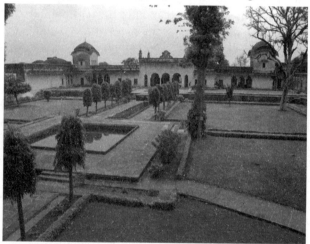

Source: Photograph courtesy of Hannah Archambault.

With Qudsiyya's reign and *pax Britannica*, a century after Dost
Muhammad, the city of Bhopal itself became the major focus of
attention. Thanks to the careful work of architectural historian
Manu Sobti, including photographs, drawings, and reconstructed
detailed plans of the city, it is possible to ascertain much of the
chronology and the building choices of the nineteenth-century
nawwabs in Bhopal city (Sobti 1993). In her buildings in the city,
Qudsiyya set the pattern of simultaneously constructing the three
types of buildings that would be characteristic for the duration of the
princely state's history. These were utilitarian projects, represented
in her case by well-designed waterworks in particular; secondly,

palaces and gardens; and, finally, sites to house and support Islamic ritual, including mosques and, beyond Bhopal, inns for pilgrims en route to hajj.

Qudsiyya's best-known building is the first congregational mosque built in Bhopal, the Jami Masjid, the classic building any ruler establishes as a sign of legitimate power. Indeed, the lack of such a building to that point is arguably an indication of the fragility of the regime in the pre-British period. The art historian Giles Tillotson places the Jami Masjid, with its elaborately bracketed and fluted columns, cusped arches, and florid ornamentation, as a routine example of late Mughal architecture. This was the architecture, he notes, that was so deplored by "the founder of modern Indian architectural history," James Ferguson, for its "decadence" and "feebleness" (Tillotson 2006: 391, 398). Admirers at the time and tourists today have thought otherwise. This mosque was notable for its three domes marked by sparkling golden spires, and it is well kept and well utilized today (Figure 3.2). Located on a high plinth, the mosque occupies a commanding position in the city.

Figure 3.2: Jama Masjid, Bhopal, showing the domes and frame for erecting awnings

Source: Photograph courtesy Hannah Archambault.

Moreover, in terms of urban planning, as Manu Sobti has concluded, the mosque must be understood for the role it played in transforming the city into a capital. The mosque was superbly situated to take advantage of a commanding height, and it anchored what would be the core area of the city (*shahar-i khas*), north of the major lake, with four roads radiating out to define the quadrants that grew up around it. The northeast quadrant was settled by rich merchants, both Hindu and (Muslim) Bohras, whose role was important in the growing trade of the period. Its square (chowk) provided an important urban space, and it housed a major bazaar. Another node was created southeast of the core adjoining the lake with residences of major nobles, including Qudsiyya's own palace, bearing her given name, Gauhar Mahal, and other administrative structures (Sobti 1993: 24). This section ultimately linked the new city to the old fort of Fatehgarh.

Qudsiyya's buildings met the somewhat ambivalent colonialist standards for princes. On the one hand, the princes were meant to be "enlightened," even "modern," exemplified in her case by her waterworks. She employed a Scottish engineer, David Cook, to construct the waterworks and develop the two lakes to provide free water throughout the city, supported by a trust she also put in place. On the other hand, the princes were meant to be authentic, the old-fashioned "natural leaders" of the people, whose support enhanced British claims to legitimate rule. Such buildings as the mosque and the lodges presumably confirmed such authenticity.

As a "Muslim" monarch, did this mean, however, that she laid the foundation for an "Islamic city?" Although this rubric has fallen into some disrepute, Manu Sobti nevertheless claims that she did.[3] He particularly emphasizes the organization of the core into four gridded quadrants, although he himself notes that it was "fairly unusual" for a Jami mosque to be the key element in defining those quadrants. Further, he points out that it is possible that the pre-nawwabi city on this site, Bhopal Taul, may well have also been divided into four equal quadrants ("according to the Prastara plan") and a *temple* may well have served as *its* core (ibid.: 46). His further suggestion that

the presence of specialized markets, and a preference for noisy or odiferous goods to be located away from the center, were derived from an Islamic system, again seems to be undue specification for patterns that transcend religious traditions, as does the use of open spaces within buildings (ibid.: 48 & 52). By Sobti's own evidence, the term "Islamic" explains little about the city's layout. However described, Qudsiyya's building had laid a strong foundation for the city's beauty and growing role as an urban center.

Despite all of Qudsiyya's efforts to the contrary, her daughter Sikandar's husband, Jahangir, who was, like her own husband, from the rival sub-lineage to her own natal one, wrested control of the state in 1837. Although ruler for only seven years, Jahangir further developed the dynasty's track for the pursuit of cultural activities, including patronage of Islamic scholarship, poetry, and literature (Preckel 2000: 43–45). The period also saw development in trade and commerce, with Jahangir himself cultivating trading interests as far as the Middle East. The major building project of his era was "Jahangirabad," a new quarter to the east of the city across the smaller lake to serve as a cantonment for the regime's largely Afghan troops. It was designed on the English model with orderly barracks, eating halls, parade grounds, and guesthouses for state guests (Sobti 1993: 37, fn. 58). Jahangir also built a house and gardens for himself along the lake. Upon Jahangir's untimely death at the young age of 27, his widow, Sikandar, became regent for her only daughter, Shah Jahan, as her own mother had been for Sikandar herself. Similarly, the expectation was that the daughter would marry a male from Wazir Muhammad's lineage who would then become the state's ruler. Sikandar, however, succeeded in securing not only colonial recognition of herself as ruler in her own right but also agreement to the succession for her daughter with the same right to outright rule.

Sikandar's reign is best known for her administrative reforms and for her active support to the British during the 1857 uprising. Trade flourished in these decades at mid-century, with a proliferation of specialized bazaars emerging in the city. Sikandar continued her

· mother's program of architectural and building projects, including "modern" undertakings of the public works, schools, and hospitals she liked to show European visitors. She paved roads and put up street lighting within the city. Her palaces continued the eclectic style of the earlier period, including the exuberant and imposing Moti Mahal, located to the north of her mother's palace, which she made her own residence (Figure 3.3). The palace had a large public court, entered via a *nakkar khana* gateway for drums, as well as a private courtyard for her minister and nobles (ibid.: 51).

Figure 3.3: An old postcard of the Moti Mahal

Source: Private collection (Ruggles).

Architectural style under Sikandar took a markedly different turn in one key building, however. This was the Moti Masjid, "The Pearl Mosque," a name familiar from two celebrated Mughal mosques in Agra and Delhi. The mosque was patronized by Qudsiyya, but begun after her rule had ended and completed only at the end of the 1860s. Particularly from the foot of the stairs leading up to the entryway, the mosque, even though smaller in size, evokes yet another Mughal mosque, Emperor Shah Jahan's great mid-seventeenth century congregational mosque built as part of his new city, Shahjahanabad (in today's Old Delhi) (Figure 3.4).

Figure 3.4: Moti Masjid

Source: Photograph courtesy of Hannah Archambault.

The Moti Masjid was located in the core city north of the Upper Lake where Qudsiyya had placed her earlier buildings. Demonstrating that he shared something of Fergusson's point of view about nineteenth-century architectural decline, the French traveler Louis Rousselet, who witnessed the completion of the mosque, grudgingly concluded that the new mosque "gives some notion of what Indians are still capable of doing—even now, after so many centuries of decay" (Rousselet 1876: 417). However, Tillotson, whose preference was clearly for architecture of the sixteenth century, sees nothing to redeem the style and describes it as "an atavistic recreation of imperial Mughal at its...zenith," a judgment that surely requires further investigation of the structure itself (Tillotson 2006: 393).

Perhaps what is most interesting about the Moti Masjid is the very turn to what we might call a "Mughal Revival" style (on the pattern of American "Spanish Revival" architecture in roughly the same period), a self-conscious attempt to engage with the distinctive architecture of an admired earlier era—no more "Islamic" than Spanish Revival

was generically "Christian." This was not an embrace of an "Islamic" style in some general way, but a claim on a very particular imperial building tradition. The choice was not obvious. Bhopal was not, like princely Hyderabad, a former Mughal province. The Bhopal lineage founder had briefly taken service as a mercenary for the Mughals but once in Malwa opted to serve a range of chieftains who offered him better options. Emperor Farukhsiyar in his brief reign (1713–19) sent troops against him. Dost Muhammad was able to use his considerable power, in the end, to gain support from the powerful Sayyid Brothers (who were influential figures at Farukhsiyar's court), but upon their fall from power, Dost Muhammad found himself ranged again against the Mughals, as represented by the regional power of Hyderabad (Husain 2002). The Bhopal regime in the great uprisings across north and central India in1857 sided with the British against the last Mughal. The cultivation of a Mughal aura came in fact with the Bhopal dynasty's positioning of itself within British India. In this context, a claim to the heritage of the most powerful rulers of what was now imagined as "Indian" history could be seen to enhance Bhopal's glory.

Naming practices within the dynasty at this decisive moment in the state's history also made a claim on the Mughal past. Qudsiyya's given name was Gauhar Ara, a name invoking jewels, like other family women's names linked to beauty or adornments. In due course, she was deemed worthy of the title *Qudsiyya*, honoring her spiritual power, a quality associated with the fused political and saintly power attributed to anyone asserting power in precolonial Bhopal—as she, a transitional figure, assuredly did. Her husband's name shared the naming pattern of all the men of the extended lineage, the name of the prophet, Muhammad, preceded by a word depicting some Sufi-like relationship to him, like *dost* (friend of) or *faiz* (the grace of) or in Qudsiyya's husband's case, *nazir* (emulator or image). These names, like the alias "Qudsiyya," pointed to the element of spiritual power in any claim to authority.

Nazir Muhammad and Qudsiyya's daughter and only child, however, was named Sikandar, a variant of Alexander (the Great),

celebrated in Persian tradition and well known in the Afghan borderlands where Alexander and his men had invaded. The name "Sikandar" was thus an unusual choice in the family, but looked ahead to a different kind of leadership and a positioning of Bhopal—as "Mughal Revival" buildings would do—within a space beyond the regional context that had alone mattered in the pre-British period.

By the time Sikandar was married to her late father's nephew, men's names had also changed. Her husband was Jahangir, the title of the third Mughal emperor. The only child born to Sikandar and Jahangir—that couple of mighty names—was a girl who was named, apparently from birth, Shah Jahan (Lord of the World), the name of the fourth Mughal emperor and, interestingly, the greatest builder of the dynasty. She in turn named her first daughter and heir Sultan Jahan, a name with essentially the same meaning as her own. A second daughter (who died in childhood) was Sulaiman Jahan, after King Solomon who was celebrated for his wisdom and power. They all appended the Turkish title (used there for the wife of a high official), "Begum," to these names, thus clarifying their female referent, thus: Sikandar Begum, Shah Jahan Begam, Sultan Jahan Begum, and Sulaiman Jahan Begum. By the subsequent generation, names had more conventional gender linkage. Some continued to repeat the pattern of names of earlier or legendary rulers. Sultan Jahan's eldest child, a daughter, was named Bilqis, after the legendary Queen of Sheba who was won to worship of the true monotheistic God by Solomon. Her three sons had gender-specific names that linked each to Allah, like Hamidu'llah (a man who praises God). These later names document the more self-conscious identification with distinctive gender roles that came with new definitions of respectable masculinity and feminity in the high colonial period.

But for Shah Jahan Begum's era, it was the claim to the name of a (male) Mughal ruler and a Mughal heritage that prevailed. A woman of about thirty when the Moti Masjid was completed in 1868 and she ascended to power, she would have been well aware, perhaps even involved in, its building, and she would continue to patronize the same style in some of her own most important projects.

SHAH JAHAN'S BUILDINGS

In power at the height of colonial rule, Nawab Shah Jahan Begum (1868–1901) was the dynasty's greatest builder. She asserted her legitimacy in a broad range of spheres. She positioned herself as a modern ruler, establishing the classic colonial infrastructure and institutions from railroads to post office to a law code to schools and hospitals. She produced a wide range of written documents, writing to an extent no predecessor in the dynasty ever had and producing texts that showed her as cultivated, informed, morally guided, and assertive of her authority within the state. Her publications included two *diwans* of Urdu poetry; a history of the state; a compendium of Hadith, arranged by topic; a guide to proper behavior for respectable women; and even a dictionary. She also produced ceremonial letters as well as memoranda, reports, and petitions, essential to her rule. In the mid-1880s, she faced fierce official disapproval and challenges to her autonomy over the purported political activities of her second husband (Metcalf 2011). Through all this period, and despite such political preoccupations, she also carved out the role that is the subject of this article, patronizing and overseeing a vast array of specific architectural projects as well as laying out new sections and modifications of the urban fabric of the city of Bhopal.

This portrait of Shah Jahan Begum from the early 1870s, shortly after her accession, suggests the changing and challenging world she lived in. It shows her in the characteristic "unisex" dress of the court with fitted pants, a long shirt, an angled cap, and some kind of robe. The outer garment, however, is the robe of the newly invented colonial honor, The Star of India, a measure of the official approval she had earned at that point—and she has chosen as her footwear English-style leather boots (Figure 3.5).

Under Shah Jahan Begum, Bhopal city entered, in the judgment of Manu Sobti, its "golden period of city building" (Sobti 1993: 26). The old core city was renewed with new buildings, repairs, and demolitions. By-laws forbade the construction of mud buildings, and occupational groups like tanners, who had infiltrated other areas,

Figure 3.5: Portrait of Nawab Sultan Shah Jahan Begum Sahiba, Nawab of Bhopal, G.C.S.I, C.S.I, Kaiser-e-Hind (1872)

Source: Photograph by Bourne and Shepherd. Reproduced courtesy of the Alkazi Collection of Photography, ACP: 94.30.0007.

were moved to the outskirts of the city. Most of the building was of the local red-purple sandstone common in the area. Most important of Shah Jahan Begum's building projects was her laying out a whole new city to the northeast of the core, begun in 1874. This was, predictably, named Shahjahanabad, and like Emperor Shah Jahan's Mughal city of that name, a mosque and a palace became its key landmarks. A critical contrast to the old city, and in this reflecting much urban planning of the late nineteenth century, was the use of substantial open spaces in contrast to the densely built-up character of the older settlement (ibid.: 31).

The masterpiece of the new city was the towering Tajul Masajid (The Crown of Mosques) built as the largest modern mosque in India and, like the Moti Masjid but on a far larger scale, a building intended to be a recreation of the Shahjahanabad Jami Masjid. The name of the extraordinary Taj Mahal Palace echoed Emperor Shah Jahan's most famous building. Among other palaces was the Benazir Mahal, a pleasure palace with enclosed gardens, fountains, and an elegant hammam. There were serais, other mosques, schools, bazaars, and all that makes up a city landscape. A masonry building was erected

as a *mina* bazaar where only women shopkeepers and customers were permitted. As in the older city, there were residential sectors for nobles, the general populace, and the infantry. Shah Jahan also built here the city's first *idgah* for congregational prayer on major feast days, located on a high, commanding site. In contrast to other cities built in the colonial era, but in further evocation of an earlier time, she encased the whole of Shahjahanabad within its own city wall (ibid.: 27).

The Tajul Masajid, unfinished at the time of Shah Jahan Begum's death, is today one of the premier sites of the city, its *minars* elegantly visible from afar and its setting at the water's edge enhancing its beauty (Figure 3.6). The mosque architect, Muhammad Raushan, was hired from Delhi and one of the two contractors was one Rathaji brought from Kathiwaar (Sanderson 1913: 12). Regarding the Tajul Masajid, Tillotson reiterates his judgment of the Moti Masjid, judging it to be "archaeological" mimicry rather than creative architecture (Tillotson 2006: 394). What is mimicry and what is creative, self-conscious engagement with a historical heritage (Weiss 2009: 44;)? The new mosque had innovative elements that set it apart from its Delhi prototype even beyond its distinctive size and siting.

Figure 3.6: Drawing of the Tajul-Masajid, Bhopal

Source: Sanderson (1913).

Gordon Sanderson, visiting on behalf of the Archaeological Survey of India, responded to the mosque very differently from Tillotson.

Its treatment is distinctly new. At either end are commodious *Zanana* [women's] chapels, while the *Zanana* gallery and the mezzanine floor at each end of the mosque...are also novel features. There is a boldness of treatment about the *chattri* [cupola]....[The building] is an eloquent testimony to the fact that the old Indian builders have not lost their skill.... (Sanderson 1913: 11)

The dedicated spaces for women (as shown below, one of the two galleries, running front to back), like the distinctive space for women in the Idgah,[4] were unprecedented in India given customary encouragement to women to pray congregationally only within domestic spaces (Figure 3.7). In creating these spaces, Shah Jahan Begum followed the reformist teachings of the emerging Ahl-i Hadith reformers (her justification as well for her controversial remarriage as a widow).

Figure 3.7: Tajul Masajid: One of the two wings designed for women's worship, currently unused

Source: Photograph courtesy of Hannah Archambault.

For her own residence, Shah Jahan Begum's choice of name turned to Emperor Shah Jahan's—and India's—most famous building, the Taj Mahal, a tribute to the emperor's love of his empress. The monumentality of the palace is particularly striking. Its style recalls the eclecticism of the city's other palaces with their liberal use of

tiers of arches, grand cusped entryways, balustrades, and domed chhatris as well as great tanks of water (Figure 3.8).

Figure 3.8: Entrance to the Taj Mahal Palace

Source: Photograph courtesy of Hannah Archambault.

Sobti also points out that by this period many buildings in Bhopal included Victorian features, represented, for example, in frescoes as well as furnishings. The following is a description of the Taj Mahal's imaginative interior by Sultan Jahan Begum, Shah Jahan's daughter:

> The frescoed gateways of the Taj Mahal Palace are so wide and spacious that a four-in-hand could be easily driven about within its portico. There are hundreds of rooms in this palace. Every room was differently coloured, and artistically furnished in colours to match. The carpets, chandeliers, chairs and sofas, divans together with their coverings, even the punkhas and the curtains, were of the same colour as the ceiling and the walls of their respective rooms. Each door was painted the color of the theme of the room behind. (Sultan Jahan Begum 1926: 262–63)

With vivid accounts of processions, viceregal visits, extravagant entertainments for life cycle events, and such amusements as rose-themed events in one of the many luxuriant gardens, Sultan Jahan makes Shah Jahan's buildings and gardens come alive. The lavish opening ceremonies to complete the building of the Taj Mahal Palace

lasted a full two years. The gardens and pavilions, some specifically for the rainy season, many located to the north of the two lakes beyond the new railway, were typically laid out in the classic *chahar bagh* pattern of four quadrants (Sultan Jahan Begum 1918: 80–83). Unlike her predecessors, historian and family descendant Shaharyar Khan writes, Shah Jahan was "vivacious and enjoyed the good life," "enjoyed being courted by princes and nobles," and added "colour, gaiety and panache to the somewhat austere landscape that the earlier rulers had painted in Bhopal" (Khan 2000: 152–53).

In 1877, Shah Jahan also established the first Public Works Department and undertook a vigorous program of building roads, digging wells, and establishing camping grounds. She built a jail, schools, hospitals, railroad lines and stations as part of the Great Indian Peninsular Railway, which reached the city in 1890, along with the mosques, administrative buildings, and palaces noted above.

Beyond the Mughal Revival and the late Mughal eclectic, Shah Jahan utilized a third style, which can be described simply as unadorned, utilitarian colonial. These buildings would be interchangeable with counterparts anywhere in colonial India and seem characteristic of the buildings that marked Bhopal's modernity and its inclusion in the British colonial world (Figure 3.9). These include the railway station, the ladies' hospital, and the Lal Kothi. This last, located in the cantonment, appears as a straightforward bungalow, but it was apparently quite grand, used for entertaining the highest colonial officials from political agents to viceroys.

It is striking that none of Shah Jahan's buildings utilize the style known as "Indo-Saracenic," the pastiche colonial architectural choice used, above all, as façade for buildings of this sort—railway stations, court houses, post offices, modern schools, and so forth. Meant to combine the putative "religious" styles of Hindu and Muslim, and thus to celebrate the colonial ability assert mastery of India's past, it was a claim by the British for their own cultural legitimacy and harmony with the past (Metcalf 1989). The style was embraced by some princely states, like Rajput Bikaner and Maratha Baroda who both hired British architects, but Shah

Figure 3.9: Waiting for the arrival of the first train at Bhopal Railway Station

Source: http://lunaticbloggers.blogspot.com/2011/07/bhopal-beats-life-of-old-times.html
(accessed January 14, 2012).

Jahan Begum, in contrast, preferred Mughal models for her most important buildings and evinced less stylistic concern for many of these others.

Sobti writes of Bhopal city as a whole:

> A visitor to the city during the time of Shah Jahan would have found the city an incredible and a stunning experience....one would have seen the town nestled among the low range of hills; an irregular mass of large and small buildings, rising tier upon tier and interspersed with lush gardens full of big and shady trees.... The beautiful skyline of the city was a composition of mass and void; the graceful minarets of hundreds of mosques could be seen.... The elaborate parapets of the palaces and *havelis* indicated the location of the houses of the nobility... a private world of luxury, riches and enjoyment.... (Sobti 1993: 27–28)

The state gazetteer of 1908 further notes multiple neighborhoods, across the three main sections of the city, each typically dominated

by specific trades, ethnicities, or families, whose mediating elites anchored them to the larger urban environment (ibid.: 32).

Sobti's greatest admiration is for the new suburb of Shahjahanabad. Even as he places it in the category of "Islamic city"—as he did Qudsiyya's city—in his final judgment, however, what he stresses is Shahjahanabad's originality. Its layout, he writes, "represented an absolutely new schema in the city," namely its use of landscape "with few precedents in the Islamic world" (Sobti 2000: 53). The buildings and large water bodies, created out of depressions in the rocks at three levels, were connected by plinths and platforms to the various buildings. Dams and embankments contained the water and offered roads and pavilions, outlined in intricate cast-iron railings. The highest pool was surrounded by the most important buildings, the Tajul Masajid, the Taj Mahal Palace, and the Benazir Palace, structures that embodied Begum Shah Jahan's assertions of power and putative imperial heritage.

Buildings like these served many purposes, as did perhaps her single most unusual project, the first purpose-built mosque in England, which to the present bears her name, the Shah Jahan Mosque at Woking in Surrey. Figure 3.10 gives the drawing for its design produced by its architect, W.I. Chambers in 1889. The mosque was a project of the great Hungarian orientalist, Dr Gottlieb Wilhelm Leitner, who was principal of Government College Lahore and active in a range of educational activities in Punjab in the 1860s and 1870s before retiring to England where he founded an Oriental Institute. Attached to the mosque, it was intended to promote the study of "Oriental" religions, languages, and cultures. The institute was primarily directed toward Europeans but open with permission to Muslims of "good background" and "high-caste Hindus." The mosque was tiny, only 16 feet by 16 feet; it almost seems to have been an orientalist decoration, like gazebos and waterworks of the time, adorning the institute. The mosque, Leitner declared, however, "is proof of a British toleration and must be used in that grateful and reverential manner" (Ansari 2002: 7). As someone eager to interact with colonial officials, and drawn to a European so evidently

Figure 3.10: Woking Mosque architect's drawing, 1889

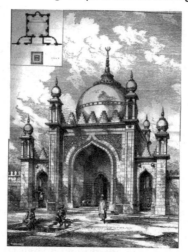

Note: The drawing was published in *The Building News and Engineering Journal,* 2 August 1889, shortly before the mosque was completed.

Source: With the kind permission Dr Zahid Aziz.

sympathetic to Islam, Shah Jahan financed a project she presumably imagined would represent Islam positively in the metropole and ally her with Europeans who could be expected to support her interests.

Neither late Mughal, nor Mughal Revival, or colonial utilitarian, in the words of the art historian Mark Crinson, it could be seen as a variation of Indo-Saracenic:

> [The mosque appropriates] forms from the Mughal architecture of India; among them, an onion dome, ogee-shaped niches and a number of decorative motifs.... The sources that authorize these forms are the Badshahi Mosque in Lahore and the Taj Mahal.... [to which are seemingly added] a number of details from Egyptian Mamluk architecture...and these details offer another kind of authority, that of the Western architect who sifts through the archive and recombines his findings to new effect.... The Shah Jahan Mosque presents a studied synopsis or distillate of knowledge about some object imagined as utterly other and, it will be contended,

> its appearance of respect or sympathy for this cultural otherness
> is part of the management of consent essential to the dynamics of
> hegemonic power. (Crinson 2002: 81–82)

It is unclear what influence, if any, Shah Jahan had on the mosques
design, but she might well have thought the underlying mentality
described by Crinson was fine in the British setting, given her
commitment to a mutually supportive relationship with the evidently
more powerful Raj. The mosque in due course was taken over by
an active Muslim proselytizing sect, the forms "reclaimed by the
ostensible objects of discourse" (ibid.: 84). It is today an important
symbol of the Muslim presence in Britain (Ansari 2002: 7).

Is the building program of the Bhopal rulers, then, in some
sense "Islamic?" Giles Tillotson, as noted above, described Qudsiyya
Begum's Jami Masjid as "late Mughal" and the two later mosques,
the Moti Masjid and the Tajul Masajid, "atavistic" or "archaeological"
"Mughal." He nonetheless prefers to make his main analytic category
for Shah Jahan's buildings "Islamic architecture." Writing of the Tajul
Masajid, he writes, "As a mosque, designed in a Mughal style by a
Muslim architect for a Muslim patron, [it] qualifies in every sense
as "Islamic architecture" (Tillotson 2006: 394). But having said
that, he ranks it as inferior "Islamic." The buildings that best merit
attention as late nineteenth-century "Islamic" architecture in India,
he argues, are the ones in Gwalior, especially the Victoria College and
the Maharaja's Museum. Designed, as he delightedly points out, by a
British architect working for a Hindu patron, he nonetheless ranks
them—rather than Shah Jahan's buildings or, his other case study,
the buildings of a third state whose ruler was of Muslim background,
Junagadh—as the best "Islamic architecture" of the period on the
grounds of "their inventive use of a recognizably Islamic heritage"
(ibid.: 97). His criterion for the designation is pure style, a style
claiming to characterize a singular "Islamic."

To call Gwalior's European-style college or museum "Islamic"
seems misplaced. The term "Islamic" properly describes function—a
mosque as a site for Islamic ritual practice, after all, is Islamic. Or the

term can be used to specify some dimension of process related to a goal in building or site, like property law or other requirements derived from sacred Islamic texts. Terms to describe a building style need to be more precise, as they are for European architecture where multiple rubrics identify specific regional, dynastic, and/or aesthetic criteria. Appropriate terms for the buildings of the nineteenth-century Bhopal rulers might include "Mughal," "late Mughal," "Orientalist," "Indo-Saracenic," or, as I suggest, "Mughal Revival." The term "Islamic" should tell us nothing about style; for that we need more specific categories. As for the term "Islamic city," it seemingly sets up models only to show their limits. The unreflexive use of the label "Islamic"—even if not in Tillotson's idiosyncratic judgment on Gwalior—often contributes to enshrining key stereotypes about Muslims, not least that whatever Muslims do can be explained by "Islam" instead of assuming that Muslims, like everyone else, are motivated by a wide range of motives—personal, psychological, lofty, mundane, pragmatic—and, in relation to objects, particularly— aesthetic or functional.

As for colonial Bhopal, any analysis of its architecture requires attention to the city's topography and its own historic patterns of city layout and building patterns. Its patrons and builders were shaped by aspects of Pathan, French, and English taste, all current at the time. The colonial era introduced new sanitation, security, and aesthetic concerns. Its princely rulers were ambitious for their own reputations and experimented, for a time, with presenting themselves as Mughal heirs. Shah Jahan Begum additionally favored what she took to be Islamic requirements in structures associated with ritual, whether in including dedicated spaces for women to pray in public or in designing tombs with uncovered graves, as shown here in the tomb she built for her second husband (Figure 3.11).

All these considerations by the end of the nineteenth century together gave the city a distinctive shape, and made it, as every observer noted, a remarkable and beautiful place. To measure its layout and architecture on a gradient of "Islamic" or not fails utterly to do it or its builders the justice they surely merit.

Figure 3.11: The tomb of Nawab Siddiq Hasan Khan (d. 1890), with vegetation growing from the site of interment within the larger structure

Source: Author's photograph.

NOTES

1. In British India, the Afghan ethnic group or tribe "Pashtun" was termed "Pathan."
2. For a detailed and engaging account of the four women rulers, see Khan (2000), and for an excellent study of the career of the fourth Begum, see Hurley-Lambert (2007). The latter book also includes an introductory chapter on the earlier period covered here.
3. See Abu-Lughod (1987) for a critique of the category.
4. My only evidence of how space for women was defined in the Idgah comes from conversation with local women in February 2010. They showed me where a row of trees and foliage had run front to back, recently removed, apparently to accommodate the press of male worshippers.

REFERENCES

Abu-Lughod, Janet L. 1987. "The Islamic City—Historic Myth, Islamic Essence and Contemporary Relevance," *International Journal of Middle East Studies,* 19(2): 155–76.

Ansari, K.H. 2002. "The Woking Mosque: A Case Study of Muslim Engagement with British Society since 1889," *Immigrants and Minorities,* 21: 1–24.

Crinson, Mark. 2002. "The Mosque and the Metropole," in *Orientalism's Interlocutors: Painting, Architecture, Photography,* pp. 79–102 (Durham: Duke University Press).

Denny, Walter B. 2011. "The Met Resets a Gem," *Saudi Aramco World,* 62(6): 36–43.

Hurley-Lambert, Siobhan. 2007. *Muslim Women, Reform and Princely Patronage: Nawab Sultan Jahan Begam of Bhopal* (London and New York: Routledge).

Husain, Zakir. 2002. "The Rise of Dost Muhammad Khan (1708–28), The First Nawab of Bhopal," *Proceedings of the Indian History Congress* (62nd Session, Bhopal, 2001), Kolkata.

Khan, Shahriyar M. 2000. *The Begums of Bhopal: A Dynasty of Women Rulers in Raj India* (London: I. B. Tauris).

Metcalf, Thomas R. 1989. *An Imperial Vision: Indian Architecture and Britain's Raj* (Berkeley: University of California Press).

Metcalf, Barbara Daly. 2011. Presidential Address: "Islam and Power in

Colonial India: The Making and Unmaking of a Muslim Princess," *American Historical Review*, 116(1): 1–30.

Preckel, Claudia. 2000. *The Begums of Bhopal* (New Delhi: Roli Books).

Rousselet, Louis. 1876. *India and its Native Princes: Travels in Central India and in the Presidencies of Bombay and Bengal.* Carefully revised and edited by Lieut.-Col. Buckle (New York: Scribner, Armstrong, and Co.).

Ruggles, D. Fairchild. 2008. *Islamic Gardens and Landscapes* (Philadelphia: University of Pennsylvania Press).

Sanderson, Gordon. 1913. *Types of Modern Indian Buildings at Delhi, Agra, Allahabad, Lucknow, Ajmer, Bhopal, Bikanir, Gwalior, Jaipur, Jodhpur and Udaipur with Notes on the Craftsmen Employed on their Design and Execution.* Published under the authority of the Archaeological Survey of India (Allahabad: Government Press).

Sinha, Gayatri. 2006. "Women Artists in India: Practice and Patronage," in Deborah Cherry and Janice Helland (eds), *Local/Global: Women Artists in the Nineteenth Century*, pp. 59–66 (Aldershot: Ashgate Publishing Limited).

Sobti, Manu P. 1993. *Urban Form and Space in the Islamic City: A Study of Morphology and Formal Structures in the City of Bhopal, Central India* (Ahmedabad: School of Architecture, Centre for Environmental Planning and Technology).

Sultan Jahan Begum. 1918. *Hayat-i-Qudsi: Life of the Nawab Gauhar Begum alias the Nawab Begum Qudsia of Bhopal.* trans. W.S. Davis, Political Agent in Bhopal (New York: E.P. Dutton & Co.).

———. 1926. *Hayat-i-ShahJehani: Life of Her Highness the Late Nawab ShaJehan Begum of Bhopal* (Bombay: The Times Press).

Tillotson, Giles. 2006. "Architecture and Identity in Three Indian States," in Doris Behrens-Abouseif and Stephen Vernoit (eds), *Islamic Art in the 19th Century: Tradition, Innovation, and Eclecticism*, pp. 387–408 (Leiden: Brill).

Varma, Supriya and Jaya Menon. 2008. "Archaeology and the Construction of Identities in Medieval North India," *Studies in History*, 24(2), n.s.: 173–93.

Wagoner, Philip. 1996. "Sultan among Hindu Kings: Dress, Titles, and the Islamicization of Hindu Culture at Vijayanagara," *Journal of Asian Studies*, 55(4): 851–80.

Weiss, Julie. 2009. "Classroom Guide," *Aramco World Magazine*, July/August, p. 44.

4 | Memorial Parks to Begum Hazrat Mahal and Mayawati in Lucknow

Cultural Landscape and Political Ideologies

Amita Sinha

Nineteenth-century Lucknow has been well captured in both photographs and paintings of not only its eclectic architecture and pastoral scenes of the Gomti riverfront but also in the portraits of the Nawabs and the Europeans who befriended them. However, missing in this array of images are visual representations of the women of the ruling family. The question "Where are the women in Islamic art?" prompts me to look for them not only in period portraiture but also in the ways that women significant in Lucknow's history are remembered a century and half later in public memorials (Ruggles 2000).

Although the public spaces of Lucknow are commemorative in their profuse use of statuary and memorial plaques, there is no such space from the Nawabi period. Consequently, there is little public memorialization of the rulers from that period, 1722–1856. However, portraits of all the Nawabs hang in the Hussainabad Art Gallery and the state museum has a small wing dedicated to Nawabi art (Llewellyn-Jones 2008). When I visited the Residency Memorial in 2005, it had recently been refurbished to commemorate 150 years of the Indian Mutiny, more popularly known as the "Uprising" or the "First War of Independence" (Figure 4.1). In the collection of male figures on display in the Residency Museum, the recently painted

portrait of Lucknow's last Nawabi ruler and early champion of the independence movement stands out (Figure 4.2). Reputed to be the only portrait of Begum Hazrat Mahal (d. 1879) in existence, it occupied pride of place on the wall. Why are there not more portraits of her? Why is it that she is not to be seen even in the city's central park, which bears her name? While mimetic representation of women is rare in Islam (occurring primarily in the book arts which were intended for private viewing), Mazrat Mahal belonged to a

Figure 4.1: Residency Museum

Source: Author's photograph.

Figure 4.2: Portrait of Begum Hazrat Mahal in Residency Museum

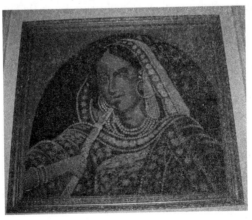

Source: Author's photograph.

larger society that did not refrain from such representation and she had become a revered public figure who, one would expect, would attract the honor of commemoration. How do we reconcile this particular absence with the profuse iconographic imagery prevalent in the larger Indian visual culture? To answer this, we must first ask why it is so important that Hazrat Mahal be memorialized in this fashion in Lucknow's public landscape.

BEGUM HAZRAT MAHAL

Although there is no full-length biography of Begum Hazrat Mahal, her legacy to Lucknow is amply chronicled in Mutiny accounts by the British and numerous articles and books written by Indian authors (Santha 1980). Her rise to power may be attributed to the unique set of historical circumstances in 1856–58 during which the fall of the House of Avadh and the departure of the last Nawab, Wajid Ali Shah, created a vacuum in leadership and a politically volatile situation. Ruggles has described six categories of empowerment for women in Islamic societies: financial independence, sons, natal family, celibacy, education, and voice (Ruggles 2000). Of these, having a son, the heir to the kingdom, positioned the mother as the regent and wielder of power in the harem and royal court. This was the route to power for Hazrat Mahal, whose twelve-year-old son, Birjis Qadar, was put on the throne of Avadh in the momentous weeks following the uprising of sepoys in the Marion Cantonment on May 1857. As the queen mother and regent she was the de facto ruler, but since these were no ordinary times, the call to leadership went far beyond the skills needed to govern a pliant court.

Chroniclers of her life agree on her lowly origins, some even calling her a dancing girl procured for Nawab Wajid Ali Shah and ensconced as a concubine in his Parikhana at Kaiserbagh Palace. He called her his "Mahak Pari" and gave her the title of "Hazrat Mahal" when he ascended the throne in 1848. Although she bore him a son, she did not accompany him in his exile to Matiya Burj in 1856 and neither did they correspond after his departure. Rapidly unfolding

events during the following year thrust her in a role that grew larger as the months passed. When the British East India Company annexed the state in 1856, disgruntled *taluqdars*, zamindars, and sepoys were looking for a figurehead to rally around which they found in Birjis Qadar and his mother, Hazrat Mahal.[1] In extremis, the extraordinary Hazrat Mahal demonstrated an innate leadership that nobody could have suspected she possessed. She governed over a hastily set up administrative structure, coordinated the different factions and smoothed over the developing fissures among them, and sold her personal jewels to pay the sepoys when the treasury became bankrupt. She broke from the practice of purdah (veiled seclusion) and often appeared on an elephant in Alam Bagh and Musa Bagh to exhort the demoralized sepoys. Not only was her very right to govern challenged by the British, who questioned her son's legitimacy, she also had to contend with the lack of cooperation by the rival leader Maulvi Ahmadullah Shah who was emerging as a contrary force.

Although there is no documentation of her early life and of her time as one of the many wives of Wajid Ali Shah, she suddenly enters into the pages of history in 1857 with her actions and words amply recorded for posterity. Her voice is heard in her proclamations to the public, her directives to the hastily reconstituted Avadh court and ministers, and missives to the taluqdars (Nayar 2007: 176–77; Taylor 1993: 213–24). We follow her movement within the city as she leaves the royal quarters of Kaiserbagh behind, arrives in a procession to the coronation of her son, visits the troops as they prepare for battle, and her final days and departure from Lucknow when the British defeat the Indian forces and begin looting. We can trace her retreat through the principalities of Avadh and her attempts to recoup forces and marshal support in the year that followed until she finds a haven in Nepal (Naaheed 2005). We hear the conciliatory and admonishing notes in her voice as she pleads for cooperation among warring factions and exhorts the troops to swing into action. Her counter-proclamation issued in response to one by Queen Victoria in November 1858 is masterful in its defiance, in its

questioning of British promises of amnesty, and its assessment of the causes of war. She questions the British right to govern a land that was not theirs and condemns the disruption of Islamic and Hindu religious mores caused by their rule.

Her unflinching strength in the face of opposition, her stubborn refusal to accept the conditions offered by the British and surrender, and her personal courage in the face of mounting adversity when in retreat, are heroic by any standards. Pride, fortitude, courage— qualities she seemed to possess in abundance—aided her quest to claim independence for Avadh from the British at a critical juncture in its history. Social and political upheavals during the Uprising paved the way for a *purdanashin* (one who practices purdah) lady to find a public voice and claim leadership but the vision and ability to execute it was uniquely Hazrat Mahal's.

Hazrat Mahal's legacy to Lucknow (and Avadh) is monumental, and yet there are no monuments to her in the city with the sole exception of Begum Hazrat Mahal Park that ironically contains the memorial to Queen Victoria, her nemesis (Figure 4.3). It was dedicated to her in 1972, almost a hundred years after her death.

Figure 4.3: Victoria Memorial in Begum Hazrat Mahal Park

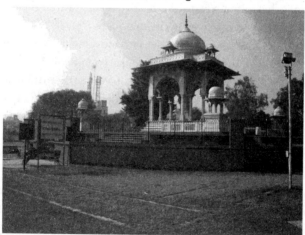

Source: Author's photograph.

Although previously used as grounds for political rallies, it is now a gated pleasure park with tall fountains and an entry fee. I was told that a proposal to install Hazrat Mahal's statue was abandoned in face of opposition from her descendants. Although the iconic Begum's position in the annals of history is assured, the city she ruled has sadly failed to find a way to publicly and visibly honor her.

Hazrat Mahal's patronage of the arts in Lucknow is not well documented. She was responsible for building fortified ramparts around Lucknow in 1857. In Kathmandu, Nepal, where she lived for two decades after her departure from Avadh, she built a mosque (that is no longer standing) and was buried in its premises. Other Nawabi begums who had an independent source of income were builders of *imambaras* with mosques within them.[2] The well known ones are Moghul Sahiba, Mallika Jamani, and Begum Sahibha (in the Residency) (Das 1991). A garden on the banks of the river Gomti was built by Nasir-ud-din Haidar and named after Vilayaiti Begum (Sinha 2009: 65–67). Khurshid Zaidi, wife of Saadat Ali Khan, was memorialized by her son Ghazi-ud-din Haidar in a mausoleum complex on the northern end of Kaiserbagh (Figure 4.4). *Imambaras* with mausoleums and mosques named after their begums preserve the memory of their patrons by virtue of association, although usually there is hardly any information available on the patroness except the dates of her birth and death.

Yet commemorative monuments have been erected to celebrate other Indian heroines. For example, every Indian child is aware of the other great Indian protagonist of the Mutiny drama, Rani Lakshmi Bai, in part because of her famous statue, riding a horse, with the sword in her upraised arm, her tiny son strapped to her back, as she bravely fights the British. Visual culture plays a significant part in the act of commemoration in India not only by capturing the likeness of a historical person through engraving, painting, and other visual displays but also by making these representations the focus of anniversary rituals. Commemoration, or celebration of memory, thus becomes a collective ongoing reenactment of the greatness of the leader in the public realm. Post-independence rulers of India

Figure 4.4: Mausoleum of Khurshidzadi

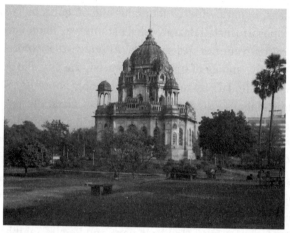

Source: Author's photograph.

have exploited this to great political advantage, as the following case of the politician Mayawati demonstrates.

Mayawati

No other leader has so consistently and vociferously promoted her legacy through an aggressive program of statue and monument building than Mayawati in Lucknow. Like her administrative measures, her impressive building record is controversial, often making headlines in the media and causing public outrage. She has been compared to Muhammad bin Tughluq in her ambitious ventures by her detractors. As the leader of the Bahujan Samaj Party (BSP), she was first elected to power in 1995 and immediately began her building campaign, pursuing it relentlessly every time she came into power (1997, 2002, 2007). A teacher by profession, she joined politics in 1984 after meeting Kanshi Ram, founder of the BSP, representing Dalits (oppressed people belonging to the untouchable castes) and other lower backward castes. The party's strongest base is in Uttar Pradesh, where Mayawati was raised, where Chamars

(leather workers) form a substantial minority of Other Backward Castes (OBCs) and to which Mayawati belongs. The backward castes have found a voice and a platform in the BSP, and through their substantial vote have an opportunity to overturn centuries of exploitation and repression by the higher castes. Mayawati and BSP were voted out of power in March 2012.

A populist by temperament and political exigency, Mayawati has not hesitated to use every ploy available to promote her party's ideological rhetoric. Projecting herself and the BSP as instruments of social change in the caste-ridden structure of Indian polity, she has pushed for rural development through Ambedkar village schemes, accessibility to higher education through Ambedkar universities and colleges, schemes for women in education, and domestic violence prevention.[3] The degree to which these programs have been successful has been questioned but what is manifest is her effort to inject into the urban space of Lucknow a memorial culture celebrating the successes of social reformers, including her own political party, in improving the condition of Dalits.

The very visible monumental projects in Lucknow include the plazas Parivartan Chowk and Samtamulak Chauraha; and the memorial complexes Prerna Kendra, Kanshi Ram Smriti Vihar, Kanshi Ram Smarak Sthal and Green (Eco) Garden, Buddha Vihar Shanti Upavan, Bhimrao Ambedkar Samajik Parivartan Sthal, and Ramabai Ambedkar Maidan. They are all commemorative spaces, celebrating the leadership of the BSP, Bhimrao Ambedkar, his wife Ramabai Ambedkar, other historical figures that the BSP regards as champions of the Dalits, and important social reformers of the nineteenth century. This is done through an ambitious iconographic program of paintings, etchings, and statuary, including narrative genres of the popular art kind, as well as the bronze statuary evocative of the persona and the ideological rhetoric s/he embodies.

Mayawati's memorials extend into the main crossroads (*chauraha*) of the city and symbolically appropriate them through statuary in giant plazas. Parivartan Chowk, north of Kaiserbagh and east of Begum Hazrat Mahal Park, an urban insertion by Mayawati in

1995, received negative publicity since it did not fit in the Kaiserbagh
Heritage District. A rather ugly tall vertical structure holding a globe
at its summit and sheltering a seated statue of the Buddha marks the
center of a huge plaza that acts as a traffic roundabout in the heart
of Lucknow (Figure 4.5). Statues of Ambedkar, Phule, Shahuji, and
Periyar with inscriptions on pedestals mark the cardinal points in
the circular plaza where a number of streets converge. This location
not only ensures high visibility and landmark status but also marks
the arrival of socio-political change (new BSP leadership) in a
historic area of the Nawabi and colonial times. Bhimrao Ambedkar
Chauraha announces entry to the gateway (*swagat dvar*) on VIP
Road linking the airport with the city. Samtamulak Chauraha at the
convergence of five streets is an ensemble of statues of BSP leaders,
a symbolic threshold to the kilometer-long spine (part of it a bridge
over the River Gomti) punctuated by imposing, handsome gateways,
leading to Ambedkar Sthal. The highly visible statue plazas afford
panoramic vistas into the urban landscape of converging streets,
and offer points of potential control. More importantly, they assert
the symbolic presence and gaze of BSP leaders at the major nodes
of the city.

Figure 4.5: Parivartan Chowk

Source: Author's photograph.

The location of memorial parks on the outskirts of the growing city ensures availability of vast land acreage and prominent locations along the major urban arteries—Buddha Vihar and Kanshiram Smarak on VIP/Airport Road, leading to Cantonment and Civil Lines, Ramabai Ambedkar Maidan on Ring Road that encircles the city and connects with the state highways, and Ambedkar Sthal on the banks of the River Gomti on the southeast margin of expanding Lucknow. The large cone of visibility from the major traffic arteries ensured by the absence of high-rise development around the parks means that the building domes dominate the skyline and command attention over long distances. Their dominant verticality denotes symbolic power as do the long horizontal stretches of Buddhist-style railings enclosing vast precincts where no other land use is allowed. Their location, size and imageability give them landmark status within the city.

Enfilade or the linear structure of space, as in a sequential arrangement of spatial segments, offers a high level of control over movement and social interaction. Power as discerned in the degree of accessibility is supported by enfilade of rooms in buildings and in nested urban precincts. Enfilade is employed deliberately in forecourts in Ambedkar Udyan, Prerna Kendra, Buddha Vihar, and Ramabai Ambedkar Maidan. A series of gateways control access to the inner court of Ambedkar Udyan, Kanshiram Smarak Sthal, and Buddha Vihar, entry to which is only possible by purchasing a Rs 10 ticket. The lack of pedestrian access to memorial precincts from streets with heavy, fast-moving traffic creates a moat like effect upon crossing, and a series of enclosures need to be penetrated before the memorial building can be entered.

Extra-human scale is created spatially and formally through building structures and elements. On the large sites—Ambedkar Sthal (107 acres), Kanshi Ram Smarak Sthal (86 acres), Eco-Garden (112 acres), Ramabai Ambedkar Maidan (50 acres), Buddha Vihar (32.5 acres)—are built huge rectangular and long linear plazas, oval and square greens, and a radiating amphitheater. In the vast spatial expanses, there is no enclosure except that afforded by a few

buildings, separated by large distances. The proximate senses—
tactile, olfactory, and haptic—are not stimulated, and vision is the
dominant sense in experiencing the physical environment. The
eye travels far along visual axes established by linear elements—
columns and rows of elephants (Figure 4.6). The long vistas to
buildings and other focal points are impressive in their command
of physical space and the sense of power that is communicated in
gazing at this landscape.

Figure 4.6: Elephant statues in Ambedkar Samajik Parivartan Sthal

Source: Author's photograph.

The extra-human scale is employed in buildings as well. The domes
soar—for example, the height of Kanshi Ram Smarak building dome
is 177' and is said to be one of the world's largest (Figure 4.7). The
building plinth is high making one climb up to the soaring interiors.
The tall bronze fountains (30' to 52'), 18'-high marble and bronze
statues, high gateways and boundary walls, massive elephants, the
71'-high *stambh* (column) in Ambedkar Sthal, the larger-than-life
animals in Eco-Garden, all dwarf the individual and reinforce the
extra-human scale of the buildings. With the exception of a few
palms, there are few trees to bring down the scale or give enclosure.
The building textures and the paving patterns in their large size do

Figure 4.7: Kanshi Ram Smarak dome

Source: Author's photograph.

not relate to the human body. The consistent use of extra-human scale in space and building elements results in diminishing the sense of physical self, making the physical environment appear dominant and powerful.

Mayawati's memorial buildings in Lucknow appear to be unique in postcolonial India where memorialization of national leaders has largely occurred using the medium of landscape design, not architecture. Indeed the closest parallel seems to be Victoria Memorial in colonial India in terms of monumental grandeur and iconography that created a past for the British Raj (Metcalf 1989). Ambedkar Sthal is an example of counter modernism and resurfacing of the ancient in Indian architecture since the 1990s (Mehrotra 2011). Ambedkar's rejection of Hinduism's exploitative and hierarchical caste structure and his conversion to Buddhism is the *raison d'etre* for the Buddhist architecture revival in BSP buildings. The neo-Buddhist style is very evident in Sanchi-stupa-inspired domes, boundary walls as Buddhist railings, *chaitya* window relief pattern on walls, free-standing square pavilions, and the Ashokan pillar (Figure 4.8).

The adoption of the Buddhist mantle comes via New Delhi where Edward Lutyens and Herbert Baker used a neoclassical imperial style

Figure 4.8: Ambedkar Samajik Parivartan Sthal

Source: Author's photograph.

of architecture to legitimize the soon to be waning British Empire. The dome of Rashtrapati Bhavan designed by Lutyens, double height façade of Baker's Secretariat buildings, upturned saucers, fountains, and flat sheets of water in tanks have been unambiguously copied in Ambedkar Sthal, Kanshi Ram Smarak Sthal, and Buddha Vihar. The difference between architecture of imperial Delhi and memorial architecture in postcolonial Lucknow lies in its programmatic function—the former houses government institutions and is literally the seat of legislative and executive power while the latter's sole function is revival/rebuilding of collective memory. Buddhist and imperial architectural elements imbue the memorial buildings in Lucknow with borrowed associations of sacred and political power from India's ancient and recent history thereby legitimizing the empowerment of Dalit community in the public sphere.

The term *sthal* and the deification of historic and contemporary figures suggest a sacred site and this is what Mayawati declares the Ambedkar Sthal to be—a place of pilgrimage. Three places associated with Ambedkar—Janmabhoomi (birthplace) in Mhow

near Indore in Madhya Pradesh, Deekshabhoomi (where he converted to Buddhism) in Nagpur, and Chaityabhoomi (Samadhi) in Mumbai—are considered to be pilgrimage sites and are visited by people in large numbers (Tartakov 1990). Although Lucknow does not have those life cycle events associations, sacredness is sought to be created through iconography, architectural forms, urban design, and the celebration of Ambedkar Jayanti.

Mayawati's memorials have been described as "architecture of statues" (Mehrotra 2011). While buildings frame statues, in open spaces within the memorial parks and outside at the city crossroads, statues in plazas and lawns become nodes and termini, creating a system of visual and physical axes that structure urban space, and become focal points of vision and movement. The ensemble of four statues facing the four cardinal directions—of Buddha, Ambedkar, Kanshiram and Mayawati—gestures to the concept of *chakravartin*, the world-ruler, whose power radiates out to the horizon. The figures gaze out in an urban *mis-en-scene* that lends a theatrical touch to the urban spaces (Figure 4.9). The function of statues goes beyond embellishment of architecture and landscape, they

Figure 4.9: Buddha statue on Gomti riverfront

are meant for *darshan* and of felicitation rituals on anniversaries and other occasions. Statues of medieval saint poets—Kabirdas, Ravidas, Ghasidas—and of warriors—Birsa Munda—are very visible reminders of greatness achieved in the face of extreme adversity. This deification is deep-rooted in Indic culture and converging with the colonial tradition of erecting statues in parks and urban squares extends the sacred in *mahapurush* iconography into civic spaces.

Mayawati, however, celebrated not only social reformers and leaders of her party but her own personality cult as well. She justified the erection of her statue during her lifetime by claiming that her mentor Kanshi Ram wanted it (Figure 4.10). Etchings with vignettes of major events in her life (and that of Kanshi Ram and Ambedkar) are found in memorial interiors, supplementing the free standing statues in a rich visual archive. Does this imply an autocratic bent of mind or a shrewd grasp of how visual culture can be manipulated to garner support, win allegiance and thus votes in a populist democracy?

Figure 4.10: Mayawati statue in Buddha Vihar Shanti Upavan

Source: Author's photograph.

Mayawati did not personally invent the cult of Ambedkar statues that had begun appearing on the Indian landscape since the late 1980s, with the support of the BSP, and perhaps even earlier, with the rise in Dalit consciousness. The small stone statues, dressed in blue suit and red tie, holding the Indian constitution in one hand and the other raised as if pointing the way to the future, proliferate in villages, towns and cities, their folk art aspect reflective of a grassroots people's movement. About 15,000 are said to be installed in the last two decades. They are a visible symbol of Dalit empowerment, an assertion of their newly found identity in Indian society, achieved through education and political franchise (Jaoul 2006). Ambedkar, who from the lowly Mahar caste rose to become the writer of the Indian constitution that guaranteed equality to all its citizens in a democratic political structure, has become the iconic hero of the struggle and achievement for Dalits, and for members of other backward castes and political parties that draw their support from them (Jaffrelot 1998).

With the rise to power of the BSP and Mayawati in Uttar Pradesh, statue installations of Ambedkar and other social reformers not only received further impetus, but monumentalized it. The little statue in the small park has given way to an ensemble of bronze statues in large-scale urban spaces and lofty interiors in Lucknow, the state capital. This signals the transformation of what was formerly a community-based movement to a state-sponsored building enterprise with seemingly endless funds at its disposal. The insertion of statuary and its associated structures into elite urban spaces in the city—heritage districts, medium and upper-income housing colonies, and along the main arteries of transportation—marks their appropriation by the party and its ideological agenda.

Critics have predicted that the memorials and statutes will build an "imagined Dalit community," transcending religious, caste and linguistic differences. The arrival of Dalit presence in public spaces in the city from where they had been excluded for centuries is empowering, an "incentive for democratic mobilization," a "remarkable tool for the pedagogy of the oppressed," and a "focal

point for ceremonies that build grass roots mobilization skills."
Narayan describes the statues of Dalit local heroes, saints, social
reformers, Ambedkar and Buddha as creating a new visual and oral
sphere of memories that together with commemorative rituals are a
cultural resource for arousing a political consciousness among Dalits
(Narayan 2011). By reclaiming public spaces through Dalit symbols
and iconography, Mayawati is not only asserting Dalit identity but
also reconstructing collective memory, instilling pride in their past
and helping them gain self-respect.

The reconstruction of cultural memory by bringing the past
into the specious present requires not the typical historian's craft,
a dispassionate analysis of past events and historic personalities,
but the creation of a social milieu within which the glories of the
Mahapurush can be sung and the metaphorical return of the hero
can be re-enacted collectively. In this the built environment becomes
the catalyst for facilitating the specious present, providing the
vivid richness of the "here and now" in settings for iconography
that seeks to instruct and inspire through mimesis. The making
of subaltern memory (not history) of a shared glorious past and
its representation in elite urban spaces is a very visible act of
empowering the community that had been rendered voiceless and
made invisible through erasure from public spaces of urban and
rural India for centuries. Memorial parks as sites of memory—*lieux
de memoire*—reify Dalit power's capacity to imagine, construct and
inhabit a monumental space (Nora 1989).

Ambedkar Sthal and Prerna Kendra were begun during
Mayawati's third term and other memorials in her fourth term.
With the exception of Prerna Kendra and Kanshi Ram Smriti Vihar,
the others designed by Jay Kaktikar of Design Associates—a Noida
firm—are located at a distance from the city core on the road from
the airport and on the banks of the River Gomti where large empty
expanses of land were easy to acquire. The function of the memorials
varies from image gallery (Kanshi Ram Smarak, Prerna Kendra and
Ambedkar Sthal), museum (Ambedkar Sthal), library and Vihara
(Buddha Vihar), to rally grounds (Ramabai Ambedkar Maidan). Built

of expensive materials such as marble, sandstone, and granite, the structures are expected to last for a "thousand years" on "land banks" on the urban fringe precluding any other urban development. They are largely hardscape urban insertions on a gigantic scale and extend into the busy crossroads of the city. With a clever manipulation of symbols, Mayawati, in keeping with her persona, has succeeded in making defiant monumental gestures that have irrevocably altered the path of the city's growth pattern.

CONCLUSION

Many urban spaces in Lucknow are memorial sites either because they contain heritage structures or they are designated or designed as memorial parks and plazas with graves, obelisks, canopies, gateways, and statuary. Often well-designed markers of momentous events in urban history, they are reminders of contributions made by individuals toward the greater public good. While buildings, memorial tablets and plaques, and other building elements remind the public of the commemoration of historical events, the memorialization of great personages (whether dead or living) occurs exclusively through iconography. As we have seen, the latter domain is conspicuous by both the absence and presence of the two most important women in Lucknow's pre and postcolonial history, revealing the visual cultures that simultaneously inhabit the past and present of the city.

Sculpture was not a significant presence in the Indo-Islamic visual culture that is Lucknow's heritage, although many Nawabi buildings were embellished by mermaids and Grecian statues. Contemporary visual culture on the other hand draws heavily upon the older Hindu-Buddhist traditions of iconic representation, even as it continues the colonial practice of installing statues in public parks. Deification of the cult of the Mahapurush (great soul) finds expression in free-standing statues, narrative paintings and engravings and quotes inscribed on walls and other surfaces. To the ubiquitous pantheon of national figures of Gandhi, Nehru, and Bose, the BSP has added Ambedkar and other social reformers. Freedom fighters and political

figures of other parties are commemorated in the city's many parks. Lucknow has cultural icons as well—Lakshman (after whom the city is named) in Lakshman Park, the river goddess Gomti in Kudiya Ghat, Buddha in Buddha Park, and ancient Indian astronomers, physicians, and mathematicians in Suraj Kund (Sinha 2000).

The life-like representations lend the famous person's name a vivid image, in keeping with the dual significance of *nama* (name) and *rupa* (image) in Indic religious thought and philosophical discourse (Davis 1997). Some statues retain their commemorative power as the focus of commemorative events; others simply become bird perches, a forgotten presence as the traffic rushes around them. Together, these urban landmarks are part of the chaotic visual scene of giant billboards, hoardings, and posters in the dense streetscape of Lucknow. They stare over frolicking children, necking couples, and sleeping old men, lending a focus and name to their park. The mass installation of Ambedkar statues, however, heralds the arrival of new social realities in the political landscape of northern India. Here, the art of statuary is thus elevated over mere embellishment of space and commemoration of the great figure into signaling social change achieved not through revolutionary means but democratic electoral process and reservation policies in education and employment.

The urban landscape of Lucknow has evolved to reflect the ongoing social change and the city's aspirations toward the future. In the process, the past is left behind, forgotten in the accelerated rush toward modernity. This is often the case when the past is perceived as less than honorable, non-progressive, and having capitulated to outside forces. However the annals of the Uprising deserve a visual text in the civic space of the city. Presently, there is only one Mutiny mural in Deen Dayal Updhayaya Park on the outskirts of Lucknow. The Residency Memorial commemorates the British struggle and eventual victory, although the newly furbished basement gallery in the museum does supplement this with the Indian perspective. The historic gardens protected by the Archaeological Survey of India (ASI) where battles were fought—Sikandar Bagh, Musa Bagh, Alam

Bagh, Dilkusha, and Shahnajaf—are also memorial sites, but with the exception of Sikandar Bagh, there is no plaque to indicate that a momentous event took place there (Sinha 1996). In Sikandar Bagh is a bust of Udadevi Pasi, who was responsible for killing a number of British at that spot, but the ASI has yet to find an imaginative way to pay homage to the leader of the Indian forces, Begum Hazrat Mahal. The riverfront provides an opportunity to reclaim derelict space for civic purposes including memorials. The journey down the river could be an encounter with historic Lucknow; a memorial to Begum Hazrat Mahal would be a welcome addition to the sites one would visit to learn about its past.

ACKNOWLEDGEMENTS

I am grateful to J.P. Sinha and R.P. Sinha for helping me in my research on Lucknow parks. *Architecture+Design*, India, published a preliminary version of this essay titled "Public Spaces in Lucknow—The Influence of Power" in February 2009, vol. xxvi(2): 80–92.

NOTES

1. Taluqdars were landholders who collected revenues from their large estates and possessed the status of minor royalty. Zamindars also collected revenue although their landholdings were smaller. See Llewellyn-Jones (2007).

2. The word imambara means "place of Imam." In Lucknow, imambaras are grand, monumental buildings built during the Nawabi period where mourning assemblies are held during the Muharram.

3. Bhimrao Ramji Ambedkar (1891–1956) was a highly educated scholar and political leader who achieved renown as one of the most effective and articulate defenders of the cause of the Mahar caste (the untouchables), to which he belonged. He adamantly rejected the caste system, and with it Hindusim, and converted to Buddhism. See Jaffrelot (2005).

REFERENCES

Das, Neeta. 1991. *The Architecture of Imambaras* (Lucknow: Lucknow Mahotsav Patrika Samiti).

Davis, Richard. 1997. *Lives of Indian Images* (Princeton, New Jersey: Princeton University Press).

Jaffrelot, Christophe. 1998. "The Bahujan Samaj Party in North India: No Longer Just a Dalit Party?" *Comparative Studies of South Asia, Africa and the Middle East*, 18(1): 35-52.

——. 2005. *Dr. Ambedkar and Untouchability: Fighting the Indian Caste System* (New York: Columbia University Press).

Jaoul, Nicholas. 2006. "Learning the Use of Symbolic Means: Dalits, Ambedkar Statues and the State in Uttar Pradesh," *Contributions to Indian Sociology*, 40(2): 175-207.

Llewellyn-Jones, Rosie. 2007. The *Great Uprising in India, 1857–58: Untold Stories, Indian and British* (Woodbridge, Suffolk: The Boydell Press).

——. 2008. "Portraits of the Nawabs: Images from the Lucknow Court 1775-1856," *Marg*, 59(4): 26-39.

Mehrotra, Rahul. 2011. *Architecture in India since 1990* (Mumbai: Pictor).

Metcalf, Thomas. 1989. *An Imperial Vision: Indian Architecture and Britain's Raj* (Berkeley: University of California Press).

Naaheed, Nusrat. 2005. *Jane Alam Aur Mehak Pari*, translated by J. Bhattii (Lucknow: Library Helpage Society).

Narayan, Badri. 2011. *The Making of the Dalit Public in North India, Uttar Pradesh, 1950-present* (New Delhi: Oxford University Press).

Nayar, Pramod. 2007. *The Great Uprising: India, 1857* (New Delhi: Penguin Books).

Nora, Pierre. 1989. "Between Memory and History: Les Lieux de Memoire", *Representations*, 26: 7–24.

Ruggles, D. Fairchild. 2000. "Vision and Power: An Introduction," in D. Fairchild Ruggles (ed.) *Women, Patronage, and Self-Representation in Islamic Societies*, pp. 1–16 (Albany: State University of New York Press).

Santha, K.S. 1980. *Begums of Awadh* (Varanasi: Bharati Prakashan).

Sinha, Amita. 1996. "Decadence, Mourning and Revolution - Facets of Nineteenth Century Landscape of Lucknow, India," *Landscape Research*, 2 (Spring):123–36.

———. 2009. "Greener (past)ures," *Indian Architect & Builder*, 22(9): 65–67.

———. 2010. "Colonial and Post-colonial Memorial Parks in Lucknow, India: Shifting Ideologies and Changing Aesthetics," *Journal of Landscape Architecture* (autumn): 60–71.

Tartakov, Gary Michael. 1990. "Art and Identity: The Rise of a New Buddhist Imagery," *Art Journal,* Special Issue *New Approaches to South Asian Art*, 49(4): 409–16

Taylor, P.J.O. 1993. *A Star Shall Fall* (New Delhi: Indus Publishers).

5 | Making Women (In)visible?

Homespun in the Nationalist Politics of Dress and Identity in Modern India 1917–1935

LISA TRIVEDI

Homespun in modern India is most often associated with the nationalist politics of Mohandas K. Gandhi, whose swadeshi movement promoted the revival of a plain, undyed, cotton country cloth, known as khadi. Gandhi's patronage of homespun fabric between 1917 and 1947 drew new and significant attention to the faltering status of one of India's greatest handicraft traditions. In addition to promoting its production, Gandhi's movement also significantly changed the meanings associated with khadi. In the course of only a few decades, khadi became the marker of a distinctly "Indian" body. Gandhi was not alone in bringing about this significant transformation, nor were his views on the meanings of khadi unchallenged during his lifetime.[1] Women were among the most vocal critics of Gandhi's project, even while they were also crucial to making homespun important not only during the nationalist period, but also critically in the post-Independence period.

In the first years of the swadeshi movement, Sarladevi Chaudhurani and Sarojini Naidu played important roles in these processes by introducing the nationalist public to khadi. In dozens of speaking engagements in various parts of British India, these women popularized Gandhi's views on swadeshi and the adoption of khadi to male and female audiences alike. In the early and mid-1920s, as khadi emerged as a material good closely associated with

Congress politics, Sarojini Naidu began to take a more nuanced view on consuming homespun. By the late 1920s and 1930s, when traveling exhibitions marketed khadi across British India, she joined middle and lower class female consumers, who refused to embrace the aesthetic plainness of khadi that Gandhi advocated without ambivalence. Rather than reject homespun altogether, women nationalist leaders like Naidu joined ordinary female consumers in demanding the production of khadi that fulfilled both their aesthetic and national sensibilities. The greatest contribution made to the prominent position of homespun in contemporary India was made in the years immediately following India's independence when women, especially Kamaladevi Chattopadhyay, worked to establish both public and private institutions that promoted homespun as a means of nurturing national culture. Women thus played important roles in the visual articulation of the modern Indian body in three related but distinct and overlapping ways: as the most important objects of Gandhian reform, as subjects who expressed their new identity by wearing khadi, and as citizens actively forging a national community in which the arts, especially textile arts, would play a leading role.

This article focuses upon the processes through which a distinctly "Indian" body was brought to life through Gandhi's swadeshi movement, as well as the tensions that emerged as Gandhian politics fashioned a new Indian identity through cloth and clothing in the nationalist and early independent period. It does so primarily by considering the effects that khadi had on the status of women in relation to the Indian nation-in-the-making. By considering the way that khadi clothing enabled women to participate in mass politics and under what circumstances, the article exposes how the patronage of homespun popularized a gendered "Indian" body and in doing so both rendered women's sexuality invisible and enabled women to participate in public protests in significant numbers for the first time.

Gandhi's views on the body, dress, and identity were neither unchallenged in his lifetime, nor without adaptation. In addition to considering Gandhi's writings on swadeshi and khadi, the article

also highlights a range of views held by contemporary women about homespun. Some of these views emerged from village women, a group targeted for reform in swadeshi rhetoric. Others are apparent in the writings of Gandhi's closest female associates and some of the greatest swadeshi advocates of the era, including both Sarojini Naidu and Kamaladevi Chattopadhyay. Not only did women of various strata of society challenge the social implications of Gandhi's plain, white, khadi dress for women, but they also rejected the form and meanings Gandhi attempted to bring to the Indian body—particularly the female body—clothed in homespun, home woven cloth.

This tension, which was visible in the nationalist period, became even more significant in the period immediately following India's independence and after Gandhi's assassination, when Chattopadhyay played a major role in promoting Indian handicrafts, including handloom cloth. Chattopadhyay maintained a view that homespun was a key emblem of Indian identity which she shared with Gandhi, but she departed significantly from his specific views of khadi's meaning and its place within national culture. Whereas Gandhi had popularized homespun as an emblem of renunciation of desire, sexual as well as material, and as a marker of discipline, Chattopadhyay patronized khadi, homespun, and handloom, specifically for their aesthetic potential in shaping a modern Indian identity and its deep effects on the quality of the everyday lives of ordinary people. Although Gandhi certainly had the greatest impact on the meaning of homespun in nationalist India, Kamaladevi Chattopadhyay—for her promotion of the beauty and simplicity of homespun fabric, India's foremost craft—should be viewed as the single greatest patron of Indian arts and crafts since independence.

NATIONALISM AND IDENTITY

Over the course of the last three decades, scholars in the social sciences and humanities have dramatically refigured the ways that the rise of nationalism is understood. The nation is no longer treated as an inevitable product of sociological factors such as a common

language, religion, history or ethnicity, but has been reconceived, in the words of Benedict Anderson, as an "imagined political community—and imagined as both inherently limited and sovereign" (Anderson 1991: 6). More recent studies of the rise of nationalism in the colonial world have traced the development and expansion of the administrative practices of colonial states that measured their subject communities and created institutional infrastructures of surveillance (Appadurai 1993; Cohn 1985; Edney 1997; Hirschman 1986, 1978; Khalid 1998; Rowe and Schelling 1991; Thongchai 1994). As important as the practices of the colonial state were in the creation of nations in the "third world," Partha Chatterjee cautioned against tracing all nationalisms to the historical experience of western nations and their empires (Chatterjee 1993). In support of this critique, I would like to raise another, specific concern with scholarship on nationalism. The historiography of nationalism commonly assumes that the imagining of national community was contingent upon "print capitalism" and rising literacy. While this combination of factors may offer a plausible explanation for the rise of nationalism in Western Europe, it is far less satisfactory in the case of a multilingual and predominantly illiterate society, such as colonial South Asia.

Departing from previous studies of nationalism, this article considers the fact that nationalism in the colonial world often arose in the colonial world without the benefit of a shared written language and rising literacy. Instead, I join a growing number of scholars who are pursuing the visual as a means of better understanding identity, nationalism, and community. I argue that the nation was popularly conceived in a discursive field in which visual and printed languages were mutually constitutive. While visual discourses of community were not unique to the modern era and to the rise of the nation state in South Asia, a visual vocabulary of nationhood, as Sandria Freitag has termed it, was quickly disseminated through a modern capitalist economy, which had developed in colonial India by the turn of the century.[2] In *Clothing Gandhi's Nation: Homespun and Modern India*, I have explored the importance of visual culture in the rise of mass

nationalist politics in South Asia by focusing upon the material culture of the swadeshi movement and the use of khadi to reclaim time, space, and bodies. In that larger study, I argue that swadeshi proponents reached out to the population through visual discourses that utilized modern forms of entertainment, such as lantern slide shows and traveling exhibitions, in order to inspire new modes of consumption. These modes were to incorporate the consumer into a broader, national community through a range of visual, tactile, and audible experiences.

The wearing of khadi was a means of making new nationalist principles visible. Swadeshi proponents defined the significance of khadi in three distinctive and flexible ways. As an ostensibly traditional product, produced through traditional means, khadi was portrayed as a material artifact of the nation. Gandhian nationalists rendered khadi a discursive concept by defining its significance in terms of the contemporary politics and economics of swadeshi. Most importantly, proponents used the plain, undyed fabric as a visual symbol to mark individual bodies as "Indian." When consumers clothed themselves in homespun, they visually expressed their allegiance to their community, challenging the boundaries of both traditional Indian society and the British colonial regime. As a result, by 1930, there was little ambiguity about the visual message conveyed by a khadi-clad body. For the international community, the British Government of India, and South Asians themselves, khadi clothing visibly transformed a colonized body into an Indian body. Understanding the contexts in which particular forms of dress gained meaning may illuminate the nature of the subject-citizen that was privileged in this period, and the role that women in particular played in the creation of a shared sense of national community. Although the khadi-clad body was seen as "Indian," contestation over the meaning of "Indian"was a matter that was far from resolved at independence.

In order to historicize the processes through which khadi clothing came to be identified as Indian, particular attention must be paid to the contestations between the ideological intent of the

swadeshi movement, as first defined, and its evolving practice. After providing a brief discussion of the historical connections between clothing, community, and power in South Asia, the article turns to a discussion of the dominant discourse on khadi clothing that developed from 1917 forward. It establishes the way in which swadeshi proponents—first Gandhi and then his female associates—envisioned khadi as a means of transforming the colonized body into a national body. I am particularly interested in considering how the nature of national community was negotiated through the visual display of khadi on women's bodies in particular because, despite nationalist claims, the clothing of the swadeshi movement was not, in practice, egalitarian. If khadi clothes came to mark Indians, dress was also used to mark men and women, for example, as distinct and unequal partners in this national community. Finally, by considering how women reacted to homespun in the nationalist period, as well as how they patronized traditional textile production after independence, it becomes clear how important women's patronage of homespun, which was founded upon aesthetic grounds rather than ascetic principles as originally envisioned, was to the creation of national identity.

CLOTHING, COMMUNITY, AND POWER IN SOUTH ASIA

Prior to the swadeshi movement, clothing in South Asia had communicated a variety of social messages ranging from community identification to political deference. Historian Christopher Bayly, in particular, has written about the important ritual role that cloth played in precolonial South Asia. The power and authority of the Mughal emperor was in part realized through the ritual exchange of cloth. In the acceptance of a gift, such as a robe or sash, from the emperor, local elites simultaneously acquiesced to imperial authority and took their place within the Empire (Bayly 1986). When the British arrived in South Asia and set about trying to "make sense" of the people with whom they came in contact, they did so by discerning identifiable difference. The British came to view the

subcontinent as a place of multiple communities defined through a variety of languages, religions, and styles of dress. The British looked upon clothing and the presence of material goods as an indication or measure of the civilization of a given people. They then set out to civilize the region by introducing new forms of clothing that distinguished their agents from the people whom they governed. By the close of the nineteenth century, the colonial society peopled by British civil and military personnel, as well as new native elites born of the colonial regime, took on a distinctive appearance of its own (Cohn 1983; Metcalf 1994). The lines between "Indian" and "British" subjects blurred, especially in the subcontinent's growing urban and administrative centers. Even women's clothing was targeted as an area appropriate for British intervention.[3]

In tandem with these reform efforts, the rapidly expanding importation of British manufactured goods into the Indian marketplace substantially affected styles of dress. Manufactured wares from England's Lancashire mills entered the Indian marketplace and goods produced in Bombay, Sholapur and Ahmedabad mills provided less expensive alternatives to artisanal goods. Thus, industrially manufactured goods, whether British or Indian, replaced locally produced cloth that had historically figured largely into exchange rituals, particularly in times of marriage. Aesthetically, the subcontinent's urban and growing middle classes favored the smooth texture, foreign design motifs and modern look associated with mill-made cloth. By the turn of the twentieth century, a crisis developed over the modernization of dress in India. Nationalists pointed to the emergence of a colonial style of dress, linking the rising impoverishment of India to the preference, especially among urban and colonial elites, for manufactured goods.

In the early years of mass nationalism in colonial South Asia, Mohandas Gandhi inaugurated a swadeshi movement that aimed to achieve swaraj, or home rule, by establishing India's economic self-sufficiency from Britain. Invoking an earlier movement, Gandhi promoted the production and exclusive consumption of hand-spun,

hand-woven cotton cloth, called khadi (Figure 5.1). Gandhi explained the significance of this cloth:

> (Khaddar) ... stands for simplicity not shoddiness. It sits well on the shoulders of the poor and it can be made ... to adorn the bodies of the richest and the most artistic men and women Khaddar delivers the poor from the bonds of the rich and creates a moral and spiritual bond between the classes and the masses Khaddar brings a ray of hope to the widow's broken up home. But it does not prevent her from earning more if she can Khaddar offers honourable employment to those in need of some. It utilises the idle hours of the nation (Gandhi 1927)

Figure 5.1: Mohandas Gandhi, pictured wearing a khadi kurta (shirt) and a topi (hat) during the Non-Cooperation Movement

Source: In a political pamphlet, "Khaddar Work in India," 1922.

Gandhi's statement points to the fact that being Indian was no natural matter. Becoming a nation entailed joining disparate groups, linking rich and poor, classes and masses, men and women. The significance of swadeshi lies primarily in its cultural articulation; khadi clothing constituted a symbolic vocabulary through which women's labor contributed to the creation of a modern Indian identity.

Gandhi and early advocates of the swadeshi movement viewed khadi clothing as a great equalizer, potentially binding together

a nation which had been torn apart by the impoverishment that accompanied colonialism. His solution to the problem of economic dependency was to change consumer habits, particularly the ways in which people dressed:

> The householder has to revise his or her ideas of fashion and, at least for the time being, suspend the use of fine garments which are not always worn to cover the body. He should train himself to see art and beauty in the spotlessly white khaddar and to appreciate its soft unevenness (Gandhi 1921)

In seeking to reclaim the bodies for the nation, Gandhi's selection of khadi was tantamount to rejecting the supremacy of the West and its imperial vision. However, to the British, these khadi wares were (as Gandhi termed it) "like a red rag to a British bull."[4] So inflammatory was this choice that Gandhi's newly designed form of headwear, the Gandhi topi (hat), was banned during this period from courtrooms, government offices, and even government colleges.

THE DOMINANT DISCOURSE AND ITS CHALLENGERS

As in most places, dress in South Asia had carried a variety of identity markers. The precise community of an individual was visually expressed through his or her attire, as was regional, religious, sex, class, marital and caste identifications (Tarlo 1996). In a photograph of Congress delegates at the Amritsar meeting of the Indian National Congress in 1919, the contemporary viewer would have seen clothing that conveyed distinctions of caste, class, region, gender, and religion. As the 1920s progressed, wearing khadi announced a different kind of identification: that of a newly emerging national community. Khadi represented a rejection of the colonialist view of India as a country of hundreds, perhaps thousands of distinct communities, unworthy of the status of nation state. By adopting khadi dress, Congress workers appeared as a single, disciplined, cohesive national community (Figure 5.2). As one worker described the new national subject created through swadeshi:

...the self-spinner has no class high or low. He spins because he takes a pleasure in spinning and because he sees its importance, if not to himself...to the vast masses of the country. He spins in sympathy for the poor....If he has a sister or a wife he will make her spin too. And ultimately the womanhood of India if they choose would be able to clothe the whole population as they did before....[5]

Figure 5.2: Seated in the front row, wearing a dark colored sari, Sarojini Naidu is pictured sitting between Kamala and Jawaharlal Nehru who were visiting Congress workers in South India in 1924

Source: Photograph courtesy of Anand Bhavan.

The ideal subject-citizen to whom the writer referred was assumed to be male and a patriarch of the family in at least two senses. He was responsible not only for his own work for the nation, but also for the labor of the women in his family. The national community was produced by the labor the millions of families led by this male subject-citizen. Interestingly, in describing the middle-class spinner-citizen as male, Gandhi also *prescribed* a new role for middle-class men in their society. Since women had given up their "traditional" roles as spinners, it was up to men to reinvigorate this particular kind of labor. By spinning, men were to transform themselves, their families, and the nation as a whole. Consider how strange the sight of a middle-class man spinning might have been to the working class and agricultural populations, where spinning was a task associated with women. With the rise of nationalist identity, the goal of the family economy shifted from providing sustenance

for a family to contributing labor to support the national community. This shift created a new emphasis upon the cultivation of universal, disciplined labor that brought with it an expanded role for men within the family economy and a more prominent position within the national community as its chief producer.

Over the course of the 1920s, a large variety of swadeshi goods appeared in the marketplace; advertisements in newspapers and small catalogues alerted the conscientious consumer to a variety of swadeshi wares such as furniture and fountain pens, medicines and mosquito curtains, perfumery and pipes (Bombay Swadeshi League 1931). Swadeshi was most generally associated with a wide array of ready-made clothing available through Indian owned and operated mills, or at the hundreds of khadi depots that sprang up in this decade. Advertisements from the *Khadi Patrika* of 1926 highlight some of the other goods, which were available in Bombay at the Khadi Bhandar (store) or through mail order. Many of the articles produced through the swadeshi movement were employed specifically for public consumption or demonstration. Gandhi topis, vests, and kurtas (shirts), the most prevalent articles produced during this period, were among the goods worn in public in order to visually reclaim the space of the nation. In addition to the clothing worn to communicate with the colonial government and its servants, undergarments, especially men's undershirts and underwear, were a modality of discipline aimed at the reform of the individual. Refraining from the use of British goods in public spaces and occasions was good, but it was even better if foreign goods were removed from one's private life. Thus, while khadi was an important communicative statement of nationalism that was used to demonstrate resistance to the colonial regime, it also penetrated the mores of traditional society through its incorporation into the domestic sphere as sheets, towels, decoration, as well as clothing that was worn within and outside the home.

In the context of the wider international community in which the Indian nation was imagined, a cohesive Indian people became visible when they appeared in khadi, particularly in public. Since middle-

class and elite nationalists wished to define themselves within the nation, they had to "appear" like the laboring masses. But if khadi transformed a heterogeneous, westernized, and elite-dominated subcontinent into a unified Indian and national community, it did not do so in the same ways for men as it did for women. Middle-class men, once public mimics of the colonial ideal, were transformed by this indigenous cloth into ideal subject-citizens of the nation. Photographs of Motilal Nehru make clear this point. The telltale markers of colonial domination—western coats, hats, and shoes— were swiftly replaced by the coarse, plain cloth in a manner of only a few years. And, so, too, were many of the caste, regional, and religious markers that had been traditionally reflected in men's clothing. The Indian and the Indian man were collapsed together in this visual vocabulary of nationhood. A man dressed in khadi became an Indian in both colonial and nationalist eyes.

POOR WOMEN AND PROSTITUTES: THE CLOTHING OF WOMEN IN NATIONALIST INDIA

Indian women, like their male counterparts, announced their identification with a national community by adopting khadi dress, ideally the khadi sari. Wearing khadi saris meant a major change of dress for those who, like Punjabis, Rajasthanis or Gujaratis, were accustomed to wearing other forms of attire and finer fabrics. Even for those women accustomed to the sari as a standard form of attire, the khadi sari marked a sharp departure from local styles that featured a conventional array of colors, designs, and patterns according to their regional origin. The adoption of the khadi sari therefore signaled a departure from regional styles of dress, and from regionalism itself, and in its place proclaimed identification with a national community.

But, the khadi sari that was popularized by Gandhi and his swadeshi movement was not simply an equivalent form of nationalist dress for women; it was a complicated sight, especially when worn by young, married women, many of whom also gave up

their ornaments in order to support swadeshi. The white, coarse homespun was frought with weighty connotations because it was associated with the dress of poor women and India's most reviled person—the widow (who, lacking family support, often turned to prostitution). How was it that men were transformed into patriotic ideals of national discipline and pride by their khadi garments, while women were asked to adopt a form of dress commonly associated with moral degeneration, weakness, and the widow-turned-prostitute?

As women were increasingly drawn into the struggle for nationhood, it was impossible to shelter women from the dangers posed by the foreign colonial regime. Nationalists therefore devised a rhetoric that reframed the visual meaning of the khadi-clad female body, transforming it from a sign of the nation's weakness to a site of national power and authority. At the same time, it became clear that nationalists viewed women's moral authority as necessary if they were to transform the material world of men. Writing on the role of women in society, Gandhi explained,

> The function of women is not to allow themselves to be prostituted by men in exchange for their support, but to be queens of the household ... running a home efficiently, caring for and educating children properly steadily seeking to conceive and transmit new, proper, and higher ideals before they come under the influence of others of the opposite sex, all these things represent work of the highest, most important and most difficult kind that can be performed in this world.[6]

Because the nation needed women to transform the public, nationalists sought ways to enable women to conduct the work of the nation without succumbing to the dangers of an immoral material world. On a visual level, khadi clothing offered women a critical solution by providing a uniform that obscured their sexuality and thus signaled both their safety and success in the "most important and most difficult" tasks that they faced.

Whether through the spinning of cotton thread, the purchasing of

swadeshi goods or the wearing of khadi clothing, women were part of the solution to the nation's predicament. Women were introduced to a new tactic that was aimed, at least ideologically, at protecting their safety and moral authority in the world outside the home. According to proponents of swadeshi politics, spinning also provided women with a secure income, thereby obviating their need to work outside the home for wages where they might fall prey to immoral trades. And, as a supplement for agricultural laborers who made up the vast, impoverished population of India, spinning would provide a small income in times of natural calamity and in the off-season. Unlike the employment available in the subcontinent's growing industrial sector, spinning offered women of the agricultural class at least two distinct advantages: it afforded them with consistent, if not well-paid employment, and, perhaps more importantly, it was a form of labor which could be carried out safely within the purview of one's family.

Financial destitution would, thus, no longer jeopardize the moral integrity of women or the nation. Aside from the poor women of colonial India, swadeshi proponents often made the case for women's spinning as a solution to the plight of the Indian widow, who existed at the margins of the family. The nineteenth century had seen the rise of social reform debates over the condition of women. Through these debates, women emerged from the context of the joint family only to be reconfigured as part of an idealized conjugal family, where they became objects of reform for the imperial regime and nationalists alike. Widows were among the most problematic persons in the nationalist imaginary as evidence of potential, or even inevitable, national moral failure. Widows were of particular concern because they were outcasts, living at the margins of the family and therefore the national community. In the absence of financial support from husbands, family, and nation, widows—who by custom could not remarry—were forced to beg and became the targets of sexual exploitation by men in their own communities. Once transformed from a beloved wife into a beggar, what would prevent them from prostituting themselves or being prostituted against their will?

Even officials of princely states like Mysore and Hyderabad were concerned over the danger of widows. At a Cooperative Conference, the finance minister of Hyderabad explained:

> Respectable widows who have no other means of livelihood used to support themselves ... by spinning and sewing. By popularising this occupation, you would not only augment the slender resources of the people but ... save them from falling prey to many a temptation.[7]

The nation's very authority and legitimacy were threatened by what I term the problem of impending prostitution. It was a danger that every woman posed regardless of class, caste, or region; it was a problem that increasingly defined women's relationship to the nation and which assumed the national community to be Hindu. In the national imaginary, all Hindu women were assumed to be potential widows and, therefore, potential prostitutes. Ultimately, it mattered not whether or not widows were actually preyed upon by men or sold themselves in order to survive. In terms of the nation, the results were the same as nationalists elided the figure of widow and prostitute. Proponents of swadeshi therefore envisioned women's spinning as a way to transform the most vulnerable, most sexually dangerous part of society into acceptable, productive members of the national community, not for the sake of women per se, but rather for their effect upon the moral authority of the national community.

The khadi-clad woman had a visual impact. A woman wearing khadi was representative, at least in the nationalist imaginary, of a bond between India's rural poor and middle classes. For middle-class women who were deemed unproductive in economic terms, spinning provided a means to contribute to the well-being of their communities. The sight of a woman in khadi was a visual message that communicated not only the reform of middle-class consumer habits and respectability, but also the end to the economic destitution of India's agricultural, laboring women as women of both classes made common cause. In this regard the clothing of women in nationalist India was similar to that of men. But, the khadi-clad

woman carried two other significant messages. Khadi also came to represent women's escape from the degradation of the material world. In the event of widowhood, from which even a middle-class lifestyle offered no security, the value of spinning would be realized; women who could spin could support themselves, rendering them free from exploitation and the probability of defilement. As the object of nationalist reform, women's appearance in khadi effectively transformed the greatest threat to the nation into the nation's greatest asset.

Additionally, khadi was a powerful signifier for its ability to desexualize the symbolism of the widow's dress. Women who traversed the boundaries of the spiritual and material worlds dressed in khadi, and thus posed neither a threat nor a temptation to the moral authority of the nation and the male subject-citizen. In this regard, the clothing of women in nationalist India entailed more than a subsuming of class, caste, or regional identities to a national one. In an article entitled "The Function of Women," Gandhi elaborated on this point in a speech to a women's meeting in 1928: "'...not only married women, *any girl, with the proper guidance, can transmute her sex appeal*, much or little, into a powerful inspirational force for good...with the results limited only by the height of her ideals....'"[8] Gandhi's aim for khadi was clear when it was to be worn by women: it was meant to be a tangible, visible manifestation of control over women's sexuality and desire. The khadi sari marked women as beacons of virtue, culture, and authenticity by hiding their sexuality from public view.

However, khadi's place in nationalist rhetoric was different for women who chose to adopt khadi clothing, as is clear in a 1930 photograph of Krishna Huteesingh and Kamala Nehru (Figure 5.3). In this case, the two young women from a prominent nationalist family in Allahabad chose not to adopt the khadi sari, but instead went much further by adopting men's clothing at the public protests they joined in the early days of the Civil Disobedience Movement. With male members of the family already imprisoned, Huteesingh and Nehru took it upon themselves to direct flag processions

Figure 5.3: Kamala Nehru and Krishna Huteesingh, wearing khadi kurta pajamas (shirt and pant) and topi (hat). They actively protested in public in Allahabad during the Civil Disobedience campaign, 1930.

Source: Photograph courtesy of the Nehru Memorial Museum and Library.

through Allahabad. They did not do so as the respectable women Gandhi envisioned, for those would have appeared in public wearing a khadi sari so as to "transmute her sex appeal." Instead, they dressed as men. The men's clothing went further than mere khadi in neutralizing Huteesingh and Nehru's sex and sexuality by rendering them invisible as women. Krishna Huteesingh and Kamala Nehru thus transformed the meaning of khadi for their own purposes, in contrast to Gandhi who believed in the equality of men and women as much as their natural differences which would be maintained in their choice of dress. The form of clothing communicated as much as the fabric. Indeed their choice of dressing in menswear suggests that they recognized a potential for dress that exceeded Gandhi's

formulations. Wearing khadi kurtas, topis, and churidar not only marked their bodies as "Indian," rather than "Indian woman," it also allowed them to claim the status of ideal subject-citizens as men. In this critical regard, women were important patrons of khadi as subjects who took it upon themselves to announce their identity as Indian on their own terms.

WOMEN'S PATRONAGE AND HOMESPUN IN MODERN INDIA

Women not only contributed to the leadership of the swadeshi movement, they constituted the bulk of the movement's labor. Despite this, some women expressed views on khadi that contradicted those of Gandhi himself. Women proponents of swadeshi politics participated in public protests by wearing khadi, and yet for many women, swadeshi politics incurred a cost. Recalling women's participation in the swadeshi movement in Lahore, Manmohini Sahgal explained:

> Women appealed to other women to discard foreign cloth Not all families could afford to throw away their clothes and buy a completely new wardrobe, but all the women had a couple of khadi saris which they wore to all the meetings and processions. It was extremely difficult to forego buying the lovely materials available, in contrast khadi was coarse and rough All the foreign cloth collected by Congress would be consigned to the flames in a huge bonfire ... (Sahgal 1994: 18–19)

Not all women could afford to adopt the new wardrobe that Gandhi and swadeshi proponents advocated during this period. In addition, although women readily wore khadi to public meetings, processions, and demonstrations, their memoirs and interviews suggest that women were ambivalent about bringing khadi into their domestic lives, particularly when it affected their identities as defined by the particular communities in which they lived. Whether they were village women or urban elite women of nationalist families, their ambivalence about khadi and its effects on their private as well

as public lives is evident in the questions, challenges, and choices about when or whether to adopt homespun.

Given the social significance of marriage for a young bride and her family, mothers were reluctant to allow their unwed daughters to take up this rough, plain clothing. Reporting a meeting with Gandhi in 1925, Mahadev Desai quoted women in one village as having expressed their ambivalence about khadi thus: "'We will (wear it), but it is rather difficult to put up with coarse Khaddar, replied one of the women....' Besides we might wear Khaddar but not our young girls. They have yet to marry and they must have the stuffs."[9] How could they arrange a suitable marriage, if their daughter wore the drab dress of a widow? Though they might enable those in their community to wear khaddar by purchasing and spinning it, Gujarati women did not necessarily believe that their unmarried daughters should transgress social custom, fearing that it might undermine a good marriage match or perhaps encourage unwanted attention of men. In other words, women might be in favor of nationalist politics without necessarily being ready to implement nationalist ideas within the family.

The tension between status in the community and support for nationalist politics was not one confined to small, rural communities but also found among elite, urban families as well. Take, for example, the Nehru family. Vijayalakshmi Pandit, who was the daughter of the well-established Congress leader Motilal Nehru and the sister of the young up-and-coming Jawaharlal Nehru. Vijayalakshmi Nehru agreed to a marriage arranged by Gandhi. Under the threat that he would not otherwise participate in the ceremony, Gandhi insisted that the bride wear khadi for the nuptials and refrain from adorning herself with jewelry. Gandhi's demands were not, according to Pandit, greeted with approval by her mother:

> Mother could not have been *more angry*. She ... could not understand his Politics, and certainly did not think he had the right to advise the *family* on *personal matters* She felt intuitively that this man was the enemy of her *home* Khadi at that point was not only coarse, it was ... very ugly. (Wolpert 1996: 48–49; my emphasis).

Like the older women in the Gujarati village who were willing to adopt khadi themselves, but not for their unmarried girls, Mrs Nehru's reaction was at least partially founded upon her specific ideas regarding the appropriateness and potential inappropriateness of khadi. Mrs Nehru had no difficulty with members of her family, even her daughter and daughter-in-law as we have seen, dressing in khadi for the purpose of public protest; however a wedding was another matter entirely.

In the end, Motilal Nehru acquiesced to many of Gandhi's requests, with a couple of significant exceptions. The bride did not wear the lavish traditional sari typical of an elite Kashmiri Brahmin family, but a khadi sari whose cloth had been spun by Kasturba Gandhi. The bridal sari was not plain white, as Gandhi preferred, but instead had been dyed a pale pink, a color specifically associated with Kashmiri brides. Although Gandhi was extremely critical of resources wasted on marriages, the Nehrus presented their daughter with 101 silk saris and several pieces of family jewelry for her married life. Mrs Nehru's role in these accommodations can only be guessed, but it is likely that Mrs Nehru had persuaded her husband that there were limits to the place of khadi clothing. Even while remaining supporters of khadi in their public life, the Nehrus did not assume that this would be the way of their daughter's future domestic life.

In addition to conflicts over the place of khadi on ceremonial occasions, nationalists also had differing views on the value of homespun, home-woven cloth to national culture and identity. Gandhi's austere asceticism with regard to homespun was antithetical to the national community that many others sought to embrace. Among swadeshi's greatest proponents during the nationalist movement was the poet Sarojini Naidu, who was the first Indian woman elected as president of the Indian National Congress and gave numerous speeches on swadeshi as she traveled to engage women to join the nationalist cause. However, Naidu did not habitually adopt the plain, white, cotton khadi sari, even when speaking to women's groups and khadi workers. Instead, she

preferred boldly colored saris, usually made of silk. According to one of her biographers, Naidu's personal correspondence makes clear that she opted to support swadeshi politics not by wearing the plain khadi Gandhi promoted, but instead by donning expensive— yet handloomed—textiles that appealed to her personal taste. Upon occasion, she expressed her impatience with khadi's limited aesthetic value, arguing for an expanded idea of swadeshi.

> How many have considered the romance and adventure of Swadeshi? Many people think that Swadeshi means making yourself look perfectly ugly by wearing the most unpleasing texture and colour of cloth, the more unpleasant it is, the higher the Swadeshi! But I have quite a different definition of Swadeshi. For me Swadeshi begins, maybe with Gandhiji's charka, but by no means ends there. For me it means the reviving of every art and craft of this land that is dying today. It means the giving of livelihood again to every craftsman—the dyer, the embroider, the goldsmith, the man who makes tassels for your weddings, the man who makes all the little things that you need for your home For me, it means the renaissance of all our literature, the revival of our music, a new vision of architecture that is in keeping with our modern ideas of life. It means for me a kind of experiment that explores and exploits every resource within the country. (Sengupta 1999: 316–17)

Unlike Gandhi, Naidu did not associate indigenous luxury goods with moral degeneration; she was not concerned that the color, texture, and design of cloth would compromise national rejuvenation. Instead, her vision of swadeshi, like that of her sister-in-law Kamaladevi Chattopadhyay, was broader, more cultural, and more artistic. She understood her nation in part through its rich repertoire of beautiful artisanal textiles. The Dacca muslins and Banarsi and Madrasi silks that continued to be worn by nationalist women, including Sarojini Naidu, can be read as evidence of an ambivalence towards, if not rejection of, the austere cloth that middle-class reformers like Gandhi promulgated.

This anti-asceticism extended beyond the elites. As early as 1921,

a south Indian lawyer and swadeshi proponent informed Gandhi of his failed attempts to popularize khadi among the women of his Tamil Brahman community:

> Khadi is not widely used in Tamil province ... mainly because the women-folk do not wear it.... Plain white cannot be worn by married women here. They can only wear dyed sadis [saris]. In former times cotton was the only wear of ladies. Now except by the poorest, cotton sadis are discarded, and silk sadis form the daily wear[10]

This remark suggests that even at this early stage in swadeshi politics social standards associated with marriage rendered women of this particular community unreceptive to khadi. Not only were colored saris a sign of respectability for women of this Brahmin community, so too was the sari's material. While Gandhi's movement promoted cotton saris, the Tamil women described above announced their economic position in society at least in part through their ability to afford more costly silk. The khadi worker's account characterized women in his community as too fashion-conscious to adopt khadi saris, but it is more likely that the women in this particular Tamil community relied upon clothing to communicate important messages about their marital status and economic position.

In response to the message, Gandhi put C. Rajagopalachariar, his most loyal follower in the Madras Presidency, on the case. Within the year, Rajagopalachariar began an aggressive public campaign to break down the social customs impeding the adoption of khadi, writing articles and giving speeches that appeared not only in the pages of *Young India*, but in regional papers like *The Hindu*. Recognizing that white cotton saris were unlikely choices for women in the Madras Presidency, Rajagopalachariar asked Tamil women to compromise by giving up silk for cotton. He also made sure that colored khadi was made available. The Madras Presidency subsequently became one of the highest khadi producing and consuming regions of the country. The women's refusal to take up the drab, white, cotton khadi may have had a direct effect on the kind of homespun that was produced

Figure 5.4: Kamaladevi Chattopadhyay (n.d.)

Source: © K.L. Kamat. Photograph used with permission from www.kamat.com.

from the 1920s onward. Indeed, the official uniform of women volunteers at the annual meeting of the Indian National Congress in 1929 was comprised of an orange sari and a green blouse. While Gandhi's original vision was utterly plain, the women as subjects who articulated their identity by donning clothing that announced their identity transformed khadi into something more versatile that they could accept. These subtle and significant changes to Gandhi's use of cloth in fashioning a modern Indian identity were challenged and reformed further following independence. In the aftermath of India's independence from Great Britain, Gandhi's assassination, and the optimism of the early Nehruvian era, leading figures in the arts and crafts turned to traditional textile production as a means to pursue national cohesion.

There may be no single patron of the arts more important in independent India than Kamaladevi Chattopadhyay (Figure 5.4). Born to a liberal Saraswat Brahmin family in Mangalore in 1903,

Chattopadhyay is known for her participation in the nationalist struggle alongside her sister-in-law Sarojini Naidu, and for her close relationship with Mohandas Gandhi with whom she shared an interest in homespun. Nationalist, feminist, and socialist in her orientation, Chattopadhyay was the first Indian woman to stand for election to a legislative assembly. While her 1926 bid was unsuccessful, Chattopadhyay quickly became a leading public figure among women in her generation. She advocated swadeshi politics alongside Gandhi during the nationalist period, and after independence promoted the arts more broadly, including handicrafts and theatre. As founder of the Cottage Industries Board and of the National School of Drama shortly after independence, Chattopadhyay sought to shape India not through the extension of Gandhian asceticism and discipline, but rather through the identification, revival, and promotion of what she deemed the traditional arts of India.

Chattopadhyay was drawn to swadeshi politics in the early 1920s as a nationalist and also because it emphasized the revival of a handicraft she prized. Although she shared Gandhi's worry about the destruction of India's textile tradition in the face of foreign and Indian mass production, Chattopadhyay imagined a different role for traditional textile production in national culture. Gandhi shunned the decorative aspects of homespun in India and instead promoted khadi as a means to promote self-restraint over sexual and material desires that he found overwhelming the modern world. As has been seen, khadi replaced the modern emphasis on bodily pleasure and beauty with simple living and high thinking. But while Gandhi idealized khadi's lack of ornamentation and the simplicity of its production, Chattopadhyay prized homespun because of the bright colors, patterned motifs, and artisanal skill, which she argued reflected the natural, material world from which Indian culture emerged. Gandhi's interests were primarily ascetic, while Chattopadhyay's were aesthetic. Indeed, Chattopadhyay viewed the arts of India as integral to the maintenance of her culture. India's past, as well as her future, lay in the preservation, revival, and development of traditional textile production.

Chattopadhyay's vigorous participation in the nationalist movement and her political activity in the years immediately after independence kept her from recording her experiences, political work, and opinions in any significant detail. However, it was between independence in 1947 and the early 1960s that Chattopadhyay contributed the most as first patron of the arts of India, creating and leading national institutions which continue today to support traditional textile and craft production. Several deserve particular mention here. Jawaharlal Nehru appointed her to head the Central Cottage Industries Board in 1948 and the All India Handicrafts Board in 1952. Both of these institutions promoted the revival of traditional textile production, including khadi, although the crafts within their oversight were much broader. One of the outcomes of this work was the establishment of the National Crafts Museum in Delhi in the mid-1950s. In the early 1960s, Chattopadhyay headed the Handicraft and Handloom Corporation 1962, which was to market goods created as a result of regional craft boards that had been established in the previous five years. Chattopadhyay's work was not only for the government, however. She was also responsible for patronizing the establishment of private organizations including the Craft Council of India based in Chennai in 1964, with its full registration with the government of India in 1977. What remains so impressive about Chattopadhyay's contributions was the way she created and promoted a web of both public and private institutions— those that revived skills, promoted production, enabled marketing, and supported artistic innovation—that would continue beyond her lifetime to sustain the artistic genius of India. Indian textiles, whether khadi specifically or handloomed more broadly, were particularly well supported in her post-independence patronage.

After Indira Gandhi recalled her from government service in the 1960s, Chattopadhyay continued to pursue her work, authoring a series of books about India's handicrafts and textile traditions that emphasize associations critical to modern Indian identity in the post-independence period. Her publications may be seen as yet another means through which she managed to make her concerns

and views known to her fellow countrymen. For Chattopadhyay, the natural/physical and emotional/spiritual spectrum, and unique features of Indian identity were all embodied in India's handloomed cloth. Preservation of textile production therefore was paramount to national identity, as she wrote:

> The handicrafts in this country were in a manner reverenced as an important part of our rich cultural history. Now though this sentiment continues to be repeated, there is a pronounced change in the general attitude towards crafts, which is completely unsetting our basic sense of life values. For though handicrafts fulfilled a positive physical need in the daily requirements of the people, they also served to satisfy the aesthetic hunger in man and provided a vehicle of his urge for self-expression which reveals a conscious aesthetic approach. The inspiration had come from the tender core of the substance of everyday life and nature's own rich storehouse. (Chattopadhyay 1976: 7–8)

Without her traditional arts and crafts, Chattopadhyay feared India would unravel both culturally and politically. Chattopadhyay's conception of national community differed from Gandhi's in two significant ways. First, she saw traditional textile arts as central to the basic needs of every Indian, and not as luxurious flourishes which satisfied worldly desires. Second, she explicitly idealized the aesthetic features of traditional arts, seeing their beauty as both natural and necessary for humanity to flourish. If handicrafts fulfilled both the practical and aesthetic needs of Indians, they were not to be the privilege of only the wealthy.

> What is the real significance of handicrafts? It lies in the newness and surprise of each object. No two are alike, for each is a fresh reaction ... Even the poorest enjoyed a variety in the articles of everyday use, for a special article was assigned for a particular use. This meant a wide range even in the clay water pots and pans, clothes and garments with distinctive colours and designs. Wall and floor decorations varied according to the days of the week and to mark

special features. All this broke monotony which is perhaps the most deadening element in life. (ibid.)

Chattopadhyay worked tirelessly not only to support the sale of handloomed cloth, but also to identify and revive its production in villages throughout India. In the year before her death, Chattopadhyay explained in the C.D. Deshmukh Memorial Lecture:

> We belong to a region which contains a rich heritage of values whose significance for the present and the future cannot be minimized— (values that) teach us that life is not made rich by simply cluttering it up with acquisitions but rather by self expression, that beauty is not determined by the possession of expensive objects but rather by making everything we use in our daily life, no matter how mundane, beautiful[11]

CONCLUSION

Gandhi envisioned khadi clothing as a means of concealing and reforming sexuality and, in so doing, opening up a way for women to participate in public protest alongside nationalist men. But women resisted the attempt to suppress their sexuality, and their alternative politics were visibly present in nationalism. Although Gandhi preferred khadi as plain, white, homespun, home-woven cloth, by 1930, the khadi that women wore in public was neither uniformly plain, nor exclusively white, and their dress was not necessarily female in style. Traveling exhibitions such as those in Bengal, the United Provinces, Hyderabad, and Mysore offered both visions: Gandhi's ideal, austere cloth as well as cloth featuring colors, like the pink associated with Kashmiri brides, and regional designs, usually visible on the sari border. In practicing swadeshi in everyday life, consumers of khadi—notably women—played a crucial role in shaping the forms that khadi took, particularly from the 1930s onward. While the nationalist movement promoted a particular way of dressing the new Indian body, the relationship between clothing and identity was not limited by the vision of a particular individual,

ideology, or organization. Particularly once independence had been won and khadi was no longer necessary as a means by which to distinguish a colonized body from a national one, India's new citizen-patrons were able to refashion the role and place that khadi would play in forging modern Indian identity. Women like Kamaladevi Chattopadhyay employed khadi first to find a place in public politics during the struggle for independence and later to shape the national culture they wished to succeed colonial India.

NOTES

1. Gandhi's swadeshi movement and his use of khadi were criticized by many contemporaries, including Rabindranath Tagore. Another critic was Anil Baran Ray, who challenged Gandhi's views in the pages of the *Bombay Chronicle* as well as in short booklets.

2. Freitag (1995); Anderson acknowledges the importance of the visual in a fleeting reference at the end of *Imagined Communities* (1991: 146).

3. Nirad Chaudhuri makes this point in his autobiography, *Thy Hand, Great Anarach!* (1987: 402–3).

4. This phrasing came from Gandhi's article "War on Khaddar," (Gandhi 1930).

5. Attributed to Devdas Gandhi, who was a son of Mohandas Gandhi. See Gandhi (1917).

6. Attributed to Mahadev Desai. See Desai (1928).

7. "Khadi in the Hyderabad State," *Young India*, December 20, 1928.

8. Attributed to Mahadev Desai (1928).

9. Attributed to Mahadev Desai (1925).

10. "Letters," *Young India*, August 25, 1921.

11. Nanda (2002); excerpt from Chattopadhyay's lecture "Of Reason Fragmented," CD *Deshmukh Memorial Lecture* (India International Centre, Delhi, 1987).

REFERENCES

Anderson, Benedict. 1991. *Imagined Communities: Reflections on the Origins and Spread of Nationalism* (London: Verso).

Appadurai, Arjun. 1993. "Numbers in the Colonial Imagination," in C. Breckenridge and P. van der Veer (eds), *Orientialism and the Postcolonial Predicament*, pp. 314–39 (Philadelphia: University of Pennsylvania Press).

Bayly, Christopher. 1986. "The Origins of Swadeshi (home industry): Cloth and Indian Society, 1700-1930," in Arjun Appadurai (ed.), *The Social Life of Things: Commodities in Cultural Perspective*, pp. 285–321 (Cambridge: Cambridge University Press).

Bombay Swadeshi League. 1931. *A Classified List of Manufacturers of Swadeshi Goods and Their Agents and Dealers* (Bombay: Bombay Swadeshi League).

Chatterjee, Partha. 1993. *The Nation and Its Fragments: Colonial and Post-Colonial Histories* (Princeton: Princeton University Press).

Chattopadhyaya, Kamaladevi. 1976. *The Glory of Indian Handicrafts* (New Delhi: Indian Book Company).

Chaudhuri, Nirad. 1987. *Thy Hand, Great Anarach! 1921–1952* (New York: Addison-Wesley).

Cohn, Bernard. 1983. "Representing Authority in Victorian India," in Eric Hobsbawm and Terence Ranger (eds), *The Invention of Tradition*, pp. 165–210 (Cambridge: Cambridge University Press).

———. 1985. "Census, Social Structure, and Objectification," in *An Anthropologist Among Historians* (London: Oxford University Press).

Desai, Mahadev. 1925. "With Gandhi in Gujarat," *Young India*, April 23.

———. 1928. "The Function of Women," *Young India*, October 18, Navijivan Press, Ahmedabad.

Edney, Matthew. 1997. *Mapping an Empire: The Geographical Construction of British India, 1765–1843* (Chicago: University of Chicago Press).

Freitag, Sandria. 1995. "The Visual Language of the Nation," Paper delivered at the Empire Studies Reading Group, Berkeley, California, November.

Gandhi, Devdas. 1917. "The Self-Spinners Tale," *Young India*, April 14, Navijivan Press, Ahmedabad.

Gandhi, Mahatma. 1921. "The Secret of Swaraj," *Young India*, January 19, Navijivan Press, Ahmedabad.

———. 1927. "No and Yes," *Young India*, March 17, Navijivan Press, Ahmedabad.

———. 1930. "War on Khaddar," *Young India*, July 3, Navijivan Press, Ahmedabad.

Hirschman, Charles. 1978. "The Meaning and Measurement of Ethnicity," *The Journal of Asian Studies*, 46(3): 555–82.

———. 1986. "The Making of Race in Colonial Malaysia: An Analysis of Census Classification," *Sociological Forum*, 1(2): 330–61.

Khalid, Adeeb. 1998. *The Politics of Muslim Cultural Reform: Jadidism in Central Asia* (Berkeley: University of California Press).

Metcalf, Thomas. 1994. *Ideologies of the Raj. The New Cambridge History of India, vol. 3, part 4.* (Cambridge: Cambridge University Press).

Nanda, Reena. 2002. *Kamaladevi Chattopadhyaya: A Biography* (New York: Oxford University Press).

Rowe, William and Vivian Schelling. 1991. *Memory and Modernity: Popular Culture in Latin America* (London: Verso).

Sahgal, Manmohini Zutshi. 1994. *An Indian Freedom Fighter Recalls Her Life* (Armonk, NY: M.E. Sharpe).

Sengupta, Padmini. 1999. *Sarojini Naidu: A Biography* (New Delhi: Sahitya Akademi).

Tarlo, Emma. 1996. *Clothing Matters: Dress and Identity in India* (Chicago: University of Chicago Press).

Thongchai, Winichakul. 1994. *Siam Mapped: A History of the Geo-Body of a Nation* (Honolulu: University of Hawaii Press).

Trivedi, Lisa. 2007. *Clothing Gandhi's Nation: Homespun and Modern India* (Bloomington, IN: Indiana University Press).

Wolpert, Stanley. 1996. *Nehru: A Tryst With Destiny* (New York: Oxford University Press).

6 | Seen through a Screen

Doris Duke's Patronage of South Asian Artists

Sharon Littlefield

The American philanthropist Doris Duke spent nearly six decades of her life building an extensive collection of Islamic and South Asian art for her Honolulu home, Shangri La (Littlefield 2002). An intensely private woman, Duke saw Shangri La as a retreat, a place where she could avoid the notoriety of having been dubbed the "richest girl in the world." By the time she passed away in 1993, Duke had collected more than 3,500 objects, predominantly from the Islamic world. A significant portion comes from South Asia, consisting of both Islamic and non-Islamic material as well as many objects that defy such classifications.

In this article, I describe first who Doris Duke was and the South Asian collection she acquired and had built for Shangri La. Second, I analyze Duke's collecting practices, her purchases and commissions, drawing heavily on archival materials that provide evidence of her activities, and document the extent to which she embraced South Asian visual idioms for Shangri La. Finally, I examine directions that aid us in making sense of Duke and her home. She was a private person who left few written records and often shunned the idea of explaining herself to others; as a result, Shangri La presents special challenges of interpretation. Taken together, these three sections offer a portrait of a patron who, with financial means and a critical

eye, worked with South Asian artisans among others to create a site both familiar and foreign to expectations.

DORIS DUKE AND SHANGRI LA

Doris Duke's father, James Buchanan Duke, had amassed an enormous fortune by the time his only child was born in 1912. He founded both the American Tobacco Company and the Duke Energy Company, and gave the multimillion dollar gift to a small southern college that led it to change its name from Trinity to Duke University. Doris Duke's life was the subject of great public curiosity at her birth; when her father passed away in 1925, she became known popularly as the "richest girl in the world." This attention was unsought and unwanted, and she deliberately avoided the press for much of her life, making a point not to share her life with the public.

Her interest in Islamic and South Asian art dates at least to 1935, when she began to purchase textiles, jades, woodwork, and metalwork during her honeymoon trip around the world. She had married James Cromwell, the flamboyant son of Eva Stotesbury, a matron of Philadelphia society. (She divorced him in 1941.) While on her honeymoon, Duke traveled to eastern destinations for the first time; in South Asia, she visited Delhi, Agra, Jaipur, Udaipur, Bombay, and Kashmir.

Cromwell noted in a 1935 letter to his mother that Doris "had fallen in love with the Taj Mahal and all the beautiful marble tile, with their lovely floral designs with some precious stones."[1] Indeed, Duke was so awed that she immediately commissioned a marble bedroom and bathroom suite for herself based on techniques and designs of the Taj Mahal and other sites of Mughal architecture (Figure 6.1). Her new suite included carved marble doorways, door and window lattice screens (*jalis*), and inlaid marble wall and floor panels. These elements were custom-made to her specifications by a British architectural firm in Delhi, C.G. and F.B. Blomfield, with the work itself being carried out by an unnamed firm of artisans in Agra.

At first, Duke thought that she would have her bedroom and
bathroom suite shipped to Palm Beach, Florida, where her husband's
family owned the mansion El Mirasol. But on the last stop of their
honeymoon, Duke and Cromwell arrived in Honolulu. Planning to
stay several weeks, they instead settled in for four months. Hawaii
offered its famous natural beauty, but it also offered privacy. An
American territory at the time, several days' travel from California
by ship, Hawaii was not yet an icon of mass tourism. As a writer in
the *Honolulu Advertiser* noted perceptively, "Honolulu has made a
hit with the [couple]—because it has left them alone."[2] Twelve years
after this first visit, Duke wrote a short article for *Town and Country*
magazine in which she recalled,

> Precisely at the time I fell in love with Hawaii and I decided I could
> never live anywhere else, a Mogul-inspired bedroom and bathroom
> planned for another house was being completed for me in India so
> there was nothing to do but have it shipped to Hawaii and build a
> house around it. (Duke 1947: 73)

From this beginning, Duke's estate, which would come to be known as Shangri La, was conceived and developed. Land was purchased in 1936 and construction began in the spring of 1937, concluding about two years later. In 1938, during construction, Duke and Cromwell traveled to Egypt, Iran, Turkey, and Syria to begin collecting in earnest and commissioning more architectural elements with which to furnish the estate. Thus while Mughal South Asia was the initial source of inspiration, Shangri La was subsequently conceived as something more pan-Islamic.

For nearly sixty years afterwards, Duke continued to build her collection using a threefold approach. Like many other collectors, she purchased antiquities from auction houses and dealers, and during her travels. But she did not limit her collection to items that happened to be for sale. She also worked with living artisans to have custom-made what was not available ready-made. She patronized artists and craftspersons in Syria, Iran, Turkey, Morocco, India, and Pakistan to make ceilings, screens, doors, a mosaic fountain, monumental tile panels, drapes, and a fireplace, among other architectural elements. She also created Islamic-style arts and architecture for Shangri La, with assistance from American architects, landscapers, and contractors. The most prominent example of this approach is the building known as the Playhouse (Figure 6.2). Its facade was modeled on the seventeenth-century Chihil Sutun pavilion in Isfahan, Iran.

Duke retained much of the archival documentation related to her activities at Shangri La, so today it is possible for the most part to ascertain which architectural elements are antiquities and which were newly made and where, whether in Hawaii or in the Islamic world.[3] In some cases, objects that are historical and ones that have been newly copied are so visually similar that without archival evidence it is a significant challenge to identify what is historical and what is newly made. This was not an attempt to be deceptive on Duke's part—she knew well what was what. Instead, it is a tribute to the craftsmanship of twentieth-century artists. For example, a well-known auction house catalogued the collection at Shangri La in 1994

Figure 6.2: Main garden and the Playhouse at Shangri La

Source: Photo by David Franzen, used with permission of the Doris Duke Foundation for Islamic Art.

and misidentified the ceiling in the Foyer as a nineteenth-century Moroccan creation when, in fact, archival research later revealed that it had been custom-made in Fez in 1938.

COMMISSIONING, COLLECTING, CREATING

Doris Duke retained documents related to her purchases and patronage, sometimes exhaustively. A good example of the archival resources which enhance our understanding of the collection and collector are those related to the creation of the Mughal-inspired bedroom and bathroom suite. In reading correspondence from 1935, it becomes clear that Duke took an active role throughout the design process in shaping the aesthetic of her interiors. For example, during the honeymoon, James Cromwell wrote from Singapore to Blomfield in New Delhi that Doris "was disturbed about the panel design of the *jalis* shown on your rough sketch as she wanted them without panels like the *jalis* surrounding the [tomb] of Mumtaz at the Taj."[4]

Duke was not, however, constrained by historical sources. She did not evidently feel that from exact duplication came authenticity; instead, she adapted both design and function to suite her particular tastes and needs (Figure 6.3). In *Town and Country*, she explained:

> I tried to keep the house in character, using original Near Eastern pieces, but in order to make it livable as well, it was often necessary to adapt them to uses for which they were not originally intended. Thus in my Indian bedroom, carved, cutout marble *jalis* or screens, which were formerly used by Indian princes to keep their wives from other eyes, have a new purpose: they are not only decorative, but a means of security, for they can be locked without shutting off the air, and when not wanted can be pushed back into the wall. (Duke 1947: 75)

Figure 6.3: Sliding white marble jali screen in Doris Duke's bedroom

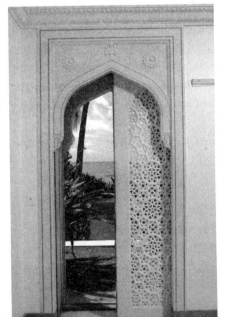

Source: Photo by David Franzen, used with permission of the Doris Duke Foundation for Islamic Art.

Knowing that Duke had specific ideas about how she wanted her marble suite to appear, it is possible to extrapolate other ways in which she might have influenced design. For example, the semi-precious stone inlaid marble panels in the bathroom show a certain simplicity in design, an elegance of line rather than an exuberance of color and pattern—the latter being closer to the marble inlay seen in much Mughal architecture. While we might attribute the difference to simpler designs being easier and cheaper to manufacture, the difference could also be attributed to Doris Duke and her preference, at least in the 1930s, for a modern aesthetic, something verging almost on Art Deco (Figure 6.4). The main residence of Shangri La is a good example of Duke's taste for the clean lines of modern architecture (Figure 6.5). It was only as she grew older and collected more art that Shangri La took on a more Islamicate aesthetic in the way its collections began to take over the built environment (Figures 6.6, 6.7, 6.8).

When the marble bedroom screens and doorframes arrived in Honolulu in 1938, they had not been well packed and had broken in transit. Duke, not wishing to have her beautiful interior compromised by repairs, ordered a new set of jalis to be made for her bedroom. Around this same time, a sample crenellation had been

Figure 6.4: Inlaid marble panels in the bathroom suite

Source: Photo by David Franzen, used with permission of the Doris Duke Foundation for Islamic Art.

Figure 6.5: The entry drive showing the façade of the main residence

Source: Photo by David Franzen, used with permission of the Doris Duke Foundation for Islamic Art.

Figure 6.6: The Playhouse, living room interior

Source: Photo by David Franzen, used with permission of the Doris Duke Foundation for Islamic Art.

Figure 6.7: The dining room in the main residence

Source: Photo by David Franzen, used with permission of the Doris Duke Foundation for Islamic Art.

Figure 6.8: Central courtyard in the main residence

Source: Photo by David Franzen, used with permission of the Doris Duke Foundation for Islamic Art.

added to the top of Duke's bedroom roof, but she found the effect unsatisfactory and had halted work on this part of the construction while she sought an alternative. Working opportunistically with her architects, Duke had the broken jalis repaired, and from them created a new architectural feature, the Jali Pavilion, to stand on the roof of her bedroom (Figure 6.9). While possibly inspired by pavilions she would have seen in South Asia including at Agra Fort, the Jali Pavilion at Shangri La was—like the sliding jalis in her bedroom—designed to suit its owner's Honolulu lifestyle. It served as a site for sunbathing.

Figure 6.9: Jali Pavilion on rooftop of Doris Duke's bedroom

Source: Photo by David Franzen, used with permission of the Doris Duke Foundation for Islamic Art.

Another example of Duke's commissioning work from South Asian artisans is the curtains that were custom-made for the Playhouse. We had not known that these were commissioned; looking at them, what was evident was that they had been made in India using hand-block printing methods. But archival research divulged the curtains' origins and has provided a correspondingly greater sense of how

Duke collected by combining creation and commission. While traveling in Egypt in 1938, she saw similar curtains in an Indian shop, and was so taken with them that she wrote to the shop's parent company in India to inquire about having similar ones made for Shangri La. In succeeding correspondence, Duke outlined her requirements for the curtains she wanted, including the type of material, design, color scheme, and size. From her specifications, the curtains were printed and sent to Shangri La.

In Duke's original conception, the curtains played a key role in the tent-like environment of the Playhouse's main interior (Figure 6.6). Although her vision of the space soon changed and the draped ceiling was jettisoned in 1940 in favor of the current Iranian-inspired painted ceiling, the curtains continued to play a defining role in the atmosphere of the main room.

In the mid-1960s, Doris Duke commissioned a second batch of Indian fabric for Shangri La, this time for the dining room (Figure 6.7). She had recently purchased nineteenth-century Egyptian and South Asian textiles, which inspired her to re-envision the original Hawaiian-style dining room filled with aquaria, shells and marine-motif furniture. The new space became more Islamic in style. Duke had the blue-striped fabric custom-made by weavers in India; it served as the backdrop for the tent-like environment upon which the historic textiles were showcased.

Over the years, the sea air has had harsh effects on the blue-striped fabric, discoloring and even shredding it. 2004 saw a major renovation at Shangri La when the worn original fabric was replaced with newly-made identical yardage. Like Doris Duke, we commissioned this new fabric, working with weavers in Jaipur by sending them a sample of the original fabric on which the new batch would be matched. So the tradition of working with artists in South Asia continues.

The Doris Duke Foundation for Islamic Art, which owns and manages Shangri La, will turn to South Asia again to replace the hanging lamps in the central courtyard (Figure 6.8). Duke originally purchased the lamps in Iran in 1938. By the mid-1980s, the salt air

and humid environs had corroded the metal so badly that much of it had been eaten away. She took a sample lamp to India in 1986, and had six new lamps made which now hang in the courtyard. In the past twenty years, however, these commissioned lamps are themselves showing signs of heavy corrosion. While cleaning and waxing can slow down damage and improve appearance, we will opt to replace the lamps in a few years by commission to metalworkers in Jaipur, rather than hiring a conservator to repair the "copied originals." In essence, the copies made in 1986 have become the originals from which the new copies will be made.

Another of Duke's significant commissions from South Asia occurred in the late 1960s, when she decided to replace the simple fireplace in her bedroom with something more elaborate. At first, she hired a Honolulu architect to design an Islamic-style fireplace to be fabricated locally. When installed, however, she was unsatisfied with the effect and so she turned to South Asia for inspiration and craftsmanship. A fireplace at Lahore Fort was identified as the model from which her new fireplace would be designed and the commission was given to Gem Palace, a company still based in Jaipur. Like the marble jalis of the late 1930s, the fireplace also arrived broken. But in this case Duke had it repaired, rather than commissioning a new one. It was installed in her bedroom where it remains today (Figure 6.10).

This idea of locally making "Islamic-style" elements for Shangri La, as happened with the first design for the fireplace and the creation of the Jali Pavilion from the broken jalis, plays out in the landscape in Duke's creation of a Mughal-style garden (Figure 6.11). When first conceived in 1937, the long, narrow terrace was known as the Allee, so-called for the central watercourse. Though neither named nor designed as a Mughal garden, the space nevertheless did contain elements typical of Mughal gardens, including the long, narrow watercourse and the *chinikhana*. Sometime in the 1960s, Duke reconceived the space, at this time renaming it the Mughal Garden, following the addition of new plants and hardscape features. She replaced the groundcover of grass with brick pathways,

Figure 6.10: Mughal-style fireplace in Doris Duke's bedroom

Source: Photo by David Franzen, used with permission of the Doris Duke Foundation for Islamic Art.

she introduced white *parterres* for small plantings, and a more emphatic division was made at the midpoint of the canal to suggest a quadripartite design scheme. She also replaced the Chinese banyans with trees that referenced historic Mughal gardens such as citrus and cypress trees. Archival evidence is sketchy about when the change occurred, but it seems to have come after a trip to Pakistan in the early 1960s, and Duke herself claimed that the design was inspired by Shalimar Gardens in Lahore.

Doris Duke had another Mughal-inspired architectural element made locally for Shangri La. A plaster arcade, inspired by South Asian design motifs with cusped arches and lotus-shaped bases, was designed for the private hall leading to Duke's bedroom

Figure 6.11: Mughal Garden, 1960s

Source: Photo by David Franzen, used with permission of the Doris Duke Foundation for Islamic Art.

(Figure 6.12). A few years after its manufacture, Duke replaced the arcade with six historic Spanish columns which she had purchased from the William Randolph Hearst collection. But as with many materials she worked with, Duke did not throw away the arcade, but instead recycled it by putting it to new use. She had it remade into a small pavilion to provide shade at the tennis court.

As a patron, creator, and displayer of South Asian and South Asian-style art, Doris Duke can be an enigma to scholars, particularly since she had a definite, strong aesthetic vision which did not correspond with the expectations of her age—nor, for some scholars the expectations of our own age. Unusually for a Western collector, Duke did not subscribe to the bias that "older = better." Indeed, her

Figure 6.12: Arcade of plaster columns outside Doris Duke's bedroom, between 1935 and 1940

Source: Photo by David Franzen, used with permission of the Doris Duke Foundation for Islamic Art.

proclivity to replace and recycle the old with the new seems more in keeping with South Asian values. Yet her interest in South Asian culture did occasionally follow patterns of American collecting. There are, for example, a few Mughal paintings in the Shangri La collection similar to what was typically acquired by serious Western collectors in the twentieth century. But overall, Duke was not compelled to collect what others deemed worthy.

Most often, she was drawn to decorative arts which she purchased while traveling in South Asia, at auctions and from dealers. On her honeymoon, she was particularly keen on textiles, purchasing seventeenth-twentieth-century hangings, spreads, and saris. Soon after, she also began purchasing furniture and doors, the latter being one of the noteworthy sub-collections at Shangri La. Over the

course of several decades she built a large collection of eighteenth-twentieth-century South Asian enameled gold vessels, enameled jewelry, and jades.

Duke rarely turned to experts to guide her purchases. She collected for pleasure rather than for social prestige or monetary value. In this way, she added to her collection examples of less familiar but no less intriguing arts such as objects which demonstrate direct interaction between South Asia and China. At Shangri La there is a large collection of Chinese jades in the Mughal style and numerous reverse glass paintings, possibly painted by Chinese immigrants in western India.

DORIS DUKE AND SOUTH ASIA

Why was Doris Duke drawn to the subcontinent to such an extent and for so much of her life? What did South Asia offer her? And why Hawaii? Compared with many of the women described in this volume, Duke was an outsider. She was neither from South Asia nor an expert on it, but an admirer. In a paradoxical way, she immersed herself in South Asian culture, yet did so from a distance. She commissioned and created South Asian environments for her private Honolulu home in the form of her bedroom suite, the Mughal Garden, and to a degree in the dining room and Playhouse. As James Cromwell described the concept for the Playhouse:

> Doris is ... planning to have a sort of combination guest-house and boat-house Cabana arrangement, built on or just above the swim pool. This guest-house would probably have double guest-rooms with a [lanai] for each, a miniature kitchen and sports-room connected to the pool. We got this idea from India and the purpose, of course, is not to have our guests continually in our hair, and vice versa.[5]

Duke's admiration of South Asia and her ease in Hawaii likely gave her freedom from the East Coast establishment society in which she was raised, but with which she never felt entirely comfortable

(Shangri La is notable for its absence of western arts). Although Duke continually reshaped and recreated elements within her home, over the decades she remained remarkably faithful to her vision of Shangri La as an Islamicate space in Hawaii, within which she could find privacy and respite. Because of Hawaii's distance from New York and Europe, establishing Shangri La became an act of both emplacement and removal. In building her home, Duke created a site whose intimacy depended partly on its distance.

It would be misleading, however, to interpret Shangri La only as a turning away from the aristocratic places and mores with which Duke was often dissatisfied. It was also a turning toward South Asia, an attempt to embrace something new precisely because of its alluring difference. I must add, too, that the answer to the question of what South Asia offered Doris Duke undoubtedly changes at different points in her life. She made numerous trips to the region, first in 1935 on her honeymoon and then more frequently in later life, including in 1961, '68, '69, '76, '86, and probably other times as well. Early on, it was her ambition to meet Gandhi. Newspaper accounts from 1935 indicate that she rearranged her itinerary in India hoping to meet the great leader—which she did, taking his photograph and collecting his autograph on a biography.[6]

As her visits increased, so too did her friends, and she returned to visit them in succeeding trips. In her later years, she also seems to have sought the spiritual teachings of India, as many have before her—or so the titles in her library suggest. But in addition to these books of later date, there are a number of scholarly titles including Richard Ettinghausen's *Paintings of the Sultans and Emperors of India in American Collections*, Stella Kramrisch's *Art of India*, and numerous titles by Mildred and W.G. Archer. Each point of entree— Gandhi, art and architecture, spiritualism, and scholarship—offered a lens through which to see South Asia. While they drew her in, she nonetheless remained an outsider looking in, a woman seeing and seen through a screen.

Understanding how and why Duke came to create such an idiosyncratic and engaging home, filled with old treasures and modern

commissions, is our ongoing task at Shangri La. Duke's commission of the marble bedroom and bathroom suite is a rare case for which we have Duke's first-hand commentary on why she made the choices she did. Yet even in this case, her story is only partially revealing. She tells us about her new home, but not about why Islamic and South Asian art specifically appealed to her—nor, for that matter, why she went so decidedly against the grain of contemporary aesthetic tastes for wealthy American collectors.

One of the challenges in interpreting her home and collection is the fact that, even with those she knew intimately, Doris Duke maintained a high degree of reserve. When correspondence had to be written, she preferred that her husband, secretaries, and agents write it on her behalf. She did not keep a diary recording her insights and experiences, ambitions or purposes. And yet, as I showed in regard to old receipts, photos, and news clippings, we can glean significant insights that help us understand Doris Duke's motivations as collector, commissioner, and creator.

From archival documents, the history of Shangri La can be pieced together. Combined with the physical legacy of Shangri La itself, an unusual pattern of collecting emerges. Duke did not collect what others deemed worthy; she did not collect what was coveted by her peers, because, at least in the earlier years, she collected not so much for herself, but for her home. She collected to create an evocative environment and hence sought textiles and architectural elements to cover the walls, ceilings, and floors. She sought objects of daily utility such as doors and furniture. And while her patterns of collection were similar when she traveled in other parts of the world, the South Asian emphasis at Shangri La is noteworthy. In the most private of interiors, her bedroom, Duke chose emphatically to display South Asian arts. In addition, Duke's commitment to commissioning art from South Asia was notably stronger than her commitment to artists from other regions.

I conclude on this point, with one final example: we know that Duke's conception of Shangri La as the site of a unified collection was fully formed by the 1980s, thanks to an oral history interview

with the American entertainer Jim Nabors, a good friend of
Duke's. Nabors recalls asking Duke what she intended to do with
the numerous pieces of Indian jewelry she had been purchasing
in earnest—was she going to wear them? Duke answered: No, it
wasn't for her, it was for the collection. This self-conscious creation
of a collection was a long step for Duke to take, but it is one she did
take gradually over the decades. Imagine the young woman, who so
fell in love with the Taj Mahal that she "had no choice but to build
a home around" her new bedroom and bathroom suite inspired
by the famous tomb. Imagine her reorienting herself to create a
collection, something for other people's eyes, a public legacy as it is
today. While South Asia remained a constant source of inspiration,
Shangri La itself underwent a transformation as its creator began
to see it in a new light.

NOTES

1. Letter from James Cromwell to Eva Stotesbury, April 1935.
2. *Honolulu Advertiser*, September 19, 1935, p. 1, cols. 3–4.
3. The archives are currently owned by the Doris Duke Charitable
 Foundation Archives, Duke Farms, Hillsborough, NJ, and are split
 between Shangri La and Duke Farms in Hillsborough, NJ.
4. Letter from James Cromwell to F.B. Blomfield, May 22, 1935.
5. Letter from James Cromwell to William D. Cross, May 6, 1936.
6. *New York Herald Tribune*, March 17, 1935; also, Rolland and Groth
 (1932).

REFERENCES

Duke, Doris. 1947. "My Honolulu House," *Town and Country Magazine*,
 August.

Littlefield, Sharon. 2002. *Doris Duke's Shangri La* (Honolulu: Doris Duke
 Foundation for Islamic Art, Honolulu Academy of Arts).

Rolland, Romain and C.D. Groth. 1932. *Mahatma Gandhi: The man who
 became one with the universal being* (London: George Allen & Unwin
 Ltd)

7 | Thinking through Pictures

A Kantian Reading of Amrita Sher-Gil's Self-portrait as Tahitian

PRADEEP A. DHILLON

Amrita Sher-Gil (1913–41) has not been forgotten by history. She has been the subject of much art criticism, appreciation, and art history in India.[1] However, the focus on making modern art in India that was part of a critical nationalist movement within a colonial context, has led to a narrow focus on her Indian oeuvre, causing her considerable accomplishments in Paris to be overlooked. For example, the art critic Karl Khandavala, despite being one of her strongest admirers, went so far as to suggest that her Paris paintings were without artistic merit (Dalmia 2006). Sher-Gil's history as a global artist was interrupted not only because she left Paris for India when European nationalism grew increasingly fascist, taking her Paris paintings with her, but also because art historical discourses are, in the main, tied to specificity of time and place. Hence, when she left Europe for India, she disappeared from European art history. Meanwhile, in India the focus of art historians has been primarily on the artworks made in India, with the result that her Paris paintings are either ignored or simply excluded from discussions about her work, defined primarily as work created in India.

Amrita Sher-Gil's biography has also played a strong role in the narrowing of our appreciation of her contributions to art history. Her father was a wealthy and scholarly Indian Sikh and her mother was of Hungarian Jewish descent. Sher-Gil was born in Hungary

in 1913, traveled widely, was educated in Italy, India, and France, married her Hungarian cousin, and died at the age of twenty-seven in Lahore in 1941. Some of her travels were the result of educational choices—first, in Florence, Italy, and then Paris, France—available to her as a result of her father's wealth and her mother's determination to nurture the artistic talent she recognized in her daughter. Some dislocations and relocations were the result of unfortunate wider historical forces. Being part Jewish herself and being married to her cousin, a Hungarian Jew, and with Sher-Gil's own professional interests strongly turning toward India, led to the final return from Europe to India in 1934. Given recent theoretical commitments, and given her biography, it is not surprising that her artistic achievements have been too often seen as being the result of divided, even conflicting identifications. Her work in Paris disappeared from European art history and was seen as being derivative by Indian art critics, while her work in India was often regarded as being insufficiently authentic.

From the perspective of a global art history, however, the limits of such particularity of analysis and criticism become increasingly clear. The emphasis on narrowly defined art-historical contexts for reasons of national politics and theoretical allegiances drove Sher-Gil from being an artist from India—that is to say, a cosmopolitan artist of Indian origin—to the more circumscribed designation of an Indian artist. Therein lies her success, and more generally, that of the success of Indian art history and art criticism. This boundedness of context, however, represents a loss to her reputation as a global artist since the prevailing modes of art historical discourse have been unequal to the task of adequately accounting for Sher-Gil's Paris paintings.[2] The increasing global awareness of the world today calls for the recognition of an unboundedness of art, disciplines, cultures, traditions, and so on. Globalization has introduced an epistemological turn.

Hans Belting has argued for a similar position with respect to world art as adopted by the celebrated contemporary Congolese artist Cheri Zamba. In his self-portrait, *J'aime La Couleur* (2009),

Zamba presents himself as a global artist.[3] Belting described Zamba's portrait for an exhibition of global art as "post-ethnic":

> It is a post-ethnic position to perform as an 'artist from Africa' rather than to suffer the label of an 'African artist' ... The self-portrait ... defines his departure from Kinshasa to Paris as a symbolical change of roles, from the ethnic role as African artist to the global role with an African ethnicity. The closed cage of his native environment opens up when the airplane brings him to international presence or visibility. He poses in the picture not just with his likeness but with the performance of his artist self, an old privilege of Western artists.[4]

While Belting limits his remarks to contemporary art, we could, with profit, take such a global approach to art in general. It is the way in which such global influences were realized within specific periods of time and places that now invite analytic attention. Amrita Sher-Gil's Paris paintings—indeed her entire oeuvre—are in need of precisely such appreciation and study. I argue that it is the lack of a philosophical theory with sufficient global reach that continues to mark the absence of her Paris paintings from contemporary European art history, and their subordination within Indian art history. In other words, these globalizing times provide an opportunity to recover for Amrita Sher-Gil her broader identity as an artist *from* India. Such an endeavor also enables a rethinking of the philosophical foundations of art historical writing, criticism, and education, and the political outcomes of such a philosophy (Pippin 2010). I suggest that a philosophical, specifically Kantian, analysis of her *Self-Portrait as Tahitian* (1934) provides just such an opportunity to examine issues regarding Amrita Sher-Gil and also art history more generally (Figure 7.1).

Taking a Kantian approach, specifically to the reading of *Self-Portrait as Tahitian* can deepen our appreciation of Sher-Gil's artistic efforts and choices in the making of a visual argument. It also offers insight into the value of reading pictures within a global context. Some of the limitations in writing and thinking about artworks like those of Sher-Gil, as I have already mentioned, arise from the prior

Figure 7.1: Amrita Sher-Gil, *Self-Portrait as Tahitian*, 1934

Source: From the private collection of Navina and Vivan Sundaram. Published with permission from Vivan Sundaram.

theoretical commitments of art critics, historians, and educators that are the legacy of a discipline that arose in the mid-nineteenth century with a strong Hegelian view of world history. Alternate philosophical approaches, such as a return to Kantian aesthetic theory after poststructuralism, could prove useful in placing Sher-Gil more appropriately within the history of modernism itself. [5] A Kantian orientation in thinking and analysis can help us see Sher-Gil's *Self-Portrait as Tahitian* in wider perspective and can also point us toward a global art history more generally, and that of modernism

in particular. This is a demand placed on aesthetic theories today by modernist works of art from around the world, as noted by art critics and historians like Gita Kapur, Hans Belting, and Partha Mitter, and as reflected also in the burgeoning of exhibitions of contemporary and modern art that defy twentieth-century categories predicated on stable identifications and narrowly defined contexts. Furthermore, this need for a wider epistemology is closely linked to issues of global equity and citizenship.[6] Works like Amrita Sher-Gil's *Self-Portrait as Tahitian* make both these demands visually and must be read as such. A global modernism that would speak to artistic production everywhere, and one that is not based on notions of lack and derivative art making, or what Mitter so elegantly terms "the Picasso manqué syndrome," is the way forward toward a more equitable representation and understanding of global cultural production (Mitter 2007: 7).

Sher-Gil's nephew Vivan Sundaram—an artist and critic in his own right—recently published a biography of Amrita Sher-Gil with *Self-Portrait as Tahitian* on the cover. This brought the image to the attention of a wide audience within the art world. Sundaram's work as an artist, a curator, and a critic has sought to expand the contexts of relevance for the making, display, and evaluation of artworks. In 2001–2, for example, he exhibited a series of digital photomontages entitled *Re-take of Amrita*. With these, he re-presented the Sher-Gil family history by combining images of Amrita Sher-Gil's paintings and photographic images of the family taken by her father, Umrao Sher-Gil. Through this work, Sundaram provided a glimpse of the global identifications and complexities that comprised Amrita Sher-Gil's life, making a visual argument for the cosmopolitan seamlessness of her sense of self (Figures 7.2 and 7.3). Sundaram presents a narrative of Sher-Gil's identity of herself as woman and artist that does not depend on the binaries of residing/traveling, Europe/India, home/abroad, and other such dominant ways of thinking about identities and identifications that inform much of the art historical discourse around her. Through this working of the Sher-Gil archives, Sundaram also made visible the possibilities of

Figure 7.2: *Bourgeois Family: Mirror Frieze,* 2001, digital photomontage

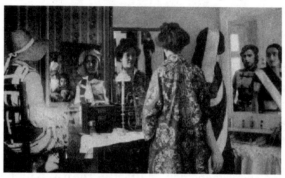

Source: Vivan Sundaram.

Figure 7.3: Untitled, digital montage

Source: Vivan Sundaram.

cultivating what Marsha Meskimmon calls "a cosmopolitanism of imagination." Meskimmon writes:

> [The project] provides an evocative portrait of a family whose intellectual and artistic endeavours crossed continents, languages, philosophies and cultures. In some senses, the Sher-Gil family epitomizes the notion of cosmopolitanism as a form of elite

cultural movement undertaken in the main by artists, writers and intellectuals to move freely across geographical and social boundaries. However, locating the cosmopolitan project described here simply within the privileged realm of the bourgeoisie dismisses too easily the significance of the transnational experience articulated by The Sher-Gil Archive and its development of a cross-cultural visual and material language. (Meskimmon 2011: 21)

For Meskimmon, cosmopolitanism, rather than being devoid of political potential, as charged by some cultural theorists, actually provides the very possibility of global political thought and action we seek today. Cosmopolitanism is committed to cultural diversity and movement beyond fixed geopolitical borders. In her view it entails a view of home tied to processes of belonging and hospitality and is a way of knowing that is always in movement. Meskimmon's insightful comments, however, remain at the level of a tentative moral and political hope. To shift from hope to articulating the moral/political and rhetorical conditions for a global art history, art historians, critics, and educators could turn more explicitly to the philosophical to the theories of Kant with considerable profit.

In two essays, "The Idea for a Universal History with a Cosmopolitan Purpose" (1784) and "Perpetual Peace: A Philosophical Sketch" (1795), Kant articulates the conditions necessary for the building of a global civic society. In his view, this would not be a world order based on dominance, but rather a federation of free and equal states within an international system regulated by ethics and the law (Kant 1991: 41–53, 93–130). Hospitality, a virtue Meskimmon also invokes, is for Kant a way of orienting ourselves toward the world with cosmopolitan intent. In his words, "It is a right for citizenship in an international cosmo-political system. Freedom of movement across and within States can be claimed as a right by virtue of global citizenship" (ibid.: 105–7).

This is pertinent to Sher-Gil, because Sundaram's work on Amrita Sher-Gil—and Meskimmon's reading of his art—provides a clear sense of Sher-Gil's global and cosmopolitan identifications. Thus,

Sundaram, through the images he created from the Sher-Gil archives, challenges the bulk of art writing that reads her mixed Sikh and Hungarian Jewish heritage and her diasporic life too easily in terms of split and divided identities (Mitter 2007: 57–58). In other words, too close a focus on Sher-Gil's mixed parentage and diasporic life have led to an overly simple reading of her paintings in narrow terms of identity. Surprisingly (or not so surprisingly), the issue of split and divided identifications is not generally raised for other Indian artists of her time, like Rabindranath Tagore and Jamini Roy, who— like Sher-Gil—were experimenting with the visual presentation of a modern internationalist India using modernist visual vocabulary. While not of mixed parentage, they too held multiple identifications having been educated in both the western and Indian traditions, and also as a result of their travels between Europe and India and between city and country.

As Yashodhara Dalmia, despite her own commitment to the divided self thesis in reading Sher-Gil's paintings, tellingly puts it, Sher-Gil "drew upon her experiences and articulated them in a striking manner. She melded Western and Indian idioms and did not, like many other artists of her time, attempt to find an authentic 'Indian' mode or weave together a nationalist agenda" (Dalmia 2006: 92). Her commitment to herself as a professional artist was so complete—sure as she was in the knowledge and techniques of modernism—that she expressed sharp disappointment when hearing of the prizes awarded her at the 5th All India Fine Arts and Exhibition in 1936. It was a two-pronged disappointment. First, one award was in the category of the best work by a "lady" artist. The disappointment at receiving a prize in this category is not surprising given her demonstrated sensitivity to the status of women both in Europe and India at the time. Second, the painting they picked— *Self-Portrait*—was not, on her own account, an example of her best work. Indian critics in the main, she thought, were condescending towards her and were still in thrall of emotional pictures and did not appreciate those that exhibited formal merit. Partha Mitter, also reading Sher-Gil as troubled, divided, alienated, and not quite

Indian, nevertheless notes how at home Sher-Gil was in the world and how fluidly she moved between Paris, Shimla, and Lahore (Mitter 2007: 58).

Sher-Gil was troubled no doubt, but that could just as easily be ascribed to her unstable home environment (Dalmia 2006, passim). It could also be that her unbounded self had difficulty fitting in either European or Indian society, both narrowly defined. If she was too Indian in Paris for some, she was too Parisian in India for others. In a poststructural sense, Sher-Gil's diversity of social identifications were not an affliction that she bore—in her case they were just a bit more dramatic—but rather the condition that everyone negotiates in lived experience. However, the unremitting attention to her identity projects biography too strongly onto her art and misses the radical cosmopolitanism of her work, especially visible in her Paris paintings. In sum, the theoretically driven need to locate her either in Europe or in India is largely responsible for the absence of her Paris paintings in the former context and their marginalization in the latter.

In *Self-Portrait as Tahitian,* Sher-Gil uses her multiple identifications to make a visual argument against Paul Gauguin's representation of Tahitian women in particular, and Europe's representation of women and non-western peoples more generally. The title of the self-portrait immediately connects it with Gauguin's paintings of Tahitian women and anticipates by almost half a century the now familiar colonial and feminist critiques of Gauguin's art and life (Figure 7.4) (see, for example, Mathur 2011).

In painting *Self-Portrait as Tahitian,* Sher-Gil points to Paul Gauguin's violation of the norms of cosmopolitan and democratic intent that Kant takes to be essential for the promotion and achievement of a perpetual peace. In the Kantian view, Gauguin paints from an epistemically inhospitable point of view.

Belinda Thompson, in *Gauguin: The Myth Maker,* which seeks to reestablish Gauguin from a global perspective, tells us that Gauguin was deeply immersed in world art and a great reader of Polynesian stories and myths (Kant 1991: 16). Nevertheless, he remains

Figure 7.4: Paul Gauguin, two Tahitian women, 1899, oil on canvas

Source: The Metropolitan Museum of Art, New York.

emblematic of western colonialism and all that it means for cultural exchange, commerce, travel, and exploitation (Thompson 2010). This is the subject of the scathing feminist critique offered by Abigail Solomon-Godeau:

> In the expeditionary literature generated by Captain Cook, Wallis, Bougainville and the countless successive voyagers to the South Seas, the colonial encounter is first and foremost the encounter with the body of the Other. How that alien body is to be perceived, known, mastered or possessed is played out within a dynamic of knowledge/power relations that admits of no reciprocity. On one level, what is enacted is a violent history of colonial possession and cultural dispossession—real power over real bodies. On another level, this encounter will be endlessly elaborated within a shadow world of representations—a question of imaginary power over imaginary bodies.[7]

This fierce indictment of Gauguin is, in Kantian terms, an expression of inhospitality within a global history. Such a history is written without a cosmopolitan point of view. Speaking of European travelers

in non-European worlds and the ethical demands of hospitality placed by cosmopolitanism, Kant wrote,

> If we compare with this ultimate end the inhospitable conduct of the civilized states of our continent, especially the commercial states, the injustice which they display in visiting foreign countries and peoples (which in their case is the same as conquering them) seems appallingly great. (Kant 1991: 106)

In order to lay out the conditions for realizing a cosmo-political ideal and the kinds of action that would undermine its realization, Kant writes that non-European lands were regarded as "ownerless territories," in which trading posts were established with the support of troops, that in turn led to oppression, betrayal, revolts, and famine (ibid.).

But just as we should not oversimplify Sher-Gil, neither should we simplify Gauguin in order to fit him too quickly within a feminist, postcolonial theoretical framework. Gauguin's letters and autobiography show that he did care for the Tahitians and was critical of the way they were treated by the European community on the island. Gauguin's appreciation and representation of world cultures and peoples then is not a straight-forward expression of epistemic inhospitality in Kantian terms, but rather is an expression of *exoticism* which is a more subtle form of such epistemic commitments.[8]

Exoticism is the appreciation of, and engagement with, cultures other than one's own from the perspective of superiority. Thus, Gauguin could be deeply and sincerely interested in world art and culture and yet create works that mythologize real people, who serve to extend critical reflections on his own society.[9] One could argue, following Peter Brooks, that Gauguin sought to present an image of Tahitian bodies that challenges what he considered the repressive and misogynist relationship with the female body in the West, particularly in France of the nineteenth century. In so doing Gauguin presents a myth of paradise that derives from the very cultural situation whose values he wishes to challenge and to whom he seeks to offer an alternative, healthier way of organizing sexual

and gender relations. Paradoxically, he does this by making Tahitian women inert objects. In Kantian terms, they are not presented as ends in themselves, but rather serve as the means to Gauguin's critical ends. However, Brooks reminds us of the lesson

> ... for all later artists who would attempt to rethink the tradition of the nude Gauguin's effort is kind of a tattoo: not so much a writing on the body—though there certainly are messages inscribed on his nudes—but writing of and with the body, making the body not so much transcendent signified as the ultimate, irreducible signifier. (Brooks 1986: 343)

According to Susie Tharu and K. Lalita:

> Our stress is on what forms the grain of these women's struggles. How were their worlds shaped? we ask. How have they turned figures, plots narratives, lyrical and fictional projects set up for different purposes to their use? With what cunning did they press into service objects coded into cultural significations indifferent or hostile to them?[10]

With the *Self-Portrait as Tahitian*, Sher-Gil follows Gauguin in the writing of and with the body but in a manner that challenges him since she is writing with her own body, thus making it an irreducible signifier. We find here no demure expression or averted gaze. The subject gazes out and beyond the frame directly challenging Gauguin's "Orientalizing" gaze. In Sher-Gil's painting, the gendered and racially marked subject presents itself as an object for viewing, but does so through a stern refusal of engagement with the viewer either through eye contact or through a demurely inviting demeanor which has traditionally been a way of painting female nudes as objects of male desire. Here, we have a nude that presents itself as an object and yet refuses objectification. The orientalizing, patriarchal gaze cannot succeed; it is interrupted.

Trained at the École des Beaux-Arts and living in Paris in the 1930s, Sher-Gil was familiar with modern art. Her self-portrait,

neither nude nor naked,[11] finds precedent in Édouard Manet's *Olympia*, which was on display at the Louvre at that time, and Sher-Gil would certainly have been familiar with it (Figure 7.5).[12] The female subject in both paintings presents herself boldly, almost fiercely, and yet with emotionless eyes that refuse to meet the viewer's gaze. In the shadowy male figure that looms menacingly behind Sher-Gil's self-portrait, in front of a lightly sketched Japanese screen, we see the press of the racial, patriarchal, and colonial structures of knowledge that Sher-Gil challenges. The male shadow that frames her references is the menacing male figure in a top hat in Manet's *A Bar at Folies-Bergere*.[13] Both Sher-Gil's self-portrait and Manet's *Olympia*, on reading this, are intended as a kind of affront or at least challenge to the gaze of presumed power and superiority. In *Olympia*, the body is turned toward the beholder, and yet, ironically, in gazing directly out in this manner, the beholder is rendered both "invisible and irrelevant" (Pippin 2010).

Figure 7.5: Édouard Manet, *Olympia*, 1863, oil on canvas

Source: Metropolitan Museum.

It is the similar absence of mutuality between the subject of painting and the beholder suggested by this invisibility, and the air of unmistakable melancholy this creates, that makes Sher-Gil's painting such a strong response to Gauguin. Here is a sophisticated artist, deeply familiar with the history of modern art, who is also a brown woman—like Gauguin's Tahitian women—and she looks out of the picture questioning and commenting on the epistemic regimes of Parisian society.

Many art historians regard Manet's *Olympia* as the signal work of modernism. Sher-Gil's self-portrait is equally extraordinary for its global extension of that modernism. Sher-Gil's acute sympathy for women and her critique of patriarchy also appear in her paintings of rural Indian women and has been noted by Indian art historians. But this sympathy manifests itself in her Paris paintings too. Her painting, *The Professional Model* (exhibited at the Salon du Cercle International Feminin in 1933) shows an aging woman with sagging breasts who seems too tired to hold her body in a model's pose. With this image, Sher-Gil presents a stark contrast and challenge to the existing conventions of representing nude females as young, healthy, and beautiful. On seeing *The Professional Model*, the Parisian critic Denise Proutaux is reported to have asked in astonishment: "Where did this young girl learn to see life with such pitiless eyes and without any illusions?" (Mitter 2007: 59) Sher-Gil at this time was but twenty years of age.

In her next Paris painting, *Young Girls*, for which she was awarded a gold medal and elected Associate of the Grand Salon in 1934, Sher-Gil develops her critical approach to gender even further. In this picture, a fully dressed, in control, non-European female observes a European woman in a relative state of undress. Both women are presented as possessing equal social status. However, the non-European woman, albeit in European dress, exercises the gaze of power that is generally attributed as "male" toward the partially undressed European woman. In this picture, Sher-Gil deftly reverses the asymmetries of power with regard to race and gender. Moreover, through these reversals the painting provides not only a critique of

colonial and patriarchal alienating structures of knowledge but also makes a strong gesture toward liberation, independence, and self-determination. In this picture, the colonial subject breaks out from under epistemic and representational regimes of western control and domination.

Furthermore, in her *Self-Portrait as Tahitian*, Sher-Gil places herself against the background of a Japanese screen. In so doing, she invokes the Japonisme of the French impressionists, and perhaps van Gogh's more hopeful engagement with Asian art (Mathur 2011). A direct precedent, and one not mentioned by Mathur, I suggest, can be found in van Gogh's self-portrait, made at Arles in September 1888 and dedicated to Gauguin. Van Gogh makes himself look Japanese through his almost shaved head and a somewhat Asian morphing of his features.[14] Thus, unlike Gauguin, in a spirit of epistemic hospitality and cosmopolitanism, van Gogh establishes a fraternal relation between Europe and Asia. In contrast to Gauguin's alienating and subordinating gaze, van Gogh offers us a mode of seeing and representing that builds toward the cosmopolis which Kant sees as the only way of achieving perpetual peace given the "crooked timber" of human nature. By dedicating his portrait to Gauguin, van Gogh presents a subtle critique of Gauguin's paternalistic representation of other cultures. Van Gogh melds into the Other, thereby eliminating that category. Gauguin stands over against the Other and reinforces the dualism. Even though Sher-Gil's paintings in India reflect the importance of Gauguin in the development of her own style, she expresses a clear preference for van Gogh. Her own paintings of the rural poor in India never quite fall into Gauguin's "primitivism," as she paints her subjects with unquestionable empathy.

In other words, Sher-Gil acknowledges van Gogh's critique of Gauguin in his self-portrait dedicated to Gauguin but makes the critique more explicit. Moreover, as we saw in *Young Girls*, she does more than just reflect on European systems of marginalization and alienation that were close to reaching a crescendo in the 1930s when she was painting this image. Rather, she finds a space for liberation and self-determination through this painting. In *Self-Portrait as*

Tahitian, by placing herself in front of a Japanese screen with both women and men represented on it, she claims a history and culture for herself as Asian. The "Tahitian" of her image is a historical, encultured agent, to be treated as an end in herself and not a means to an end.

Sher-Gil's critique, however, is not limited to content in *Self-Portrait as Tahitian;* her critique extends to the formal aspects of her painting too. Nelson Goodman, in his *Languages of Art*, provides the most strenuous arguments for representations in one-point perspective being a matter of convention rather than that of rendering reality on the basis of the laws of optics (Goodman 1976: 10–19). Any kind of pictorial rendering of reality, for Goodman, is always a translation and hence based in convention.

> Pictures in perspective, like any others have to be read; and the ability to read has to be acquired. The eye accustomed solely to Oriental painting does not immediately understand a picture in perspective. Yet with practice one can accommodate smoothly to distorting spectacles or to pictures drawn in warped or even reversed perspective. (ibid.: 13–15)

As an artist, Sher-Gil anticipates the understanding of the conventions of perspectival rendering that the philosophers Merleau-Ponty and Goodman would argue for much later. By painting *Self-Portrait as Tahitian* using a one-point perspective, Sher-Gil has consciously painted a political picture in terms of both content and form. It is possible that she anticipated the epistemic role played by perspectival rendering of reality in the rational ordering of the world from within the centers of Europe. This is possible only if one accepts that perspectival renderings are a matter of convention. The historian John M. Headley, in *The Europeanization of the World*, ties cartography and perspectival drawing together as efforts to order the world in a comprehensible manner to the viewer who stands beyond and above it. Headley sees this way of seeing as necessary to the quest for Empire that developed as a result of the rise of capitalism in Europe in the sixteenth century (Headley 2008:

9–62). Given Sher-Gil's education in Paris, it is not implausible to accept that Sher-Gil understood Cézanne's lessons regarding lived perspective, and so she would have understood that perspectival renderings are a matter of convention and hence tied to cultural epistemic norms. It is not at all surprising then that she would place herself and Asia within precisely such a spatial representation, one that simultaneously invokes both depth of history and richness of culture and epistemologies of power and control. In sum, Sher-Gil, in the *Self-Portrait as Tahitian*, reflexively and systematically uses the modernist canon to challenge its own assumptions. Therein lies the groundbreaking power of her contribution to a global visual modernism.

Much of the recent discussion in art history on the need to de-center the study of modernism sees it primarily as a movement that spread to other regions from its centers in the West throughout the twentieth century, shaping global perceptions of, and trends in, contemporary art and literature. This was a transformation that left few societies untouched. These discussions are also marked by an insistence on considering art produced in different parts of the world using the modernist vocabulary as artworks in and of themselves and not as derivatives of artworks that used to be the centers of modernism. Sher-Gil, on the other hand, prompts us toward a different moral and historical possibility. Rejecting Hegelian notions of cultural progress linked to historical laws, Sher-Gil reminds us of Kant's mighty lessons regarding the human capacity for reasoning, the importance of the free use of reason articulated in public through preferred forms of representation, and a philosophical history that lurches toward a larger view of human possibilities. The tragedy of Sher-Gil was not only that she died so young, but also that she understood and exercised the innate capacity for freedom at a time when the world was growing ever more limited.

Hans Belting recognizes the demise of a Hegelian view of modernism and worries that an art history that is tied too strictly to traditions might subsume the works of art themselves. On this, Jonathan Gilmore notes, "Contemporary art, by contrast, seems

different—not anxious, oppositional, or nostalgic in its relation to the past. One wonders what an analogous art history, 'set free' from the grip of its own tradition, would turn out to be."[15] This freedom is what Amrita Sher-Gil achieved so well through her visual critical thinking, and the public use of reason in *Self-Portrait as Tahitian*. The image demands the Kantian sense of universal human dignity.

Sher-Gil was a pioneer and ahead of her times in seeking a new place for herself when she painted not as a European or an Indian but as her cosmopolitan self. This is precisely what Belting meant when he wrote that "contemporary artists no longer think of themselves as Indian artists, or Tanzanian artists, but rather as artists from India, from Zaire, from Brazil and so on. They claim for themselves a place that is at once global and local" (Belting 2009). What we argue for today, was already articulated by Sher-Gil through her Paris paintings and especially *Self-Portrait as Tahitian*. A nationalist art history, no matter how critical a position it holds, is not equal to the task of capturing the cosmopolitan vision of the world that artists like Sher-Gil and Cheri Zambo articulate.

Sher-Gil's Paris painting have been largely ignored or marginalized in the western canon of art history and Indian art criticism. But in this article I have shown why her *Self-Portrait as Tahitian* is hard to ignore in the global context within which we live today, where centers of art are just as likely to be Shanghai and Sharjah as they are Paris and New York. We are being called on today to theorize broadly, drawing images from around the world into a rich art historical discourse. While the theoretical underpinnings for discussing art derived from Hegelian and structuralist positions have been enormously useful, they have their limits. Through their analytic lens, paintings like Sher-Gil's *Self-Portrait as Tahitian* are likely to receive insufficient attention since they are not tied to a single tradition. The concept of "hybridity" that is often used to address cultural forms shaped by different cultures is sterile by definition, since it is predicated on a blending of already fixed and defined entities. I believe Kantian value theory can go quite some distance in enabling us to develop protocols of art history and criticism that capture the artistic efforts of a Cheri

Zambo or an Amrita Sher-Gil, the worlds they are commenting on, and the cosmopolitan futures they envision. This not to argue for reading, making, and evaluating paintings outside history, but rather engaging in art practices with deeper moral awareness and broader international, historical responsibility. As Kant wrote regarding "the burden of history" on our future descendants:

> No doubt they will value the history of the oldest times, of which the original documents would long since have vanished, only from the point of view of what interests *them*, i.e. the positive and negative achievements of nations and governments in relation to the cosmopolitan goal ... and this may provide us with another *small* motive for attempting a philosophical history of this kind. (Kant 1991: 53)

Amrita Sher-Gil's *Self-Portrait as Tahitian* provides such a Kantian lesson in philosophical history.

NOTES

1. For full length treatments see Vivan Sundaram's definitive two-volume *Amrita Sher-Gil* (2010); also, Anand (1989), Dalmia (2006), and Sundaram et al. (1972) among others.
2. See Mathur (2011). Also see Mitter (2007: 45–65) for the beginnings of such a criticism.
3. http://www.mutualart.com/Artwork/J-AIME-LA-COULEUR/01BE62A6F6326FCB/
4. Hans Belting first saw it at the exhibition "Magiciens de la terre," organized by Jean-Hubert Martin in Paris in 1989. See Belting (2009), and globalartmuseum.de/media/file/476716148442.pdf (last accessed September 21, 2011).
5. Paul Guyer has been in the lead in making the case for the contemporary significance of Kant philosophy in general, but his *Critique of Judgment* in particular. See, for example, Guyer (1996). Also Derrida (1997) and Dhillon (2013).
6. On the continuing importance of modernity for framing discourse on cultural production in India and other parts of the non-western

world, see especially Geeta Kapur's trenchant arguments in *When was Modernism* (2000).

7. Solomon-Godeau (1986: 320). But for an alternative yet feminist reading, see Donahue (2000).
8. See Todorov (1998) on the metaphor of travel as an epistemic trope.
9. This is a familiar move in anthropological discourse.
10. Tharu and Lalita (1993: 40) cited in Kapur (2000: 3).
11. For this distinction, and the related distinction between art and pornography, see Maes (2011).
12. On the provenance of the painting, see the Musée D'Orsay website: http://www.musee-orsay.fr/en/collections/index-of-works/notice.html?no_cache=1&nnumid=000712&cHash=3ebae2ac84
13. I owe Jennifer Grayburn this point.
14. Van Gogh was deeply interested in the Japanese style of painting. A year before he did the self-portrait, he painted *La Courtisane*—an image of a geisha.
15. Jonathan Gilmore, "Discipline Problem: Jonathan Gilmore on Hans Belting," Book Review of *Art History After Modernism* by Hans Belting, in *Artforum*, October 2003.

REFERENCES

Anand, Mulk Raj. 1989. *Amrita Sher-Gil* (New Delhi: National Gallery of Modern Art).

Belting, Hans. 2009. "Contemporary Art as Global Art," in H. Belting, A Buddensieg and E. Araíya (eds), *The Global Art World: Audiences, Markets, and Museums*, pp. 38–73. (Ostfildern: Hatje Cantz).

Brooks, Peter. 1986. "Gauguin's Tahitian Body," in N. Broude and M. Garrard (eds), *The Expanding Discourse: Feminism and Art History*, pp. 329-345 (New York: Harper Collins).

Dalmia, Yashodhara. 2006. *Amrita Sher-Gil: A Life* (New York: Penguin Viking Press).

Derrida, Jacques. 1997. *Truth in Painting*, trans. Geoffery Bennington and Ian McLeod (Chicago: University of Chicago Press).

Dhillon, Pradeep A. 2013. "A Kantian Approach to Global Art History: The Case from Indian Modern Art," in Vittorio Hosle (ed.), *The Many Faces of Beauty* (South Bend: University of Notre Dame Press).

Donahue, Suzanne. 2000. "Exoticism and Androgyny in Gauguin," *Aurora: The Journal of the History of Art*, I: 103–21.

Goodman, Nelson. 1976. *Languages of Art* (Indianapolis: Hackett).

Guyer, Paul. 1996. *Kant and the Experience of Freedom* (Cambridge: Cambridge University Press).

Headley, John M. 2008. *The Europeanization of the World* (Princeton: Princeton University Press).

Kant, Immanuel. [1784] 1991. *Kant: Political Writings* (ed.), H. Reiss, trans. H.B. Nisbet (Cambridge: Cambridge University Press).

Kapur, Geeta. 2000. *When was Modernism: Essays on Contemporary Cultural Practice in India* (Delhi: Tulika).

Mathur, Sonali. 2011. "A Re-Take of Sher-Gil's Self-Portrait as a Tahitian," *Critical Inquiry*, 37(3): 515–44.

Maes, Hans. 2011. "Drawing the Line: Art versus Pornography," *Philosophy Compass*, 6(6): 385–97.

Meskimmon, Marsha. 2011. *Contemporary Art and the Cosmopolitan Imagination* (New York: Routledge).

Mitter, Partha. 2007. *The Triumph of Modernism: India's Artists and Avant Garde, 1922–1947* (London: Reaktion Books).

Pippin, Robert. 2010. "After the Beautiful: Hegel and the Philosophy of Visual Modernism," paper presented at the Philosophy Colloquium at the University of Illinois, Urbana-Champaign.

Solomon-Godeau, Abigail. 1986. "Going Native: Paul Gauguin and the Invention of Primitivist Modernism," in N. Broude and M. Garrard (eds), *The Expanding Discourse: Feminism and Art History*, pp. 312–29 (New York: Harper Collins).

Sundaram, Vivan. 2010. *Amrita Sher-Gil: A Self-Portrait in Letters and Writing* (Chennai: Tullika Books).

Sundaram, Vivan, Geeta Kapur, Gulam Mohammed Sheikh and K.G. Subramanyan. 1972. *Amrita Sher-Gil: Essays* (Bombay: Marg).

Tharu, Susie and K. Lalita (eds). 1993. *Women Writing in India: 600BC to the Present, Volume II: The Twentieth Century* (Delhi: Oxford University Press).

Thompson, Belinda. 2010. *Gauguin: Maker of Myth* (Princeton: Princeton University Press).

Todorov, Tzvetan. 1998. *On Human Diversity: Nationalism, Racism, and Exoticism in French Thought* (Cambridge, MA: Harvard University Press).

8 | Pravina Mehta

A Woman Architect in Post-independence India*

MARY N. WOODS

Since the nineteenth century when British imperialists and Indian nationalists first clashed over "Mother India," women have symbolized competing visions of a reborn and resurgent India. Claiming to protect and nurture her best, each party chose women to symbolize its ideas about a new India. The colonizers argued that they had saved Indian women from purdah, sati, and child marriage. Ushering women into a modern world outside the home, British and American missionaries established the first schools for girls.[1] In India—as elsewhere in the colonial world—women's emancipation became a touchstone for the argument that British rule was progressive and benevolent.

Early nationalists, for their part, countered that westernization had cost India its cultural essence and traditions, and that a new and independent India would reclaim this heritage. Indian women were regarded as the guardians of this traditional realm, different from and superior to the materialism and technocracy that the British offered Indians (Sinha 2000). However, leaders of the independence movement also saw not only a traditional but an emancipated

* This work is part of a larger project on the history of women architects in Mumbai and New Delhi from the 1930s to the present day. Much of the information gathered for it comes from personal interviews that I conducted with Malvika Chari, Lalit Chari, Rumy Shroff, Sanjay Mehta, Shirish Patel, Malatiben Jhaveri, Carmel Berkson, Carmen Kagal, and Minakshi Amundsen in 2006–8 and 2010–11.

woman as the symbol of a new India. "Woman has as much right to shape her own destiny," Mohandas Gandhi insisted, "as man has to shape his" (Moore 2005: 192). As prime minister of the new nation, Jawaharlal Nehru believed the emancipation of women symbolized a new beginning for India (Brown 2003: 201–2; Moore 2005: 59). Perhaps the iconic image of this Indian woman was Nargis, a Hindi actress and international star, in the film *Mother India*. As Radha in this 1957 epic, she portrayed a village woman sustaining her family and yet sacrificing personal happiness for the communal good. Nargis's Radha was indeed Mother India, at once one with Gandhi's traditional India of the soil and with Nehru's socialist ideals for a modern India.

Yet Indian women have been more than simply icons and images, objects and projections of the male gaze. They actively constructed a new India as both leaders and followers in the independence movement. Sarojini Naidu was a freedom fighter before Gandhi appeared on the scene, and in 1925 she became the first woman to lead the Indian National Congress party. Even ordinary women took extraordinary steps into the public realm during the independence struggle. In the Quit India Movement, women from different castes boycotted British products, demonstrated in the streets, and endured imprisonment for their defiance of imperial rule (Sengupta 1997: 32–33).

After independence, the women of the Nehru family continued Naidu's tradition of leadership. Emerging from her father's shadow, Indira Gandhi became prime minister in 1966, governing for fifteen years until her assassination in 1984. Sometimes called "the only man in her cabinet," Gandhi was one of the few women leaders of the postwar period and a pivotal figure in the Non-aligned Movement during the Cold War. Now Sonia Gandhi, her Italian daughter-in-law and leader of the Congress party, is widely hailed as the mastermind behind its stunning political comebacks in 2004 and 2009.

In addition to exercising dramatic political agency, women have literally built a new India. Since the 1930s and 1940s, women architects have designed and constructed building types ranging

from homes to offices, factories, and subways in India. Moreover, they have advocated for and preserved India's many different pasts: Mughal forts and tombs; Hindu temple complexes; the Raj's monuments and public buildings; and *chawls* (tenements) and urban villages. Although the number of women who actually practice in India was and still is relatively small, today they constitute the majority of students in many of its 180 schools of architecture.[2] Yet even before women were educated as architects, they were present at the lowest rung of architecture, laboring on construction sites as head loaders. They still work these jobs today, carrying away earth and debris and balancing building materials on their heads that will be used for homes, shops, skyscrapers, and information technology (IT) campuses.

A DAUGHTER OF MOTHER INDIA

Pravina Mehta (1923–92?/1925–88?)[3] was one of the first of a new generation of women to study and practice architecture in India. Although only a few of her buildings survive today, Mehta created a small but diverse practice, working in different materials and across disparate scales. She designed houses and factories as well as schools and institutions. She also envisioned a new Bombay, the city of her birth and practice, planning for its expansion and future development toward the east along with her colleagues Shirish Patel and Charles Correa. Whether in her office or India's first schools of architecture, Mehta was always a teacher too. She moved fluidly between exploring the fundamentals of Western modernism and the traditions of Indian architecture. She helped to found institutions to promote learning and education for Indians across lines of caste and religion, and organized international exhibitions and publications to educate the world about her country.

Mehta's generation straddled the freedom movement and the new nation state. She, like her better known colleagues Charles Correa and Balkrishna Doshi, recast a modernism they had experienced firsthand in the West for an independent India. Her work reveals

the challenges as well as opportunities modern architects faced in India over a remarkable period of time: from Gandhi's Quit India Movement to Nehru's modern socialist state and to the waning years of a planned economy on the verge of reform and liberalization. She did not live to see the new India of today, a global economic power.

She was a pioneer in a profession typically dominated by men in both the East and West. She came to maturity at a time when the emancipation of women was central to visions of a modern and independent India, and yet she always insisted she was simply an architect. Mehta bristled at being called a woman architect, and she would undoubtedly object to the emphasis here on her gender. But to this my response is that when critics and historians write about practicing architects, we too often deny the presence of women by blindly focusing only on those who are male and white. Thus the seemingly neutral term "architect" signifies a group that is both highly gendered and racialized. In the twenty-first century only one woman, Zaha Hadid, has finally entered the exclusive club of contemporary "starchitects" like Rem Koolhaas, Frank Gehry, Thom Mayne, and Renzo Piano. More troubling than Hadid's exceptional status is that today women, in the West as well as in India, account for somewhere between 40 and 60 percent of all architecture students. But after graduation they begin to disappear from architecture practice in huge numbers.[4] As an antidote to that attrition, we must recover the histories of those women like Mehta who persisted and succeeded. Moreover, telling the history of modern Indian architecture from the perspective of a woman designer seems especially crucial, given that women's emancipation was so bound up with the independence struggle and new nation. Such a history of modernism is all the more rich and complex because it intertwines Indian women with the nation state. As historian Pat Kirkham has written about her work on women designers: "I make no apologies for singling out for study a sector of society whose histories are still not told in all their complexities—and certainly not in terms of design" (Kirkham 2000: 14).

Yet these histories are difficult to write because women are often elusive prey for scholars. Telling Mehta's story has involved

an excavation and archaeology of modernism. When she died in the 1990s, her practice ended and there was no one to carry on the firm. Because the traces of an architectural practice (drawings, models, photographs, sketchbooks, correspondence, contracts, etc.) are bulky and unwieldy, her office papers were thrown out. Brinda Somaya, a prominent Mumbai architect and preservationist, was able to salvage Mehta's architectural library before it too was dispersed or discarded. Thus we know her taste in reading but not her design process or thoughts.

Instead, it is oral tradition that has resurrected Mehta's life and work through interviews with her family, colleagues, assistants, and former students: these form the basis for this history. Through these interviews I was able to locate and visit Mehta's extant buildings (although like the office records, many of her buildings have not survived). Although her sister Malvika Chari told me she had little information, in fact, she possessed the Rosetta Stone in the form of remarkable memories and photographs, which she generously shared with me. Her collection of images included studio portraits and family snapshots but also photographs of models, drawings, buildings, and construction sites. Shirish Patel, a leading civil engineer and Mehta's friend and colleague, had introduced me to Mrs Chari, but he too proved an invaluable resource, sharing his memories, photographs, and blueprints. Moreover, he saved me from misattributions, identifying which buildings in a larger complex discussed here were by Mehta and which were not, when I could not distinguish between them. Mr Patel and Mrs Chari—as well as my colleague Madhavi Desai—traced out an ever-widening circle for Mehta. I am deeply grateful for their help, trust, and friendship.

One particularly evocative picture of Mehta from Mrs Chari's collection is a photo collage (Figure 8.1). In a white room, Mehta wears traditional dress with her head modestly covered. Seated on the floor, she is grounded in this space, absorbed in some task. The interior is her design, but the purpose of the image is unclear. Is it a portrait, design study, or pedagogical exercise? The furniture is minimal and built into the architecture of the room. A few objects

(a textile, basket, terra cotta, and perhaps metal vessels) rest on the floor and shelves. They punctuate the space and move the eye through and across the room.

Figure 8.1: Pravina Mehta seated in an interior, photo collage (n.d.)

Source: Collection of Mrs Malvika Chari, Mumbai.

The aesthetic is minimalist, as Minakshi Amundsen who worked for Mehta told me, but it is not bare. Materials, structural elements, and surface treatments enliven the white room. Exposed beams cross the ceiling and the white plaster wall bears the imprint of a palm leaf or coconut mat pattern. Louvers modulate the light admitted by the window at the rear; fixed louvers along the wall to the right filter out the rain and dust but still ventilate the interior.

This mysterious image is an apt portrait of both Mehta and her architecture: the traditional woman in a modern space and the modern white interior in a world of traditional objects, form, and figures. It speaks about the equally powerful pulls of tradition

and modernity that Mehta experienced in her life and work. The interior is akin to a modern museum where a few carefully curated handcrafted objects and traditional forms, including Mehta herself, are on display. Yet her gaze, averted from the viewer, asserts her own agency and inner life.

HOME AND THE WORLD

Mehta was the daughter of a prominent Bombay solicitor who was a stalwart of the nationalist movement. Congress party leaders like Naidu, Gandhi, and Nehru consulted with her father, and they visited the family home, an Art Deco villa with gardens on Carmichael Road in Bombay's western hills. Mehta was, her sister Malvika told me, a rebel from the outset. Defying tradition, Mehta refused to be sequestered during her monthly periods, and her example emboldened both her mother and grandmother to do the same. The elder women of the household also answered the nationalist cause, boycotting British goods, and taking Mehta and her two siblings to the prayer meetings Gandhi held on Chowpatty Beach. As a teenager, Mehta joined a friend, Malatiben Javeri, in a Quit India demonstration outside a Bombay school where they were arrested and then imprisoned for two months. Unlike most women of their class, they did not shun the lower-caste women who were jailed with them. Instead, Mehta and Javeri gave these women food, money, and clothing, even to the point of tearing up their saris as sanitary cloths for them.

Mehta's father was liberal-minded, educating his son and two daughters. While Mehta's brother became a chemical engineer, her sister Malvika became a physician. They attended the New Era School in Bombay, a progressive institution where many of the teachers were socialists and nationalists. It was very free, Malvika Chari said, with students mixing with faculty and boys with girls. The arts were emphasized too. From an early age the Mehta sisters and their brother were taught classical music and dance, and Mehta was especially devoted to painting and embroidery. She designed clothes for herself and her sister.

Throughout her life Mehta wore khadi, the traditional homespun cloth that Gandhi urged his followers to wear as part of the boycott against British goods. Wearing khadi, Gandhi insisted, erased the differences of class, caste, region, and religion made visible in dress. It clothed the bodies of citizens of the new Indian state and, as handloomed cloth, it resurrected, celebrated, and gave material presence to Indian histories denied and suppressed by the colonizers (Trivedi 2007: 82–86). Thus wearing khadi was an act of defiance and solidarity. However, while the ascetic Gandhi advised his female followers to wear white khadi as a sign of modesty when they left home for public marches, protests, and prayer meetings, women like Naidu and Mehta chose to dress in brightly colored and vibrantly patterned handloomed cloth in traditional weaves (Figure 8.2). Such textiles were symbols of Indian skill and artistry in the past but also in the present for them (Trivedi 2007: 91). As worn by Naidu and Mehta, traditional handlooms were the dress of a new Indian woman, moving elegantly and confidently into the public realm.

Figure 8.2: Pravina Mehta (n.d.)

Source: Carmel Berkson, photographer. Collection of Mrs Malvika Chari, Mumbai.

Mehta also became fascinated by modernity. Watching *Things to Come*, the 1936 film based on the H.G. Wells novel, Mehta was taken by the city of the future that the set designers had created on screen. They evoked a city of glass, steel, and concrete, a new world of transparency and movement. Inspired by these visions, Mehta began to design furniture as well as clothing. She was still in her teens when she was accepted into the Sir JJ School of Architecture, where she followed Perin Jamshedji Mistri, the first woman to study architecture there in the 1930s. Minnette de Silva from Ceylon was the other woman student at Sir JJ with Mehta.

By the 1940s, the Bombay school had been in existence for almost fifty years. Originally established to train Indian draftsmen for low-level positions with consulting British architects to the government, it was, when Mehta and de Silva enrolled, a full-time program lasting five years (Reuben 1968). Many of its graduates established their own practices or became partners in British firms, while others attained positions of authority in the government, building the new bureaucracy by the twentieth century (Lang et al. 1997: 144–45). Unlike many Western schools, Sir JJ was rather progressive in welcoming women students by the 1940s. In comparison, the École des Beaux-Arts in Paris, which was founded in the seventeenth century, had accepted its first woman student, the American Julia Morgan, only in 1898. Founded in the late nineteenth century, British schools allowed women to fill the vacancies left by the young men killed in the First World War. Harvard admitted women only after their studios were depopulated because of the military draft for World War II (Fletcher 1934: 93; Woods 1999: 76–77).

The British architects who first organized and then directed the Sir JJ program established a Beaux-Arts curriculum of drawing, composition, and analysis of historic architecture. Studio was at the heart of the curriculum (Batley 1930). From 1923 to 1943 the school was led by Claude Batley, a British architect who founded a Bombay firm in 1913. He insisted that students analyze historic Indian buildings, small domestic works as well as monumental

architecture, through site visits and measured drawings. Western modernism, Batley taught his students, was an exotic misfit if it did not respond to the Indian climate and traditional forms of indigenous architecture, through such features as thick walls, courtyards, and terraced roofs (Batley 1946: 2; Reuben 1968).

Batley was an evolutionary teaching in revolutionary times. The appointment of Chimanlal M. Master, who had studied at the Architectural Association (AA) in London, as his successor in 1943 must have been a powerful sign of change to Sir JJ students like Mehta. But by that point, Mehta, who had fallen in love and married a classical dancer, had left Bombay for Chicago. There she and her husband performed but she also studied architecture and planning at the Illinois Institute of Technology (IIT). In the 1930s, Western students at the AA and in the US were excited by the work and teaching of modernists like Walter Gropius, Le Corbusier, and Mies van der Rohe (Crinson and Lubbock 1994: 100–6; Lang et al. 1997: 143). Mies had been director of IIT since 1937, and the first faculty members he hired were former Bauhaus teachers and students (Schulze 1985: 210, 215). During the years that Mehta studied there, Mies' designs for the IIT campus on the southside of Chicago were under construction. Thus Mehta saw brick, steel, and glass transformed into a modern community of rigorous proportions, purified geometries, and crystalline forms. Crown Hall, the IIT school of architecture, opened in 1956, the year she returned to India.

Mies, the last director of the Bauhaus, created a program at IIT that emphasized the "means" of architecture (materials like wood, brick, steel, and concrete), "purposes" (functions and building types) and finally "planning and creating," (speculations about order, organicism, and the integration of architecture with painting and sculpture). Distilling and then perfecting a sense of architectural order were fundamental to his design methodology (ibid.: 213–14). Mehta internalized these ideas and strove to realize them in her work and teaching. When she taught at the Academy of Architecture in Bombay, she emphasized the Bauhaus design fundamentals of line, form, and color. Sanjay Mehta, a Bombay architect who worked for

Mehta (but no relation) in the 1980s, remembered that she referred to the Bauhaus at least once a week when he was in her office. Of her own design process, he said:

> It was about geometry and the play of geometrical forms. Purity, cleanliness, there were no wishy washy gestures anywhere. Either it's black or it's white. There is nothing in between. It was very cut and dried. There was never a distinction made between research, knowledge, and the actual project when I knew her. In one hour we would be reading history books, in the second making drawings for some floor design. It was never about only architecture. It was about all the other arts such as dance, music, painting, and everything that goes with the liberal arts.

Mehta, like Mies, believed architectural truth lay in architectural details. Hence, designing the jamb for a window completely absorbed her. She took pains to create the template for the architectural drawings produced for a project. The graphic construction of the drawing itself was as much a statement of her design intentions as the final building. The graphics, Shirish Patel felt, were fundamental to good design for Mehta. Yet Sanjay Mehta said she began her design explorations with a small study model. The modern was very much a part of Mehta's everyday life too, and Sanjay Mehta recalls that her office on Marine Drive had icons of modern art and design: black and white photographs; a Wassily Kandinsky painting; Buckminster Fuller's map of the world; and a Ray and Charles Eames green leather chair.

But Pravina Mehta soon realized that the iconic Miesian vocabulary of steel and plate glass was not viable for her India. Not only were glazed and transparent structures climatically inappropriate for the harsh sunlight and driving monsoons of the subcontinent but due to foreign exchange restrictions and a still developing Indian industrial sector, it was difficult to obtain such modern materials and technologies. The government, for example, rationed the cement necessary for reinforced concrete structures. Sanjay Mehta estimated there were only two hundred elevators then

in the entire city of Bombay. Working with traditional materials and technologies was not just an artistic or political statement for Indian architects of Mehta's generation. It was a necessity.

When Mehta had returned in 1956, after ten years abroad, she felt that she had to rediscover India. Traveling alone (she was now divorced) on the railroads and sleeping on the station platforms, she drew, photographed, and studied the India of villages and temples and immersed herself in Indian handicrafts. Such "fieldwork" was an important part of her teaching and practice throughout her life. Sanjay Mehta remembers her taking the staff out of the office to measure and draw monuments of Indian architecture just as Batley had done with his Sir JJ students. It was not necessarily related to a specific project, he said, but it was important to her that we learn about our heritage. Carmel Berkson, an American sculptor and photographer who first came to India in the 1970s, remembers Mehta as one of the few Indians she met then who truly cared about the country's history. Mehta called it "retrieving the connection," between the past and present.

A PRACTICE OF ONE'S OWN

If Pravina Mehta is remembered at all today, it is as the collaborator of Charles Correa, still today one of the few Indian architects to achieve international acclaim and recognition. She and Correa with Shrish Patel worked on the plan for New Bombay (1965–70) and then on the Kanchanjunga Apartments (1970–83) in Bombay. She and Correa were also involved with the international exhibition "Vistara—The Architecture of India" (and accompanying publication), one of the government's Festival of India programs that toured Japan, France, Great Britain, Soviet Union, and the United States in the 1980s (Dutta 2007: 262–75). Yet they were only occasional collaborators. She first practiced with Hema Sankalia, another pioneer who had studied with Mehta at the Academy of Architecture. But they parted ways, and Mehta practiced on her own for most of her professional life.

Such an independent practice was and still is unusual for women architects. Perin Jamshedji Mistri, the first woman to graduate from Sir JJ's architecture program, as noted above, practiced in the Bombay firm her father had established in 1891. Since independence most women architects in India have worked with a spouse.[5] This is true of many prominent women architects in the West too: Jane Drew and Maxwell Fry (who worked on the housing for Chandigarh); Alison and Peter Smithson; Denise Scott-Brown and Robert Venturi; Billie Tsien and Tod Williams; and Elizabeth Diller and Ricardo Scofidio (Searing 1998). Zaha Hadid and younger architects like Lindy Roy and Deborah Berke are the exceptions.

Here I have chosen to highlight for examination three projects by Mehta: Uma Patel House, Kihim near Ali Baug (1964); Advani-Oerlikon Factory, Chinchwad (1962–64 and 1972–75); and Avehi Center, Mumbai (1980s). The study is facilitated by photographs, blueprints, and a publication from the collections of Malvika Chari and Shirish Patel, which together document these very different buildings extremely well. Such documentation is a rarity when dealing with Mehta's architecture.

Mehta designed a house in Kihim for Uma Patel. Patel, like Mehta, came from a prominent family, her father, H.M. Patel, being the finance minister in the new central government. The site for her house, Kihim, was to the southeast of Bombay's harbor along the Konkan Coast. Settled in the seventeenth century, the area is known for its dense stands of coconut trees and woods filled with rare butterflies, birds, and flowers—an ideal spot for Uma, who studied agriculture abroad, to pursue her interest in poultry breeding. It is today the site of Bollywood film shoots and vacation homes of wealthy city dwellers, but when Patel moved there, it was still a quiet retreat.

At the Patel House Mehta demonstrated she had learned Claude Batley's lessons about a modernism designed for India's blinding light and driving monsoons (Figure 8.3 and Figure 8.4). But she also engaged with the great modern icon, Le Corbusier, whose houses for the Sarabhai and Shodhan families were just being completed

Figure 8.3: Pravina Mehta, Miss Uma Patel House, Kihim (n.d.)

Source: Collection of Mrs Malvika Chari, Mumbai.

Figure 8.4: Pravina Mehta, Miss Uma Patel House, Kihim (n.d.)

Source: Collection of Mrs Malvika Chari, Mumbai.

when Mehta returned to India in the mid-1950s (Lang et al. 1997: 218). At Kihim, Mehta adapted Le Corbusier's modernism, which had been conceived for the hot and arid climate of Ahmedabad, into an architecture more appropriate for south India. Raised on a plinth above the ground, the Patel House was protected like a traditional Indian dwelling. Then Mehta took Le Corbusier's Mediterranean *brise soleil* (a sun baffle extending over the entire façade) and married it to the thick wall construction typical of indigenous buildings, thus creating a modern *jali* screen that was fused with the building wall. The overhanging roof above the low-slung house framed the horizon line along the coast. Shirish Patel, who was engineer for the house, described it as a "fortified structure on the land side.... It looked like a gun emplacement on the back where you came in. And then when you entered there was this astonishing view, looking out onto the water." Responding to site and function, Mehta ensured privacy on the land side and then openness to the sea.

Windows and verandahs were deeply recessed into the thickness of the walls, another feature of traditional buildings in India. A square window on the side framed views of surrounding trees. Sheltered by the projecting angle of the roof, the verandah became an outdoor room set deeply within the house. Yet the monsoon rains still drenched the interiors. The two distinctive roof profiles as well as the syncopated fenestration patterns created a dynamic, asymmetrical elevation. But the thick walls grounded these elements as light and shadow animated the façade. Here study models placed in the light must have been key for her design development. The Patel House looks like a small, white ocean liner, a modern form Le Corbusier celebrated, beached on the Konkan coast.

Mehta and Shirish Patel worked together again on the Advani-Oerlikon Factory in Chinchwad, an industrial center in western Maharashtra. With a few exceptions, like Zaha Hadid's BMW Central Building (2004) at Leipzig, architects, much less women, are not often entrusted with the design of industrial facilities. As

a manufacturer of welding supplies and equipment, the company, a Swiss-Indian venture, was important for the industrialization of post-independence India. Today Advani-Oerlikon is the largest welding supplier and producer in India (Ador Group 2008: 3–5).

Shirish Patel and his firm were retained as the prime consultants for the project. All working drawings, including the architectural drawings, were prepared in his office to simplify coordination and ensure completion of the factory on time. He and his firm decided on the layout of the factory, the spans, and use of a thin shell concrete roof for maximum economy. Mehta became consulting architect to his firm for a small fee. Shirish Patel wrote me that she advised us:

> where we might be going wrong and provided at the most sketches to point us in the right direction. She took the job with utmost seriousness, muttering "graphics, graphics ..." and gave us the pattern of windows. I think it is that one single feature of window patterning that lifts the project immediately to a different level, much above the ordinary.

Figure 8.5: Pravina Mehta and Shirish Patel, Advani-Oerlikon Factory, Chinchwad (n.d.)

Source: Collection of Mrs Malvika Chari, Mumbai.

Figure 8.6: Pravina Mehta and Shirish Patel, *Brise Soleil* and staircase, Advani-Oerlikon Factory, Chinchwad (n.d.)

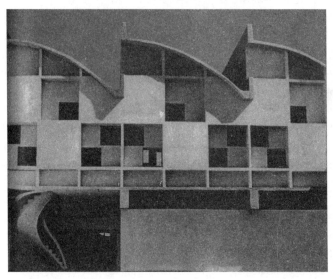

Source: Collection of Mr Shirish Patel, Mumbai.

Rather than detaching the administrative offices from the manufacturing facilities, Patel placed the executives directly above the workers in the office extension he designed in the 1970s. Again Mehta used a *brise soleil* as this façade of the two-story unit (Figure 8.6). Highly textured, it was made of sandcast plaster painted grey and white. Joining the two levels of labor and management was a spiraling staircase of concrete, a structural tour de force by Patel. The staircase was split into three sinuous ribbons of concrete: one strand for the treads and two for the balustrades (Figure 8.7). Whether ascending or descending the stairs, it became a performance against the backdrop of a *brise soleil* that recalled the Mondrian paintings Mehta admired. The circulation was celebrated as a sculptural form animated by light and shadow, a trope of modern architecture, instead of being hidden away in a dark and narrow stairwell. Sadly, the office extension was later demolished.

Figure 8.7: Pravina Mehta and Shirish Patel, detail staircase, Advani-Oerlikon Factory, Chinchwad (n.d.)

Source: Collection of Mrs Malvika Chari, Mumbai.

Established by her sister Malvika, Avehi is a nonprofit institution located in Sion, a northeast suburb of Mumbai. Its purpose was and still is to produce and distribute audio-visual materials for educational purposes. In Hindi, *avehi* means "to know," and it is an institution serving Gandhi's and Nehru's visions for an inclusive India. Avehi's mission is to build "a social society whose aims are to provide non-formal education and instruction ... in keeping with the principles of secularism, equality, social justice, and respect for all communities, languages, cultures, and religions...." (Avehi). Avehi media programs educate all ages about issues of human rights, communal harmony, social justice, and gender sensitivity in both formal and informal settings.

The site in Sion Mehta had to work with was very small: 600 square feet. Yet she managed to create a sense of space around the building (Figure 8.8).

Figure 8.8: Pravina Mehta, rear view of Avehi Visual Resource Cener, Sion, Mumbai (n.d.)

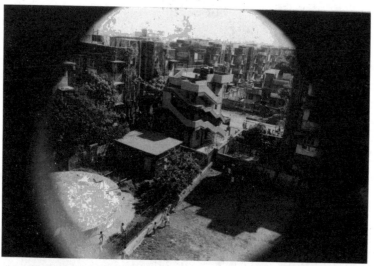

Source: Carmel Berkson, photographer, Collection of Mrs Malvika Chari, Mumbai.

A library and administrative offices occupy the ground floor, a multipurpose hall opening onto a double-height terrace is on the second story, and a workroom and recording studio are on the top floor (Figures 8.9 and 8.10) (Avehi). To save precious interior space, Mehta wrapped an exterior staircase around the building's side and rear façades (Figure 8.10). She extruded this zigzagging form out of the thickness of the overhanging canopy on the building's principal façade. The staircase knit the front and side elevations together with its sculptural form. One moves up the stair by grasping the metal tube embedded in the balustrade. Further, enlivening movement through the space, the wall opposite the staircase is articulated through the interplay of simple geometrical relief panels. As at the Advani-Oerlikon office extension an architectural event was created from the everyday choreography of moving through the building.

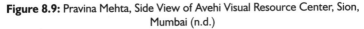

Figure 8.9: Pravina Mehta, Side View of Avehi Visual Resource Center, Sion, Mumbai (n.d.)

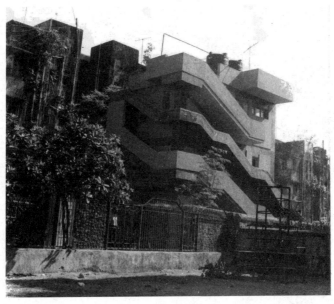

Mehta also designed built-in furniture for the administrative offices and recording studio, like simple wooden bookcases cantilevered from the wall. Because of import and currency restrictions still in effect during the 1980s, Indian architects had to design their own office furniture or purchase it from one of the few Indian manufacturers. The overhanging canopy on the street facade, thick-wall construction, and deep window reveals keep the building remarkably cool and well ventilated even during the dog days before the monsoons. Moreover, the streamlined canopy pays homage to the first modern buildings designed by Indian architects, the Art Deco structures of Mehta's youth from the 1930s and 1940s. The overall composition and attention to detail are impressive in a building that slips modestly and comfortably into its surroundings. Despite its small scale, Avehi has a powerful presence.

Figure 8.10: Pravina Mehta, Main Façade of Avehi Visual Resource Center, Sion, Mumbai (2008)

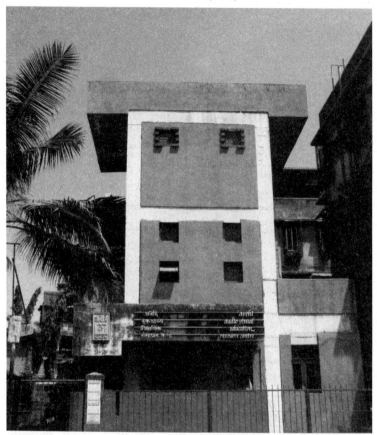

Source: Carmel Berkson, photographer, Collection of Mrs. Malvika Chari, Mumbai.

A VISION OF INCLUSION

Pravina Mehta was a pioneer in a profession typically dominated by men in both East and West. In a society where women are traditionally defined by marriage and children, she also led an unconventional personal life, marrying twice without children. She was a woman of position, education, and privilege, all of which trumped the sexism of her society. And yet she would object to being identified as a woman

designer, being first and foremost simply an architect. Although Mehta never spoke about feminism, Sanjay Mehta told me that she did refer to personal and professional compromises she had made as a woman.

It is misleading to impose ideas about women's liberation produced from Western feminism of the 1960s and 1970s onto this pioneering generation of Indian architects. As Kumari Jayawardena has astutely observed, although women's emancipation in South Asia was influenced by Western ideas of suffrage, socialism, and liberalism, it "was acted out against nationalist struggles, assisting a national identity and modernizing of society" (Jayawardena 1989: 3). The utopian visions of Western modernists for a humane architecture deeply affected Pravina Mehta. But her emancipation as a woman and designer was about the art and craft of making a new Indian nation state that embraced its past as well as its future. She drew her inspiration in life and design from a Gandhian vision of inclusiveness that transcended divisions of class, caste, region, religion, and, yes, gender too.

NOTES

1. In *Mother India* (1927) American journalist Katherine Mayo, abetted by British imperialists, attacked Indian self-rule on the grounds of the traditional culture's purported misogyny. See Mayo (1927) and Jha (1971). See also Moore (2004/2005: 58–59) and Brown (2003: 200–1).

2. See "Preface" in Mehrotra (2011: 7). The Council of Architecture, which regulates architectural curricula and maintains a register of architects in India, has no statistics on the number of women enrolled in schools today.

3. Jon Lang lists Mehta's dates as 1925–88 (2002: 49). However, Malvika Chari, Pravina's sister, told me in a 2008 interview that Pravina was born in 1923 and died in 1992.

4. While women have represented from 40 to 50 percent of all architectural students in the United States since the 1990s, they accounted for only 13.3 percent of American Institute of Architects members in 2007. Yet

this is a more encouraging statistic then a 2004 estimate that only 9 percent of all registered architects in the United States were women. Figures in the United Kingdom are equally dismal with women making up 38 percent of architectural graduates and yet only 12 percent of registered architects. See Ouroussoff (2007) and Stevens (2009).

5. The importance of the professional and personal support of parents and husbands for women architects is underscored in Madhavi Desai's contribution to this volume.

9 | Shifting Boundaries and Creating Identities

Women Architects in India: 1960 Onward

MADHAVI DESAI

At the turn of the twentieth century, traditional Indian society was gradually shifting toward the path of modernity and progress as a result of the social reform movements of the nineteenth century under the British Raj. Women figured prominently in both colonization and modernization. One of the indirect justifications that had been used for British colonial presence was the sequestration of women, read as a sign of the backwardness of Indian society. With modernization, the newly Western-educated men from the liberal and elite section of Indian society wanted to have educated wives who would be suitable companions. There was also a subtle aim of demonstrating their modernity to the rulers through the changing role of women. Thus, there was a strong desire in Indian men to change the traditional family and release women from the confines of domesticity. However, notwithstanding this, "the issue of women's education was debated strictly within the paradigm of the dominant patriarchal ideology" (Joshi 2008: 25).

The first half of the twentieth century was also a time of an intense nationalist struggle for political freedom. Indian women came out of their kitchens and homes and into the public realm in large numbers during this period under the leadership of Gandhi. He categorically stated that "the women of India tore down the purdah and came forward to work for the nation. They saw that

their country demanded something more than looking after their homes..." (Kumar 1997: 83). Indian society underwent tremendous economic, technological, sociocultural, and political changes after gaining independence in 1947 from British rule: the post-independence era was a period of major transition for women. The Indian constitution proudly promised equality between genders to all citizens. The economic transformation after the two world wars and the growing women's movement both in India and abroad paved a path for larger public participation of women on the one hand. On the other, however, "The critical consciousness gained during the freedom struggle—as well as women's access to a political arena provided by it—was lost to a great extent."[1] This had to be gradually regained in the ensuing decades following independence.

The gains, once achieved, were remarkable. New work ethics, technology, and lifestyles were introduced. Higher education for girls became more widespread, at least in urban areas. Some women had political appointments and many women's organizations were formed. A significant number of women took employment in typical feminine occupations such as teaching, nursing, and secretarial work. Until the 1950s, however, only a handful took up sciences or career-oriented courses that required advanced university degrees. By and large, they—like women in advanced societies around the world—preferred those fields considered appropriate for women, such as literature, home science, social work, the arts and languages.

In the 1960s and 1970s, a young woman generally graduated with a bachelor's degree in arts and married at twenty-two or twenty-three years of age, at which point she devoted herself to home and family. But gradually, with growing gender consciousness, women began to want to enter and achieve distinction in those gendered spaces that were previously off limits to them. A few of the first generation of "daughters of independence" began to join medicine, engineering, journalism, media, and management. Some participated in politics and the administrative services. Women's studies centers were established in the 1970s. There was the beginning of a conscious

sense of building up of one's career. The women's movement in India was by then well underway, though it was not very visible, linear or homogeneous. It was creative and yet regionalized and fragmented. The 1970s heralded what is termed as the New Women's Movement, developed around fundamentally new issues and structures in various parts of the country (Desai 2006: 63).

Family structure, household organizations, and lifestyles were gradually modified. The forces of influence included a reduction in the number of children that women bore, encouragement for advanced and/or professional education, acceptance of women's employment and career satisfaction outside of home, the growing predominance of nuclear families and the diminishing significance of kinship and caste in society. More and more women sought freedom, self-expression, and self-development. This had an impact on the profession of architecture as the rather young field began to branch away from engineering, attracting more and more girls to it.

WOMEN AND THE BUILT ENVIRONMENT[2]

As a profession, architecture remained the prerogative of men after independence, and even at the turn of the twenty-first century, the profession is deeply patriarchal. As in other parts of the world, there is a substantial and worrisome discrepancy between the number of female students (about 50 percent and more) in schools of architecture and the numbers of women practicing in the field (about 11 to 12 percent).[3] This is in sharp contrast to other design fields such as fashion, graphics, textiles, and perhaps even interior design where women have gathered the critical mass. Even in those cases where spouses practice architecture together, the usual practice is for the woman architect to limit her responsibilities to the office while her husband predominantly meets with clients, contractors, and conducts site visits. At the same time, because it provided women with a safe point of entry into the field, there are women who have benefited immensely from this joint practice scenario and have been able to carve out an identity for themselves.[4]

The decades after 1947 were crucial in the development of Indian architecture. There was an intense search for identity and expression in architecture which was to serve as a symbolic and physical representation of the nation. On one side, revivalism was prevalent as a result of the long and painful nationalist struggle the country had gone through. On the other, there was a strong desire among the political leadership—more specifically the first prime minister, Jawaharlal Nehru—to employ architecture as a means of expressing the modernity of the young nation state, which had the distinction of being the only democracy in Asia. Kazi Ashraf and James Belluardo have written that for India, modernism offered "a vision of the future based on a functionalist language that was free of colonial associations and of reference to specific religious or ethnic traditions" (Ashraf and Belluardo 1999: 14). In the long run, it was modern architecture that triumphed: India did not merely *receive* modern architecture as an import from other areas of the world—it became a key player in its development.

As I have written elsewhere with colleagues, "In the educational realm, a whole new system had to be laid as a foundation for modern technological developments...." And in this system, colleges and institutions devoted to research and technology were essential to the modernization project (Lang et al. 1997: 183). In the ensuing decades, Indian architects came up with thoughtful and varied responses to the external and internal forces as they gained confidence in themselves, though a majority of the built environment has remained rather mundane. Architecture remains a male-dominated profession with elitist values that give exorbitant importance to prestige, glamour, and image making, leading young designers to aspire to stardom by creating iconic buildings.

It is within this scenario that we find the first few women joining the field of architecture in India: they were exceptions and yet they blazed a trail for future generations to follow. Pravina Mehta, Gira Sarabhai, Urmila Elie Chowdhary, Hema Sankalia are some of the names that are historically important. These early architects belonged to elite families and were well connected. They joined

the professional course due to their families' liberal views and unconditional encouragement for higher education. They had sophisticated taste and were aware of the arts such as literature, painting, and music. Their privileged background gave them the security and perhaps the arrogance of class and exposure and helped them reach a level of success where their contemporaries failed to make a professional dent. Gira Sarabhai, born in 1923 and in her late eighties now, was at Frank Lloyd Wright's Taliesin West in Arizona for a few years during the 1940s. She is a designer par excellence (Figure 9.1). Pravina Mehta (1923 or 1925–92), with her master's degree in architecture from the Illinois Institute of Technology (IIT), was a rebel and a visionary. She mooted the New Bombay Plan in 1965 along with Charles Correa and Shirish Patel. Urmila Elie Chowdhury (b. 1923, received her bachelor's degree in architecture from Sydney University in Australia) worked under Le Corbusier on the Chandigarh Capital Project in 1951.

Figure 9.1: Extension of a house, Ahmedabad, by Gira Sarabhai, 1954

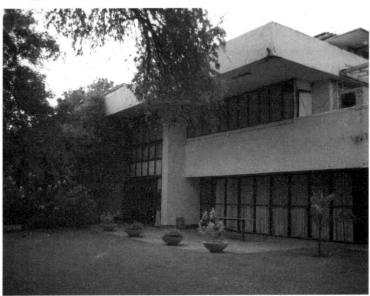

Source: Photo courtesy Miki Desai.

By the mid-1960s, not only the upper middle class, but also the girls of that class were able to aspire for a professional role, however distant it may have seemed at the beginning. The course was long and arduous, lasting six years, in comparison with the four-year program of a typical college degree. In the 1960s and 1970s, these girls were a minority (generally four to five in a class of thirty to forty),[5] and they experienced social restrictions that their male peers did not experience, when, for example, they tried to work at night in studios. Furthermore, their parents—far from belonging to the privileged elites—were not much aware of architecture (or the built environment for that matter) as a profession; nor was the society as a whole. It was also the time of the Great Masters building in India, within the ethos of total adaptation and fascination with modernism. This project of modernity as well as the modern movement in architecture shaped the lives and careers of these women in India.

The following is a series of short biographies that touch upon the professional (and personal) lives of women of achievement as they took hesitant steps in the profession without role models and network support.[6] They negotiated the various forces of resistance while venturing into the public realm, sometimes with non-conventional approaches and attitudes, to reach a level of success. These examples, of course, are not all-encompassing but represent some notable architects whose careers are representative of the trajectory of the second generation of women in architecture in India.

BRINDA SOMAYA, MUMBAI

One of the most famous woman architects in India, Brinda Somaya (born June 28, 1949), after thirty years in the field, now heads a large corporate practice. With offices in Mumbai and Bangalore, she has a wide range of projects that comprise commercial, educational, institutional, interiors, corporate, and conservation projects including international collaborations. She has won many national and international awards, including an honorable mention from the Union of International Associations (UIA), the Vassilis

Sgoutas Prize (2008) for Alleviation of Poverty for her project, Rehabilitation of Bhadli Village (Bhuj), and the Golden Architect Award for Lifetime Achievement from the Architecture + Design and Spectrum Foundation Architecture Awards (2007). Somaya has also participated in innumerable conferences, and her work has been published and exhibited internationally. In 2012 she received the honorary doctorate degree from her alma mater, Smith College, Massachusetts, USA.

In architecture, Somaya combines an engagement with art, science, history, archaeology, sociology, and travel. Her design methodology focuses on site, location, climate, and the client's brief within the context of the sociopolitical forces. In interviews with the author, Somaya has stated that she loves the variety of challenges posed by climate, cultures, and types of buildings as her practice grows in the country. Though primarily influenced by modernist principles, her designs have a variety of manifestations and a range of aesthetic choices. She has designed several large educational and institutional campuses, including holiday resorts in historic and scenic places.

She states that her goal is to raise the spirit and enjoyment of a person experiencing her design. She does not believe that a building is a piece of art or a sculpture. Clients' needs and the structure's function are primary to her as she consciously tries not to impress her own personality on her designs. She takes on projects for "their cerebral fascination," not merely for their size or prestige, and she views landscape, interiors, conservation, and urban design as integrated entities. Designing some of Mumbai city's most prestigious landmarks, as well as conserving its precious heritage sites, she has been on many committees and juries at city and national levels. She believes that development and progress must proceed without straining the cultural and historic environment, a belief that underlines her work. Her oeuvre, spanning large corporate, industrial, and institutional buildings, extends to public spaces, which she has rebuilt and sometimes reinvented as pavements, parks, and plazas for which she has won several awards (Figure 9.2).

Figure 9.2: Zensar Technologies, Pune

Source: Photo courtesy Brinda Somaya,

With the liberalization of the economy, there has been a change in the scale of projects and the availability of new technologies. Somaya feels that Indian architecture is now in a golden age. Of heightened importance to her are community projects like converting a garbage dump in the city of Mumbai to a green, public space or facilitating the rebuilding of a village in Gujarat on its earlier footprints after the devastating earthquake with full citizen participation. It should be noted that for a long time it has been her practice to put a clause into her architectural contracts requiring the provision of toilets, electricity, crèches and play areas on the construction site for the workers and their children. In this respect, her practice espouses a progressive social and political agenda.

Somaya's daughter has followed in her mother's footsteps and joined the firm in the past few years. Somaya has built up her practice slowly but surely with confidence and she is unusually successful "in a man's world."

NEERA ADARKAR, MUMBAI

A classmate of Brinda Somaya, Neera Adarkar (born September 5, 1949) has a multifaceted personality in the field of architecture, working as a designer, researcher, teacher, writer, and an activist. Her architectural practice, shared with her husband and another male architect, is based in Mumbai. She has struggled over the years to escape from the stylistic limitations of her 1970s modernist education when she felt that the architectural pedagogy was narrowly defined and strongly influenced by engineering skills. She has recounted that at Sir JJ, where she studied architecture in Mumbai, the only phrase used to represent modernism was "Form Follows Function," and it attempted to justify the "box-with-a-flat-façade" type of architecture. As time passed and her understanding matured through the study of the works by Charles Correa, Le Corbusier and Louis Kahn, she began to disown the stifling pedagogical influence of modernism as narrowly defined and to discover modernism's possibilities for spirit and the magic of space. Her projects range from institutions to heritage listings.

Adarkar joined the women's movement and became an activist in the early 1980s. Her involvement in the theatre movement of that period led to her participation in the multidisciplinary art activities emerging out of the women's movement (Figure 9.3). More recently, she was active in a campaign for saving the textile mill districts of Mumbai from the onslaught of the real estate mania, which sought to realize Mumbai's potential as a "global" city by converting its lived spaces into abstract capital. Over the years, her romantic belief in the neutrality of space went though massive conversion as her consciousness became redefined through her involvement in the feminist movement and gender studies. Since then, she strongly feels that design philosophy cannot be seen in isolation but has to be understood in the context of the social and political relationships in any given society. Gender and class are important considerations for planning a built environment. In 2004, Neera co-authored a book titled, *One Hundred Years, One Hundred Voices, Oral History of*

Figure 9.3: Neera Adarkar with women from the slums, Mumbai

Source: Photo courtesy Neera Adarkar.

Girangaon, which reconstructed the history of Mumbai's textile mill district, popularly known as Girangaon, using the oral narratives of the residents. In 2011, she edited a book titled *Chawls of Mumbai: Galleries of Life*.

Adarkar identifies herself as a feminist, which to her means eradicating the exploitation of women's labor and sexuality, and insisting on the recognition of women's right to make choices at all levels. Married to an architect, she says that she strongly believes that a woman's identity should be independent of her marital status in order to gain rights and tenure to housing and infrastructure. Adarkar's direct involvement with the women's movement as well as her political activism gives her empathy for gender and class and a unique identity in the field of architecture.

REVATHI KAMATH, DELHI

Revathi Kamath (born October 2, 1955) is a respected architect who works passionately for ecology, environment, and architecture.

Perhaps as a result of having played with mud and doll houses in a tribal area in her childhood, Kamath slid into a pathbreaking manifestation of contemporary architecture when she set up her practice in 1980. She collaborates with her architect husband Vasanth who was her former teacher; however, they handle most of their projects separately. The deep study and exploration of raw earth and other indigenous building materials has formed a part of her daily life for over thirty years. She has diligently gathered the wisdom to enable her successfully to build a dozen projects with these materials that have now been brought into the mainstream. This is an extremely important aspect of her work.

Hard working and totally immersed in the design process, Kamath does extensive drawings and works out the basic structure herself. She adheres to no boundaries in her role as an architect, interacting with a wide range of different people involved in the making of a project, from craftsmen, engineers, and bureaucrats to clients and affected community members. For her, participation is key. To realize an integrated architecture, she uses low-energy-consuming as well as low-waste materials and lets the process of building direct the aesthetics as far as possible. From her exposure to tribal culture in her childhood, Kamath was keenly interested in the vernacular architecture of the world, the impact of which can be perceived in her designs, for example, the School of the Handicapped in New Delhi (Figure 9.4). She was also impressed by Laurie Baker's work in Kerala, as it showed her the "other" way of building in a strong modernist ambience in the country. With some 500 projects to her credit, Revathi Kamath has worked relentlessly as a designer for three decades. She was earlier involved in teaching architecture.

She has also experimented with steel for the past twelve to fifteen years, building about ten projects, some as large as 10,000 sq m, integrating the widespread craft skills in steel fabrication into the architectural vocabulary and expression of buildings. In her work, steel has been taken beyond its modernist and mannerist expression of "modernity." She believes that the extensive use of

Figure 9.4: The school for the handicapped, New Delhi

Source: Photo courtesy Revathi Kamath.

steel minimizes the quantum of reinforced concrete which is un-
ecological, consuming large quantities of water in its fabrication and
rendering its constituent materials irretrievable and un-reusable,
except as dump.

More concerned with the feminine than feminism, for Kamath a
woman's consciousness is part of her environmental awareness
and humanism. However, she consciously tries to use women's
traditional knowledge and practices, such as the cow-dung plaster
used by some village women to coat the walls of their houses, the
mirror-work that has adorned palaces and ordinary homes since the
Mughals onward, and floor and wall paintings in buildings. She also
assimilates the presence of the craftsmen in the building process.
She tries to design for low-energy consumption and minimal waste.
In recent years, she has developed several large-scale projects such
as wildlife sanctuaries and tourist resorts. Her two children are
grown; but when they were young, Kamath balanced career with
motherhood by keeping her office next to her home, letting the
children spend a lot of time in the office, and taking them with her
to visit out-of-town sites.

ANUPAMA KUNDOO, AUROVILLE/BERLIN

Somewhat similar to Revathi Kamath, and driven by her passion for architecture, Anupama Kundoo (born April 24, 1967) has made a name for herself at a young age as an alternative practitioner with a focus on the materiality of architecture, especially alternative low-impact roofing systems. She has a PhD from the University of Technology, Berlin, and now lives and practices in the city of Auroville, near Pondicherry in south India (Figure 9.5). Although the aesthetics of modernism appealed to Kundoo, its influence remained latent during her education. She was greatly inspired by the Golconde house (1948) by Antonine Raymond in Pondicherry, one of the first modern buildings in India. She found it contextual, climate-specific, site-responsive and recognized that it had an intimate contact to nature. She was also impressed by the writings of Le Corbusier and his "architect-as-artist" model. For her, architecture is a manifestation of theory and thought, and thus an architect needs to be a whole figure who is able to reflect society and

Figure 9.5: Architect's own house, Auroville, 2000

Source: Photo courtesy Anupama Kundoo.

provoke discussions in it regarding its development. A major living influence and mentor was the architect Roger Anger of Auroville, with whom she shared the joy and playfulness of architectural experimentation, research, and innovation while aiming for beauty and harmony. She is the author of *Roger Anger: Research on Beauty Architecture: 1953–2008* (2009).

Kundoo observes contractors, engineers, masons, and laborers, invigorated by their excitement and involvement in the project. She works with local people, trains them, and learns alongside them. She regards the socioeconomic as important as the climatic and environmental realities of a project, and enjoys the whole process of architecture and how it is made, rather than the end product alone. She explores, understands and then exposes the inherent quality and beauty of each material, while making the least impact possible on the environment in the process.

The building and manufacturing are both preferably done on site. There is no scaffolding in rural areas and she places emphasis on the judicious use of concrete. She often works with details, yet she was involved in setting up the master plan for the south Indian city of Auroville (inaugurated in 1968) because the micro to her is important to understand the macro. To her technology is not as important in a space as feeling the sense of beauty and well-being. She is married to an architect and has a young son with whom she now lives in Berlin for part of each year.

ABHA NARAIN LAMBAH, MUMBAI

Abha Narain Lambah (born September 14, 1970) has brought the field of architectural conservation in India to a forefront. She has been one of the pioneers, bringing in many new aspects as professional concerns in the field. In the past five years, the climate for conservation has improved as the heritage movement has expanded, and with growing awareness, government agencies are now engaged in areas that were previously the purview of citizen initiatives. Lambah tailors her approach to the individual projects,

as the buildings belong to different historic time periods (from the ancient to the colonial), functional types, and stylistic categories, and have suffered different levels of deterioration.

She is a hands-on person and stresses practical experience. She also writes on conservation issues and has won many awards and fellowships, including four awards for conservation from UNESCO.[7] Her clients range from government and private corporations to communities. As a conservation architect, she consciously keeps her own design "ego" in check as she focuses on understanding and maintaining sensitivity to the original design intent of the historic building's architect, as in her restoration of Elphinstone College, for which she won a UNESCO Asia Pacific Heritage Conservation honorable mention in 2004 (Figure 9.6). Thus, it is the response to the material, design, and period of the original building that guides her on each project. She respects the authenticity of material and looks at the building, the precinct, or an entire plan in a holistic manner.

Figure 9.6: Elphinstone College renovation, Mumbai

Source: Photo courtesy Abha Lambah.

Wherever possible, she uses the traditional craftsmen and carpenters, as well as local engineers. An example of this kind of work is her restoration of the fifteenth-century Maitreya Buddha temple in Ladakh. Although physically challenging, the project gave her new sensitivity to people and insights into working at the community level because she employed local craftsmen to rebuild and waterproof the earthen-walled structure in the traditional *bhojpatra* technique. Her office is small, which encourages a cohesive work group that enables her to remain personally involved in each project.

With a young daughter, she and her husband have had to balance job with family, and sometimes this means bringing her daughter with her to out-of-town sites. Though Lambah never felt conscious of being a woman professional in the liberal atmosphere of Mumbai, where she is located, she is immediately aware of it in other cities, such as New Delhi. She admits to having had to climb bamboo scaffolding on construction sites at times to be taken seriously.

In past decades, women have struggled to achieve their place in the male-dominated world of architecture, necessarily defining themselves in the male mould while at the same time struggling to differentiate themselves from it, but in the twenty-first century, a definite paradigm shift can be observed. Many women architects—precisely because they are not entrenched in traditional ways of practicing architecture—now work with the integration of energy, water, and building materials and are strong advocates of using the principles of ecologically and culturally sustainable design in projects. Incorporating rainwater harvesting and water recycling, they also stress climate, site conditions, and the availability of primary natural resources as well as appropriate constructional techniques. Minimal use of concrete, cost-effective building techniques, and attention to landscape make their projects stand out as visibly innovative and different. Some, at the same time, are modernists and have rather corporate practices with very contemporary and global expressions. They use bright colors, defining strong forms and fluid "walls" in varying planes. They design playful spaces and explore various materials and textures. Since most architects have been educated in

the post-independence period within the modernist framework, it reflects on their work in one way or another.

MADHAVI DESAI, AHMEDABAD

I conclude with a brief biography of myself because it illustrates a different career path through the field of architecture. Born on June 11, 1951, I belong to the second generation of women architects in India. I grew up in a nuclear family in a relatively liberal environment. My father was a medical consultant who had a lot of influence on me; yet I rejected the field of medicine and joined architecture. I loved the course from the moment I entered university, envisioning the possibility of becoming an accomplished and influential designer. After a master's degree in architecture from the University of Texas at Austin, I returned to India and set up a joint practice with my husband, Miki Desai. However, by the time I was thirty-three years old, I had two children and had begun to realize that my career was nowhere close to being where I had imagined it would lead me. That realization was painful, and the personal became the political as I delved into feminist literature, along with many other women of my generation. Abandoning architectural practice, I became a teacher, a researcher and a writer, devoting the same energy to the discourse of architecture that I had formerly devoted to its design and creation (Desai 2007; Lang et al. 1997). Along with my interest in colonial architecture, the path from issues of women architects led to the area of gender and the built environment. Teaching has been rather experimental for me and interaction with the young students inspires me as a scholar. I am also fortunate to have a spouse who shares my deep commitment to architecture as a force for social good and beauty. Thus, with these numerous activities, it has been an exhilarating journey down the road of architecture as well as feminism, where I strive for a way of life that moves from self to wider concerns.

* * *

To conclude, if the first women architects were exceptional individuals, the women mentioned above can be termed, in a sense, trailblazers because they pursued various directions in Indian architecture while challenging and breaking feminine boundaries of society and setting new trends to create identities for themselves in order to reach professional excellence. They mostly belonged to the urban upper middle classes, to families where education mattered a great deal. Their parents and grandparents were generally relatively progressive, and each of them received special encouragement from one of the parents to develop her career, the father in most cases, who served as a career role model. The mothers were housewives as a rule, but were educated and culturally sophisticated. For this new group of architects, their husbands and families continue to be their main support and strength even today. All those profiled above have a strong character, an assertive nature, total commitment, and a thoroughly professional attitude toward their goals. Each one of them has a passion for architecture that has enabled her to create a special identity and a career path for herself whether she has worked alone or in partnership.

We can perceive that during the second half of the twentieth century, women were the beneficiaries of political reform and modernity within the larger social framework. They were also part of the promotion and acceptance of modern architecture through the educational and professional processes, as the social climate demonstrated an extraordinary modernity within the tremendous diversity of India.[8] Curiously, most of these women architects, with the exception of Neera Adarkar and myself, do not perceive or call themselves "feminist," stressing their dislike for any such "ism," although they all strongly believe in gender equality as a basic right. Although they empathize with women's issues and disadvantaged positions in Indian society, I suspect that to gain success, most of these high-achieving women professionals have chosen not to reject but to absorb society's dominant masculine values and behavioral traits. Without the construction of feminist consciousness, most of them are also not aware of their gendered struggles, or at least have

not ascribed professional struggle to the politics of gender. It is difficult for them to acknowledge that architecture is not a neutral profession and that it cannot be separated from its social and political context (Anthony 2001; Desai 2007; Weisman 1994: 2). Though these women often refer to inspirational teachers and employers, most of them are reluctant to name any single person as a role model or a mentor. Being from the upper middle class, many of them also do not see any impact of the women's movement on their lives! Yet, with or without an acknowledgement of the larger issues of the women's movement, these women have opened the door to the next generation of architects. It is high time that histories of modern architecture acknowledge the impact of these dynamic women.

NOTES

1. See Mala Khullar's "Introduction" in Khullar (2005: 10).
2. I am grateful to all the women architects for the time they have spared for the verbal and written interviews as well as for sharing the photographs of their projects for publication. I am thankful to Mr Priyavadan Randeria and Mrs Panna Thakore for permission to use his archival photos for this article. Part of the paper relies on data collected jointly by Dr Mary Woods and myself while we worked on an earlier version of the project. See the article on Pravina Mehta by Dr Woods in this volume.
3. Unfortunately, there is no study in India, and all my efforts to get statistics from the relevant organizations have failed so far. In the UK, however, in July 2003, the Royal Institute of British Architects (RIBA) published the results of its research into the dropout rate of women from architectural practice. This is the first research of its kind to have been completed in that country. Carried out by the University of the West of England on behalf of RIBA, the report found that a combination of factors, including poor employment practice, difficulties in maintaining skills and professional networks during career breaks and paternalistic attitudes, cause women to leave the profession (http://www.architecturewomen.org.nz/archives/riba-research-why-do-

women-leave-architecture-may-2003). Seventeen percent of the total persons involved in the profession of architecture are women according to the website of the American Institute of Architects (AIA).

4. It should be stressed here that without gender sensitivity, the built landscape is commonly accepted as a neutral background. Most men and women designers also strongly believe in the neutrality of the profession and the self, the women preferring to call themselves "architects" and not "women" architects. In an attempt to be "mainstream" most women architects stay away from "women's issues" for fear of being labeled feminists or not being accepted as a "true" professional. The history as well as the practice of architecture has marginalized women as creators and users, ignoring these issues in the professional and academic discourses in the country. As a result, the production of buildings and the creation of theoretical knowledge remains status quo in the context of gender.

5. There is no statistical analysis available for girl students, either historical or contemporary. These are figures that I have gathered in my field research.

6. The narratives about the women architects are based on personal and written interviews, publications about their work, and questionnaire data.

7. UNESCO Asia Pacific Heritage Conservation Award of Excellence in 2007 for the restoration of Maitreya Temple in Ladakh; UNESCO Asia Pacific Heritage Conservation Award of Distinction in 2007 for the restoration of Convocation Hall in Mumbai; UNESCO Asia Pacific Heritage Conservation Award of Merit in 2006 for the restoration of the Sir JJ School of Art in Mumbai; UNESCO Asia Pacific Heritage Conservation Award of Merit in 2004 for the Dadabhai Naoroji Streetscape project in Mumbai.

8. This connection between women in architecture and modernity needs to be studied much in detail.

REFERENCES

Anthony, Kathryn H. 2001. *Designing for Diversity: Gender, Race, and Ethnicity in the Architectural Profession* (Urbana: University of Illinois Press).

Ashraf, Kazi and James Belluardo (eds). 1999. *An Architecture of*

Independence: The Making of Modern South Asia, (New York: The Architectural League of New York).

Desai, Madhavi (ed.). 2007. *Women and the Built Environment* (New Delhi: Zubaan).

Desai, Neera. 2006. *Feminism as Experience: Thoughts and Narratives* (Mumbai: Sparrow).

Joshi, Svati. 2008. "Introduction", in Purnima Bhatt, *Reminiscences: The Memoirs of Sharadaben Mehta*, compiled and translated (New Delhi: Zubaan).

Khullar, Mala (ed.). 2005. *Writing the Women's Movement: A Reader* (New Delhi: Zubaan).

Kumar, Radha. 1997. *History of Doing: An Illustrated Account of Movement for Women's Rights and Feminism in India, 1800–1900* (New Delhi: Kali for Women).

Kundoo, Anupama. 2009. *Roger Anger: Research on Beauty. Architecture: 1953–2008* (Berlin: Jovis).

Lang, Jon, Madhavi Desai and Miki Desai. 1997. *Architecture and Independence: The Search for Identity, India 1880 to 1980* (New Delhi and Oxford: Oxford University Press).

Weisman, Leslie. 1994. *Discrimination by Design: A Feminist Critic of the Man-Made Environment* (Urbana and Chicago).

About the Editor and Contributors

THE EDITOR

D. Fairchild Ruggles is Professor in the Department of Landscape Architecture at the University of Illinois at Urbana-Champaign. Her books include the edited volume *Women, Patronage, and Self-Representation in Islamic Societies* (2000) and *Islamic Gardens and Landscapes* (2008).

THE CONTRIBUTORS

Catherine B. Asher is Professor of Islamic and South Asian Art and Architecture in the Department of Art History at the University of Minnesota. She is the author of many books and articles on South Asia, notably *Architecture of Mughal India* (1995; reprinted 2001).

Madhavi Desai is Adjunct in the Faculty of Architecture at CEPT University and partner in ARCHICRAFTS Studio. She is co-author of *Architecture and Independence: The Search for Identity: India 1880 to 1980* (1997) and editor of *Gender and the Built Environment in India* (Zubaan 2007).

Pradeep A. Dhillon is Associate Professor in Educational Policy Studies and Linguistics at the University of Illinois, Urbana-

Champaign. In addition to serving as the editor of the *Journal of Aesthetic Education*, she is the author of *The Theater of Meaning: Aesthetics in Semantic Theory* (2006).

Alisa Eimen is Associate Professor in the Department of Art at Minnesota State University at Mankato. She contributed an essay to the edited volume *Architecture and Identity* (2008) and co-curated the exhibition *The Precious Object for* mnartists.org in 2009.

Sharon Littlefield was Curator of Islamic Art from 1999–2011 at Shangri La (the Doris Duke Foundation for Islamic Art). She is the author of *Doris Duke's Shangri La* (2002).

Barbara D. Metcalf is Professor Emeritus in the Department of History at the University of California at Davis. She has written and edited numerous volumes on South Asia, including *Islamic Revival in British India* (1982) and *Husain Ahmad Madani: The Jihad for Islam and India's Freedom* (2009).

Amita Sinha is Professor in the Department of Landscape Architecture at the University of Illinois at Urbana-Champaign. The author of *Landscapes in India* (2006), she has also designed and written numerous master planning reports on historic sites in India.

Lisa Trivedi is Associate Professor in the Department of History at Hamilton College. She is the author of *Clothing Gandhi's Nation: Homespun and Modern India* (2007).

Mary N. Woods is Professor in the School of Architecture at Cornell University.
 She is the author of *From Craft to Profession: Architectural Practice in 19th-Century America* (1999) and *Beyond the Architect's Eye: Photographs of the American Built Environment* (2009).